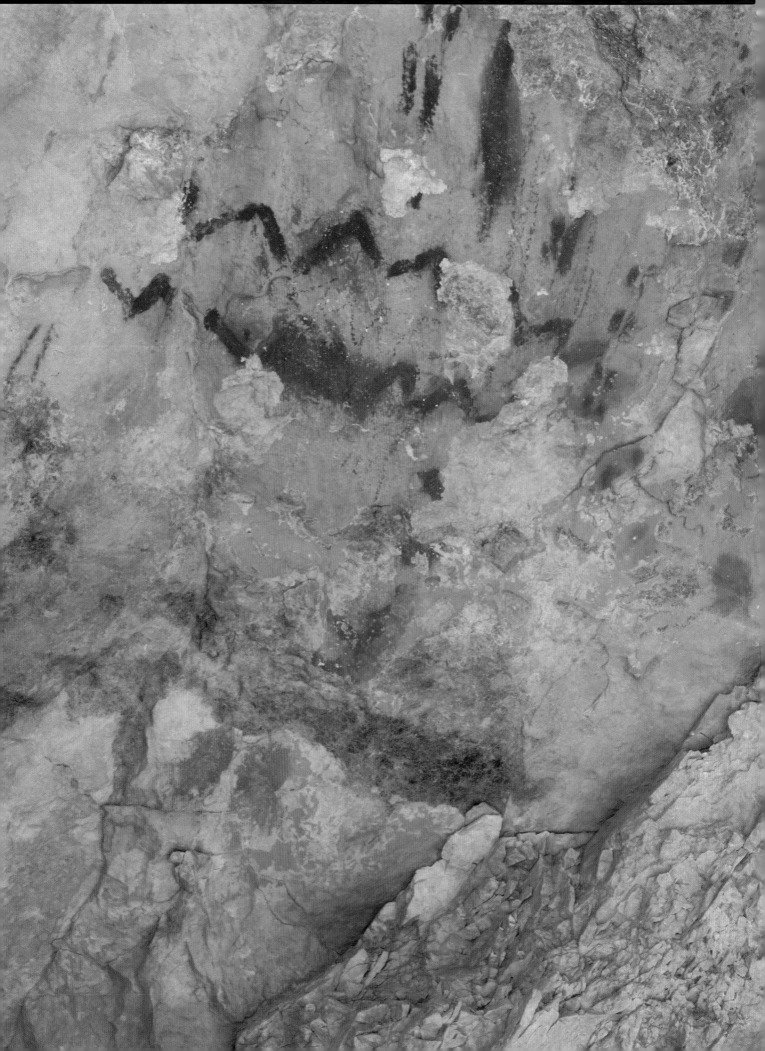

Painted Dreams

Native American Rock Art

Thor Conway

NorthWord
PRESS, INC

Minocqua, Wisconsin

Edited by Greg Linder and Kim Donehower
Designed by Patricia Bickner Linder

Published by NorthWord Press, Inc.
 P.O. Box 1360
 Minocqua, Wisconsin 54548

For a free catalog describing NorthWord's line of
nature books and gifts, call 1-800-336-5666.

Library of Congress Cataloguing-in-Publication Data

Conway, Thor.
 Painted dreams : Native American rock art / by Thor Conway.
 p. cm.
 ISBN 1-55971-213-9 : $29.95
 1. Indians of North America--Antiquities. 2. Rock paintings--
North America. 3. Picture-writing--North America. 4. North
America--Antiquities. I. Title.
E98.P34C66 1993
970.01--dc20 93-19666
 CIP

Printed in Hong Kong

Acknowledgments

I am grateful to the three individuals who made this book possible: Fred Pine, master keeper of ancient tribal traditions; Dan Pine, truly a holy person; and Julie Matey Conway, my talented wife, artist, companion, and editor. Julie and I shared the experiences in this book together. Her considerable work in rewriting and balancing my words has greatly improved this book. *Painted Dreams* is their achievement, too.

I also want to thank my children—Amber Wahsayah Conway, Tara Nowahtin Conway, and Cedar Geegahkwah Conway—whose questions about rock art sites often led me to new dimensions of understanding.

I want to thank the many Elders of the Ojibwa, Cree, Algonkian, and Ottawa tribes who shared their personal knowledge and experiences, including Kush Kush Michael Paul, Chief William Twain, Chief Gary Potts, John Odjig Fisher, Shannon Cryer, Louie Meawasige, Bill Meawasige, Mrs. Jane Espaniel Mckee, Mrs. Madeline Katt Theriault, Chief Norma Fox Wagoosh, William Souliere, Phil Potts, Walter Neveau, Joe (Shiner) Shining Rock, Adam Osawamick, and again Fred Pine and Dan Pine. *Meegwech.*

Many individuals have shared their knowledge and encouragement, especially Frank and A. J. Bock, William Hyder, Kathi Conti, James Swauger, the late Selwyn Dewdney, the late Klaus Wellman, Doris Lundy, Timothy Jones, James Keyser, Clement Meighan, and Georgia Lee. I also want to thank Ian Wainwright and John Taylor of the Canadian Conservation Institute for their insights shared over the past 20 years.

I extend my gratitude to Tom Klein and Pat Klein of NorthWord Press for their interest in my dream; and to Greg Linder for his editing.

Special thanks to Heritage Discoveries, Inc. for permission to reprint several Ojibwa and Chumash folk tales that first appeared in *Spirits On Stone, The Shrine of the Earth Goddess,* and *California Stonehenge.*

Table of Contents

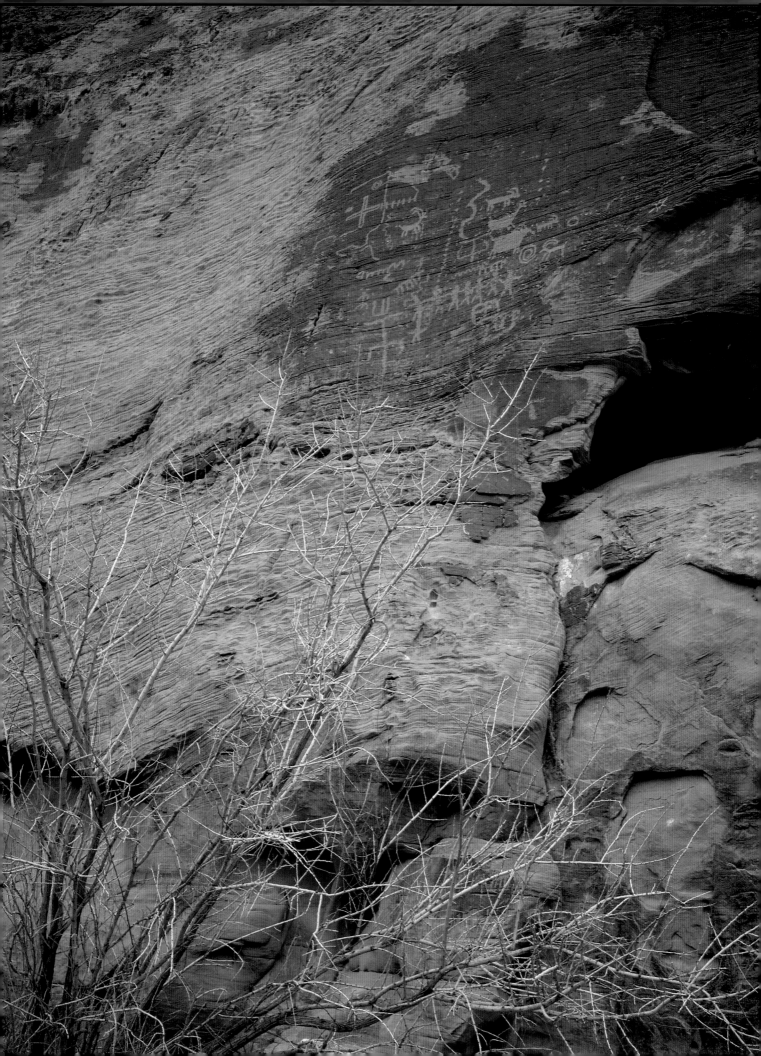

Preface

by Sah-Kah-Odjew-Wahg-Sah (Fred Pine, 1897-1992)

When you study this traditional culture like I did, you will find that it's true teaching. The way paintings are bringing up Indian beliefs today returns us to the past. When I was a boy, I fasted and dreamed. These visions come back to me now.

The markings on the rocks. It's not a story. It's just like a map for your mind. You'll see a big crooked line—that's the shape of the country, the spirit of the land.

Writing on rocks. Indians traveled and looked ahead in their lives. For a better place to live. Animals for food. Writing tells you what the background is to the country. You can follow the rocks [pictographs] from Lake Superior all the way down to Parry Sound [eastern Lake Huron], where Indians traveled the coast. Now that I'm getting old, I realize that this is true teaching.

Pictographs represent. Everything that's on Agawa Rock is a good sign. It tells you how to maneuver. Every little article painted there, that you see, always has a meaning to it. A meaning—like shorthand. But if you understand this meaning, you will know the path to travel in the spiritual world. I will tell you these things because my culture is part of this land. And we live together.

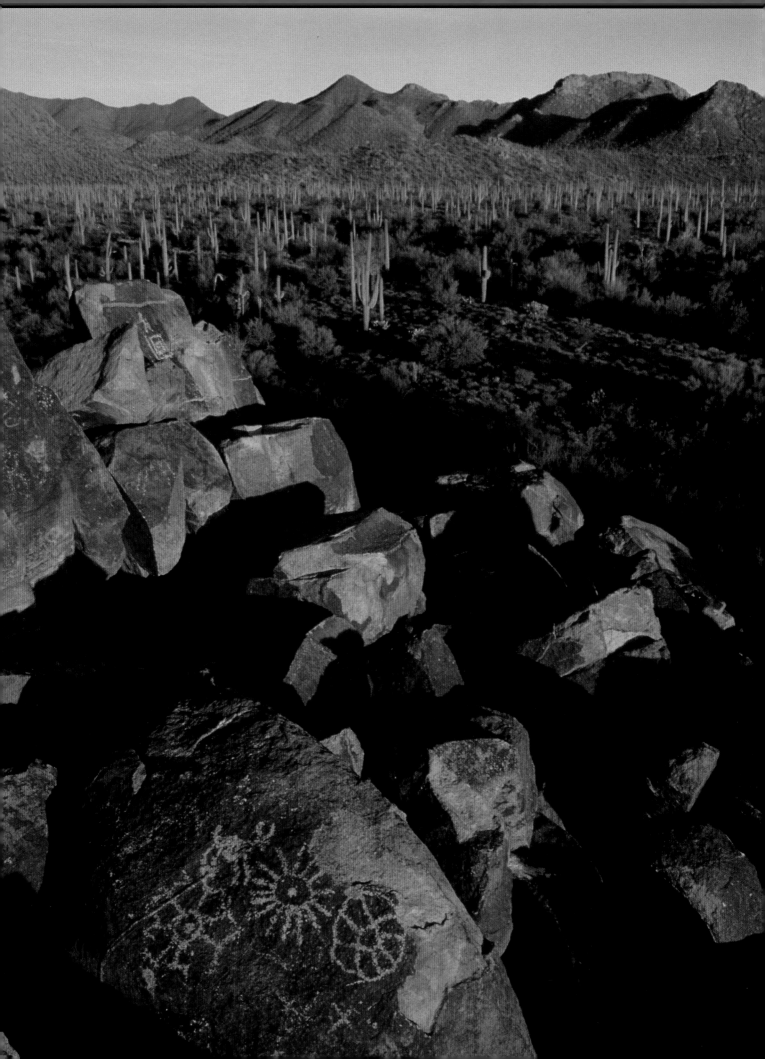

Introduction

I have walked on the edge of the world, alone, yet guided by the voice of the land. From earliest childhood—I always claim I was born an archaeologist—I have felt compelled to seek the lasting traces of Native American ways. Growing up in the Allegheny Mountains, I pursued archaeology as a means of making contact with past aboriginal wisdom. The tribes that once roamed the dark hollows of western Pennsylvania were gone, but faint traces of their ceremonial world remained in the form of intriguing petroglyphs. Gradually, formal education, a busy career as an anthropologist, and the love of wilderness led me to Canada. There, fate eventually brought me together with my cultural grandfather, an aged Ojibwa medicine man known simply as Fred Pine.

A long journey eventually led me across the continent, to remote areas where tribal energies continue to give life to the land. From the upper Great Lakes to the isolated shoreline of Vancouver Island, along Maine's cold coast, to the chaparral-covered mountains of southern California, I have merged work as an anthropologist and archaeologist, in my quest to appreciate and understand rock art. The images carved and painted on stone were usually accessible with moderate effort. The intent behind these enduring "dreaming rocks" was more difficult to discover.

Gradually, I learned more of the tribal traditions and rich North American mythologies. I spent seasons with the Nootkan descendants of the aboriginal whalers of Vancouver Island. I worked with the Tsimpshian of Prince Rupert, whose

◀ *Rock art reminds us that another world existed where we now tread. Saguaro National Monument, Arizona.*

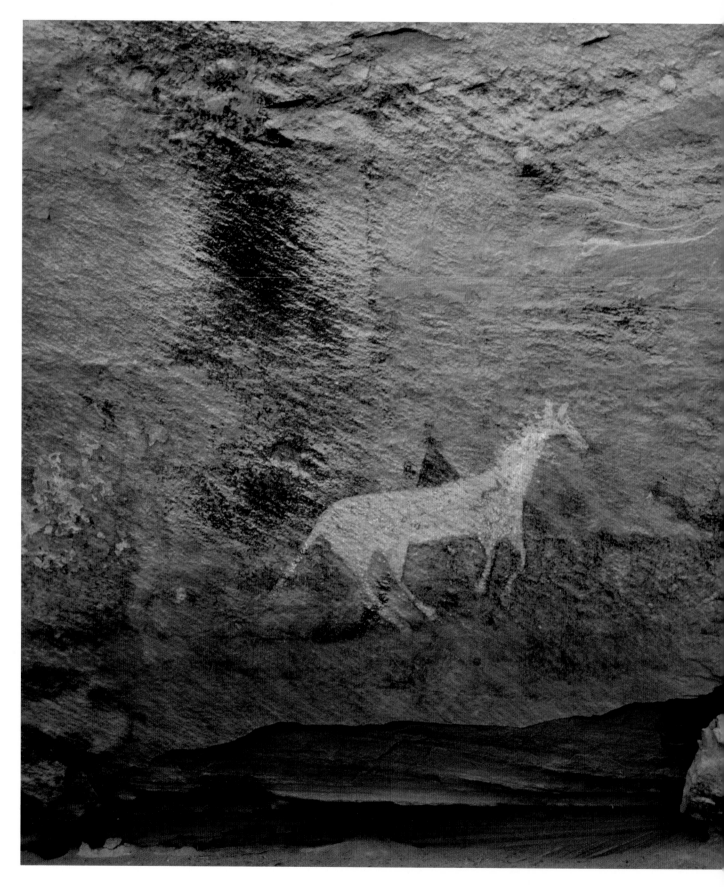

▲ *A pictograph horse with Spanish rider wearing a winter cape, Canyon de Chelly, Arizona.*

Raven legends transform the northwest coast of North America. I had an apprenticeship with Ojibwa, Chippewa, and Algonkian shamans of northern Ontario, and I worked with the Cree hunters of the sub-Arctic. From these experiences, I grew to understand that rock art and other native concepts about the sacred earth were not isolated phenomena: Despite five centuries of momentous change and acculturation, many native people had, against all odds, retained their traditions and beliefs concerning the sacred landscape—wisdom passed on by their ancestors. I also learned to better appreciate mythology as a sophisticated form of instruction, to look at the land's own metaphors, and to listen to the words of the shaman.

As a boy, I often wandered through the deep river valleys and hemlock-darkened hollows of western Pennsylvania. There, I felt the lingering presence of long-vanished tribes—a feeling never captured in the dry words of science, yet always present in the carvings that covered the walls of abandoned rock shelters. This sense of native spirit in the land was also tangible as I skirted the banks of the Clarion and Allegheny rivers, where seasonally flooded rock slabs glowed with the power of carved panthers and other ancient dreams.

Summer holidays were organized around trips to Maine, where I viewed carvings left on glacially scoured bedrock near Machiasport; later to the southwestern United States where I gazed, overwhelmed, at the profusion of Pueblo, Anasazi, and older rock art; then on through the Great Basin's mysterious carved legacy; and to the eastern Rockies, where I found hidden galleries left by the horse tribes and their ancestors. There, I was entranced by images of mounted warriors and armed tribesmen carrying shields decorated with dream powers.

I grew up surrounded by rock art that was created by the eastern Algonkian tribes, but I never heard their spoken traditions concerning the illustrative spirits on stone. These Native Americans had been silenced by disease and warfare decades before the first Europeans entered their homeland in the upper Ohio River drainage basin. I could not pry loose the secrets behind the intriguing images. Rock art researchers from Pittsburgh's Carnegie Museum had documented the legacy of a Pennsylvania area tribe we now call the Monangahela people, probably cousins to the Shawnee. But time had forever muted their native voices, just as industrial progress now

buried the riverside carvings beneath steel, concrete, and the flood waters of numerous dams.

As in most areas of the United States and Canada, it was relatively easy to uncover evidence of aboriginal settlement in western Pennsylvania. I followed the same trails as the Seneca raiders. I excavated their rock-shelter hunting camps and villages fortified by earthworks, and I dug deep into past river hamlets buried in the silt-laden floodplains. The artifacts certainly told stories, but most of the native world was missing. Not satisfied with the material connections, I wanted to learn firsthand about the richly textured dreams and the spiritual relationship with nature that have evolved over hundreds of centuries of living native culture. And I wanted to live with wilderness.

Because of my desire to learn from traditional aboriginal Elders and to live in a land closer to its original state, I began a Canadian odyssey that continues into its 23rd year. In 1970, I began field work with Nootkan groups on the remote west coast of Vancouver Island. This was an introduction to a complex culture and to one of the richest artistic traditions found in North America. Seasons passed. I moved to Prince Rupert, where Tsimpshian rock art covers the tidal edge of the continent; then on to Victoria and Vancouver, where Salish tribal carvings lie within reach of these cities. Several years later, I returned to Ontario to become a provincial government archaeologist. Thus began a long sojourn with the Algonkian tribes of the upper Great Lakes and sub-Arctic.

In 1981 I met Fred Pine, an extraordinary Ojibwa Elder living on the Garden River Indian Reserve near Sault Ste. Marie, Ontario. He was the oldest living native person in the eastern Lake Superior area at that time, and a very cautious shaman who would not teach anyone. I also began to work with Fred Pine's uncle, Dan Pine Sr., whose fame as a healer and spiritual leader was widespread. At first, neither of these Elders would talk about rock art. They had to prepare me, through a long apprenticeship, for an understanding of this enigmatic, religious art. This work involved traveling, immersing myself in creation myths, and developing my relationship with the sacred earth.

My personal quest for tribal wisdom was soon interwoven with the Pines' own journeys, as they struggled to keep aboriginal traditions alive. My study of rock art started in the 1960s. By the time I met Fred Pine, I felt prepared to ask him about this religious art because I had 20 years of research behind me. He just laughed when I mentioned my background.

"The medicine people have been drumming for longer than that," he said.

"You don't know anything," he abruptly told me soon after our initial meeting. He stared a hard, barely tolerant gaze across his kitchen table. "You don't even know how you got here. Do you?"

I had worked with shamans and tribal religious leaders for several years before visiting Fred Pine, so I realized that some of his gruff manner was a screening process. Because of the long years of racism, government suppression of native culture, and the efforts of intolerant non-native religions, many traditionalists had developed a protective demeanor out of necessity—creating nearly impenetrable barriers to learning their sacred beliefs. Now, at the end of the 20th century, awareness of the importance of keeping native culture alive for the benefit of younger generations of Native Americans, as well as for all residents of North America, is growing. The revival of native ways has evolved with great effort, but the Elders whose traditional beliefs were for so long ignored by modern society have often been reluctant to share their carefully nurtured knowledge.

Fred Pine demanded an answer: "Well, do you?" At that moment, I sensed his skills as a teacher and native orator.

"The spirits directed me here," I replied.

He didn't say anything for a few minutes. Then he asked me, "Are you serious about learning the culture?" I nodded. He continued: "You know how the grouse calls his girlfriend by drumming his wings near a log? That sound travels a long way—more than you would expect. Well, I sent a message to you, from my dreams. I brought you here. That is the power I have because I fasted. I never revealed anything about what I was taught. I wouldn't tell you anything, either, but the Little Wild Men instructed me to open up to whoever approached me. For 84 years, I never taught anyone. I don't want to teach you, either, but I must."

This uncomfortable beginning soon faded. Years passed. And gradually Fred Pine's personal dream, which I had initially confused with my own, was realized. Sometimes, as I asked Fred about the details of a particular painting or carving, he would tap the end of his wooden, snake-headed cane on our kitchen floor and begin to sing in the cryptic idiom of Ojibwa ritual songs. "Do you understand what I sang?" he would ask with a slight chuckle.

"Yes," I would answer. Then, more honestly, "Well, no." I hesitated to reply. I knew enough of the language to interpret part of his song, but most of the words remained unrecognizable. Yet I always felt an intuitive message from this shaman's songs. Fred would ask me to repeat the song in English. When I did, I found myself answering questions I had planned on asking him later that day. This kind of dialogue happened so often that I gave up trying to understand the process. Frequently, the insights I gained into the meaning of rock art fit my preconceptions in a general way, but they were usually far less direct than I had expected.

Although Fred taught me through an indirect method of education, he also remained a classicist who demanded that I not only learn but understand his carefully articulated knowledge. At first, I was confused by the two teaching styles. Then I appreciated his balance between inner knowledge, gained from association and experience, versus external knowledge transmitted in a formal manner.

On visits to rock art sites, Fred spontaneously opened up his wealth of personal knowledge, which he had kept private for so many decades. Other times, he would divert our discussions to other subjects. Some days, Fred would patiently explain the background of various red ochre images. When I followed with more probing questions, he frequently sat with his head bent toward his chest—he was very old—and squeezed his eyes shut. He moaned a barely audible "ahhhhhhhh" while he thought. I know I asked him to travel to the furthest reaches of his memory—sometimes 85 years into his past—in order to help me understand the ancient cliff markings. It was difficult and challenging for him. Only our love for each other, grandfather to grandson, enabled us to face the challenges involved in retrieving distant memories.

Fred Pine and I traveled widely together. We often spent the summers retracing the sacred duties necessary to honor the earth spirit. We visited the camping grounds of his youth; stopped at marshes, creek beds, and lakes to pick certain herbal remedies; and roamed the hills to learn aboriginal place names and stories identifying holy mountains. Other years, we made pilgrimages to many sacred sites. Long hours of driving were filled by listening to his legends, which detailed the accomplishments of the shamans of his youth. Fred's knowledge was unsurpassed.

Dan Pine Sr. was a different kind of teacher. He seldom spoke without acknowledging his spiritual guides through life. Dan Pine radiated holiness in a calm, thoughtful manner. His personal stature in the Midewewin—the Grand Medicine Society—was unsurpassed. Whether working as a healer or a vision quest facilitator, this thin, frail-looking Elder radiated divine energy. Born in 1900, he was taught the spiritual and cultural wealth of his nation and shared it with anyone who seriously wanted to learn his wisdom. He nurtured traditional beliefs and performed ancient rituals throughout his life. By the time of his passing in 1993, Dan Pine had witnessed a revival of the medicine lodge that he had kept alive during the long decades when aboriginal traditions were suppressed.

In the same years that Fred Pine tutored me, I also began working with another shaman—one who prefers anonymity. "Man Who Sleeps A Lot," a name alluding to his skills at entering the trance world, also introduced me to the art of his ancestors. As an active intermediary between the affairs of humans and spirits, he led me over an extended period of time through the shaman's world—a realm balanced between poetic expressions of human nature and terrifying, primal energy. This is a whispered world, where shadow dwells not as a lack of light, but as darkness cast upon an object. It is also a place where healing light and restoration occur. Through a shaman's eyes, rock art contains a familiar record of the dreamscape—a perception as real to aboriginal nations as that gained from the outward world.

In 1988, I started a heritage consulting business so I could be free to pursue aboriginal knowledge. This freedom led to a dual lifestyle: West Coast winters, during which I explore the rock art and archaeology of California and write books; and Canadian summers, in which I am employed by tribal governments to document traditional land use and the wisdom of the Elders.

I work with a great sense of urgency because, within my lifetime, the last generation of Elders—individuals who are more connected to the time of Creation than today's world—will join their ancestors. Before they leave, I feel it is my duty to honor them, and to help retrieve their priceless gifts of native spirituality.

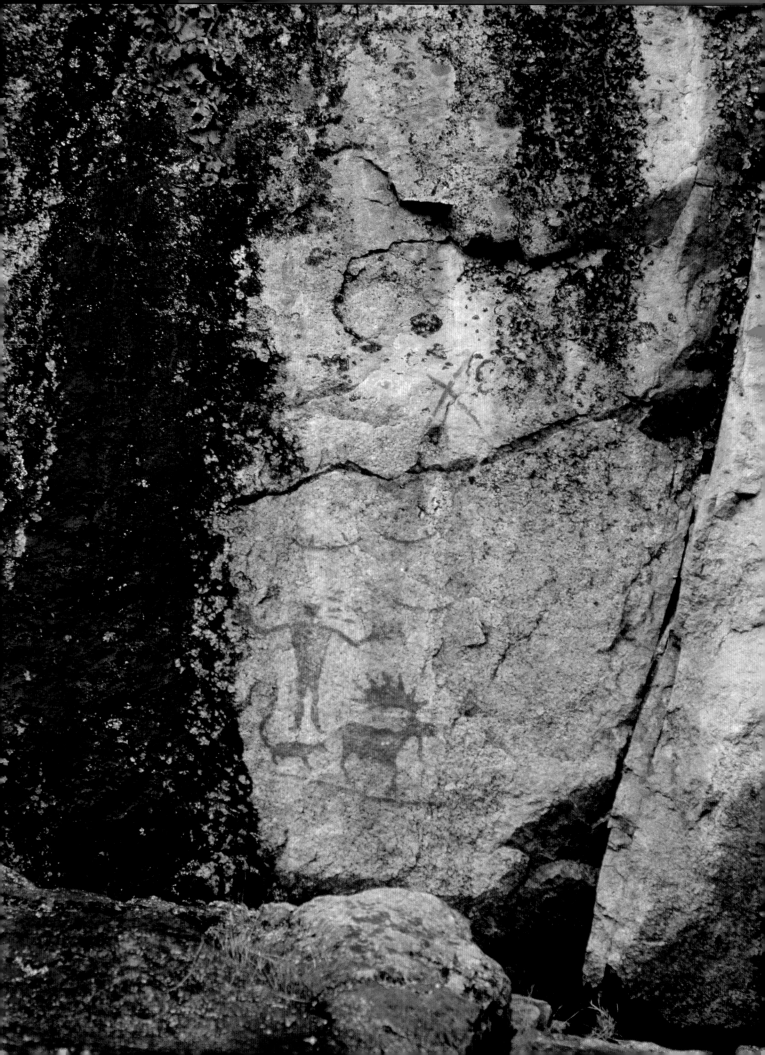

What Is This Gift Called Rock Art?

When I was a boy, everybody was sent to dream. The old people placed us on a rock where voices had been heard. Sometimes they would build a small enclosure to shelter us during the fast. This place was the Dreaming Rock. And there I received my education. How will you know the Dreaming Rock? The markings my grandfather placed on that rock are his visions. You see, when you look at that rock, it is still dreaming. That's why those markings last. The Dreaming Rocks' spirits let you see their dreams.

—Fred Pine

Across North America, the dreams of native people lie immortalized in stone. An immense collection of paintings and carvings form the complex heritage we call rock art. These wondrous images—whether found on towering cliffs, low rock ledges, cave walls, boulders, or expansive outcrops—have endured their passage across the centuries. The Elders of the Great Lakes tribes refer to these often sacred places, marked with ancient art, as "the Dreaming Rocks." Rock art is today the most visible legacy of Native American forebears—an intimate expression and appreciation of the spirit of the land.

▲ *A magnificent moose with multi-tined antlers near the Ontario–Minnesota boundary. Lac La Croix, Quetico Provincial Park, Ontario.*

◄ *Pictographs at Hegman Lake, northern Minnesota.*

As tribal groups reclaim their sacred heritage, the Dreaming Rocks that are publicly accessible should be approached with respect. We are guests in these holy places. Here we can open our eyes to painted visions, our ears to the messages of the Elders, and our hearts to the presence of the sacred. In this way, we may recover the timeless wisdom that remains preserved on the Dreaming Rocks—messages that may contain the key to our survival on earth today.

Much of the enduring rock art stands as a fossilized hint of personal religious activity—the encompassing spirituality that is the hallmark of Native American traditional life. Just as the wind-kissed, standing stone circles of the Celtic homelands are reminiscent of empty temples and ancient rituals from long ago, North American rock art recalls the dreams and visions of Native Americans at their natural cathedrals.

As with all great religions, the ceremonial and physical expressions of Native American religious life began through direct, inspired contact with the vast mystery of existence, whether by shaman, priest, or similar visionary. From such singular beginnings, rites, rituals, and other sacred observances nurtured visions of the divine. Some of these dreams were permanently rendered in stone at specially-chosen settings across the sacred landscape.

WISDOM OF THE ELDERS

The rich complexities of North American rock art are regarded as tribal voices that provide living links to the past. In the 20th century, only a few aboriginal societies retain such direct links to their heritage—native Australians, the San Bushmen hunters of southern Africa, some South American Indian groups, and several dozen tribes in North America.

The look of North American rock art varies from region to region and across prehistory. Collections of pictographs and petroglyphs are shaped by tribal beliefs—the imagery of sedentary Pueblo villagers would not be mistaken for the art of the salmon-fishing tribes of the northwest Pacific, or that of the trance-inspired hunters of the sub-Arctic. Although *Painted Dreams* explores the diversity of native spirituality revealed on stone, an underlying current connects not only all North American tribes but all indigenous nations across the globe. It is the universal language and imagery of shamanism and personal spirituality. When we turn our attention inward, superficial differences are quickly dropped as we discover an archetypal common ground.

The soul speaks in the language of images and symbols.

Despite the relatively early discovery of Dreaming Rocks in the United States and Canada—several dozen commentaries from the 17th, 18th, and 19th centuries mention rock art sites from Massachusetts across the Canadian wilderness to California's gold fields—North American rock art research has lagged behind that of European scholars, who were confronted with masterpieces of Ice Age art in France and Spain. When the study of rock art in Canada and the U.S. did begin, its special status was quickly recognized, and a tone was set that continues to influence our understanding of tribal imagery. Individuals who married into or worked closely with Indian tribes soon learned that North American rock art, unlike its European counterpart, remains a living tradition.

By the 1850s Henry Schoolcraft, an Indian agent living at Sault Ste. Marie, Michigan, had made an outstanding contribution to the preservation of Indian customs, lore, history, and rock art through his numerous books containing native oral history, legends, and personal observations. At some point in his professional negotiations with Ojibwa leader Shingwaukonce, Schoolcraft learned that the aged veteran of the War of 1812 possessed much personal knowledge about rock art. Shingwaukonce, Dan Pine's grandfather and Fred Pine's great-grandfather, drew images from Agawa Rock and another then undiscovered Lake Superior site for Schoolcraft, and added the oral history that interpreted the origins of these pictographs. Schoolcraft set the tone for future North American rock art studies when he amassed this information as well as tribal mythologies and other native images in his publications.

Colonel Garrick Mallery, an army officer stationed on the Great Plains in the decades after the Civil War, began an encyclopedic study of rock art that culminated in his *Picture Writing of the American Indians*. He, too, recognized the insights that could be gained from comparative studies of Indian art. In an attempt to interpret tribal art, Mallery consulted buffalo hides painted by the Sioux, as well as Ojibwa and Chippewa birchbark prayer scrolls, and a wide range of marked wooden artifacts.

WHAT IS ROCK ART?

Visible mysteries, capable of transporting us across time into a world colored by mythology, confront us at thousands of marked rocks. To native people, every part

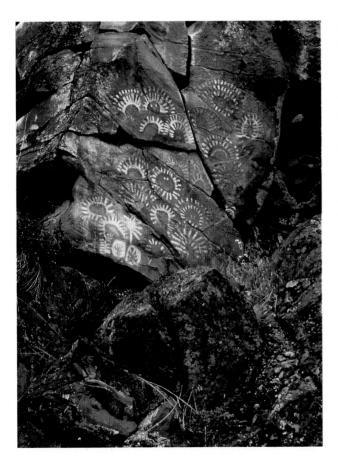

with any tour, some rock art attractions are briefly mentioned, while others are omitted altogether. In *Painted Dreams*, I write about sites that I have personally experienced or I describe images that, based on my training by tribal Elders, I believe add another dimension to the appreciation of rock art. I prefer to linger at pictographs and petroglyphs where the voice and intent of native spirituality is well-preserved.

Rich and numerous records of Indian intellectual and religious heritage are preserved throughout the United States and Canada—abundantly in the Southwest, more sparsely in the southeastern United States, and across the Great Plains. Some of these areas have been studied in detail, and are well-represented in recent publications. The sampling of rock art sites presented in *Painted Dreams* tells, through native voices whenever possible, the stories told on these ancient tapestries.

My life has been enriched by years spent with Native American spiritual leaders, tribal storytellers, and visionaries who are direct descendants of the last painters and carvers of stone images. I have also walked trails with numerous contemporary artists, scientists, conservators, archaeologists, and other individuals who have long-term interest in rock art. Their stories and discoveries are also woven into these pages.

QUESTIONS TO ANSWER

At public rock art sites, I often hear the same questions being asked: "Who painted these images? Does anybody know their age? Did Indians really carve these images? Are rock art sites rare? How does the paint last so long?" These are followed by a question that has many different answers: "What is the meaning of these paintings and carvings?"

Painted Dreams explores answers to these questions. Because native spirituality is a complex subject, the explanations will naturally lead to further questions about the diverse meanings of rock art.

ROCK ART SETTINGS

Throughout the long years of prehistory, tribal groups divided the land that became the United States and Canada into a series of interlocking, sacred landscapes, where shamans surveyed and interpreted natural formations, their visions influenced by well-honed mythologies. Individuals actively seeking North American rock art sites have found numerous kinds of site settings. Rock art sites can be as simple as a single painting on a sheer cliff, or as complex as thousands of

of creation is animated with life. Rock art acts like a hologram—a multi-dimensional vision that speaks to the soul. Rock art requires contemplation, and it is capable of inducing thoughts about the supernatural through a clever blending of natural setting and intriguing images. By considering all of the Dreaming Rocks across the United States and Canada, we hold in our minds supernatural touchstones, like faceted crystals offering different appearances and separate meanings, yet united as a glimpse into the very heart of aboriginal existence.

A single, satisfactory definition of rock art can never be devised. Its origins are diverse, and its images are as infinite as the imagination. Despite this complexity, there is a simple interpretation—rock art is an integral part of the sacred earth.

Native Americans created carefully marked shrines and centers of spiritual activity across the North American continent. Although I have explored these mysteries for nearly 30 years, many areas remain unknown. In this book, I have chosen to revisit diverse areas in the United States and Canada. As is the case

▲ *Sunburst and halo pictographs in the Columbia River area, Washington. Some have minimal faces. The overall effect is a rare radiance on otherwise drab rock.*

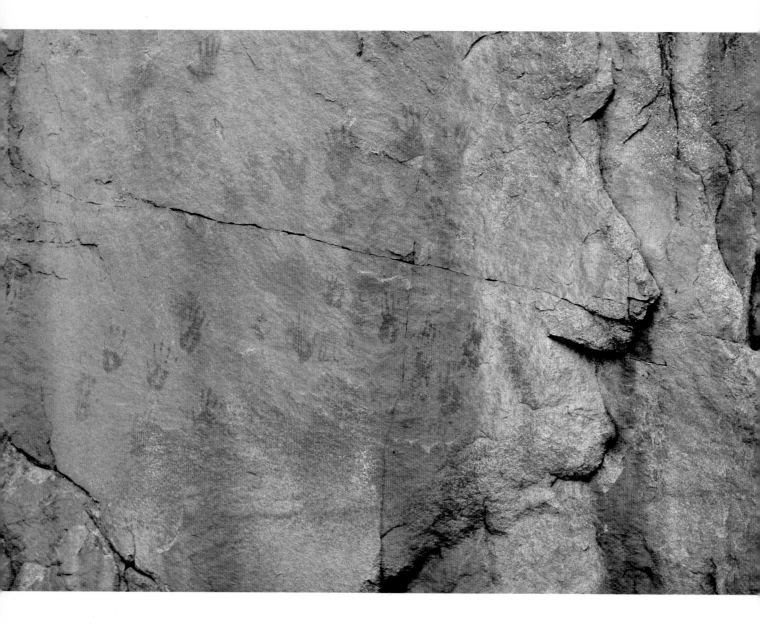

designs filling the walls of a box canyon. On the northeastern edge of eastern Canada, Micmac artists of Nova Scotia left finely engraved, almost scratched, images on slate-like bedrock along inland lakes. Their Algonkian cousins to the south in Maine preferred to peck a pantheon of native spirits into boulders and tide-washed outcrops. While cliffs, canyons, boulders, ledges, and sloping bedrock surfaces provided the majority of rock art settings, related ancient images include designs drawn by scraping the surface of lichen-covered stone walls, carvings or paintings within caves, and secretive art hidden from view.

AREAS AND SITES VISITED

Most residents of Canada and the United States live within a two-hour drive of a Dreaming Rock. Thousands of uncounted rock art sites lie partially hidden in lake and forest wilderness areas and backcountry canyons, while other sites in state and provincial parks are more accessible. The distribution of rock art is sparse in some regions and inexplicably abundant in others. The dream-like, painted and carved images challenge our interpretive abilities. To most of us, these deliberate actions of native visionaries are mysterious creations.

▲ *Numerous handprints on a cliff beside Lac La Croix, Quetico Provincial Park, Ontario. For the Ojibwa of this area, creating hand images was part of preparation for warfare.*

Although *Painted Dreams* is not a guide book, some of the sites used to answer questions about rock art are located in parks, and are easily accessible. Whenever possible, managed and protected rock art sites are used as examples of this fragile heritage.

If the definitive line between the United States and Canada were drawn using aboriginal boundaries, it would undulate like the serpents painted at so many sites. The War of 1812 and other events beyond the control of aboriginal populations led to the creation of the border that is defined so absolutely today. In the not so distant past, native territories were marked by natural stone monuments and identified by ancient tales. *Painted Dreams* treats the entire North American continent as aboriginal land defined by regional recognitions of the sacred earth.

In *Painted Dreams*, we will be jumping across two countries. We will visit the broken coast of Maine, where it is challenging to even depict the shallow petroglyphs; we will briefly pause at a tributary of the Allegheny River in Pennsylvania to discover a famous cougar wearing a deer mask. After traveling to Agawa Rock on the northeastern shore of Lake Superior, we take a gargantuan step—mimicking the strides of the local Ojibwa trickster, Nanabush—into northern Michigan and Minnesota. There we can view related pictograph cliffs painted by the spiritual leaders of the same Ojibwa and Chippewa First Nations, as well as petroglyphs left by the ancestors of the prairie-dwelling Sioux.

A Sioux tribal rock in southwestern Minnesota helps us recall the wisdom of Black Elk and the sacred pipe. Similarly, our scrutiny of Writing-On-Stone in southern Alberta can only be understood by reference to the Great Plains tribes, such as the Blackfoot warriors who roamed the eastern Rockies on horseback. When we stroll among the wind-sculpted rocks of Writing-On-Stone, northern Great Plains native culture is resurrected as we learn about the concepts behind the carved, shield-bearing warriors.

Further west, the complex artistic traditions of the northwest coast, so strongly rooted in coastal British Columbia, flow down the western shores of the continent well into Washington state, through the ancient whaling village of Ozette, and into the Columbia River valley. The rock art of the Columbia leads us inland to the plateau tribes of the northwestern United States, where Coyote shaped the river. Upon arrival at the quiet banks of the Columbia River between Portland and The Dalles, we will meet America's prehistoric Mona Lisa. In California, spectacular examples of Chumash rock art, left in the dry hills above Santa Barbara, lead us into a discussion about the world of shamanism and trance experiences. There, we find Chumash Indian caves filled with psychedelic dreams. In the Four Corners region of the Southwest, we explore shrouded mummies, an inscrutable 20-foot panel called Newspaper Rock, and masked gods emblazoned on New Mexico canyon walls.

Later, we stand on the north shore of Lake Superior and hear the wisdom of the 95-year-old grandson of the last pictograph painter, as he reveals the mythology and beliefs that inspired Great Lakes area rock art.

THE SHAMAN'S VOICE

Aboriginal voices, which reveal vivid tribal mythologies and carefully memorized oral histories, provide clues to deciphering rock art. On this journey, we will ponder mysteries marking an inner wilderness whose messages are as meaningful today as they were 500 years ago. The voices of Native American shamans put the breath of life into rock art as we listen to the teachings of Ojibwa, Chippewa, Cree, Algonkian, Nootkan, and other tribes. As often as possible, *Painted Dreams* speaks with tribal words nurtured by native beliefs. This book is primarily an appreciation of and tribute to the cultural richness of aboriginal America, although the hard-earned results of current research also complement what is presented here.

A ROCK ART VOCABULARY

Most pursuits develop their own peculiar jargon. Rock art studies employ a few reasonable terms to describe the images carved or painted on stone surfaces. Two general words—*pictograph*, which refers to a painting, and *petroglyph*, which defines a carving—divide rock art into recognizable categories. To the Native American visionaries who left these enduring records, the distinction was probably less important than the image.

Shamans, individuals who entered trance states to gain access to the spirit world, produced a great amount of North American rock art. Another segment of ancient paintings and carvings record dreams encountered while following a *vision quest*—a deliberate initiation into the mysteries of the supernatural followed by the acquisition of divine power. In many tribes, vision questing was done by a majority of men

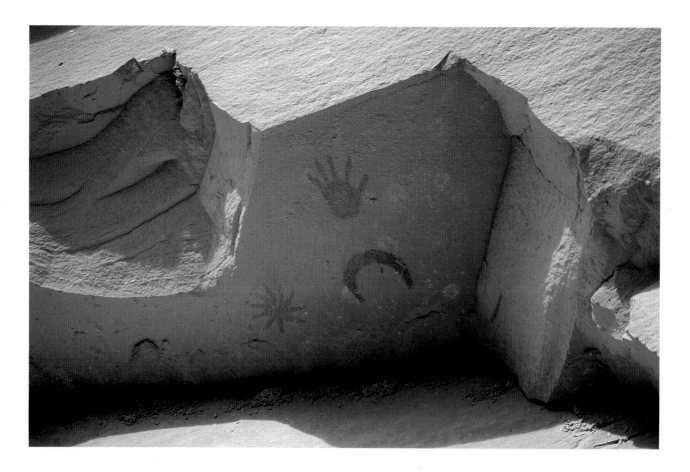

and women who did not progress to the status of a religious specialist. *Elders* are the men and women of vision. The word *Elders* is capitalized out of respect to them. It follows the usage favored by tribal groups today.

The physical setting of rock art sites varies from the gallery-like groups of pictographs and petroglyphs carefully juxtaposed on vertical walls to broad outcrops covered with petroglyphs and the jumbled boulder fields of the Southwest. A few terms help define individual displays of rock art. *Panel* describes a cohesive rock art unit visually separated from other clusters of markings. *Motif* refers to the type of symbol depicted in an individual painting or carving. Hand prints, zigzag lines, warriors on horseback, or moose representations are just a few of the numerous motifs found on Dreaming Rocks. A *cupule*, or "little cup," is a deliberately carved pit found on some rocks.

APPRECIATING ROCK ART

The spiritual side of rock art appreciation stands far beyond the analytical world of research. A majority of pictograph and petroglyph locations are considered holy ground. Walking among galleries of mystical images, we are transported to a metaphysical world where we are obligated to respect spiritual dimensions. In California, visitors to rock art sites will sometimes find a small bundle of sage along with decorated feathers left on a ledge. Sage is a purifier, a symbol of our sincere intent when approaching ancient wisdom. When crushed, sage gives off an aroma that fills the air, creating a ceremonial space around us. It reminds us of Black Elk, a famous Lakota Sioux medicine man, who sat on a specially prepared bed of sage when seeking his visions.

Somehow, in order to make a transition from everyday life to the supernatural, we need to alter our immediate environment. These enhanced conditions are created at a large number of rock art settings through a co-mingling of natural rock formations, light, sound, and the personality of the site. These places hold the achievements of native dreamers who left their visions showcased on stone.

The voice of Lone Man, relating the wisdom he learned from another medicine man nearly a century ago, eloquently states the importance of sacred stones.

▲ *Astronomical themes occur in rock art. This panel, painted on a rock ceiling at Chaco Canyon National Monument, New Mexico, may represent a supernova.*

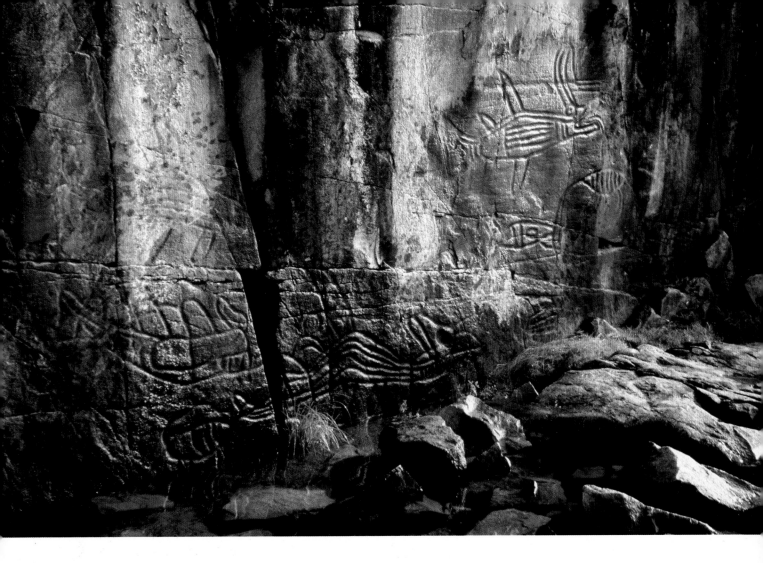

He explained the theory behind the appearance of the sacred, in and through special rocks, to the anthropologist Frances Densmore. Although Lone Man spoke about a small stone amulet carried for personal protection, he also identified the presence of spiritual knowledge in special stones of any size. He refers to *Wakan Tanka*, a Sioux term meaning Great Mystery—the greatest unexplainable spiritual power. Lone Man's words, which begin by recalling instruction he received from an Elder, apply so well to rock art:

"The earth is large, and on it live many animals. The earth is under protection of something, which at times becomes visible to the eye. One would think this would be at the center of the earth, but its representations appear everywhere, in large and small forms—they are the sacred stones. The presence of a sacred stone will protect you from misfortune."

He then gave me [Densmore] a sacred stone, which he himself had worn. I kept it with me wherever I went and was helped by it. He also told me where I might find one for myself. Wakan Tanka tells the sacred stones many things which may happen to people.

Visiting a sacred site requires a focus. Rock art comes from dreams, thoughts, and sensory experiences. After a while, we need to leave behind the self, the present moment, and our questions. We must let nature have its way. In the presence of the greatest rock art sites, we come to understand that time and generations are merely passing intervals.

▲ *Creatures of the sea, both real and imagined, add a dimension of sacredness to a cliff at Sproat Lake, Vancouver Island, British Columbia.*

Discovering Images from the Past

Travelers who unexpectedly encounter someone studying rock art usually want to know, "How do you find rock art sites?"

The answer varies from region to region. In the canyons and mesas of the southwest, few backcountry hikers or visitors to ruins in state parks fail to notice the abundance of pictographs and rock carvings. Elsewhere, discovery may be triggered by a natural event, such as an encounter with a long-buried collection of bedrock carvings recently exposed by a toppled tree, or a chance sighting of cliff paintings while canoeing through the northern Minnesota Boundary Waters.

Unexpected discoveries are common. Canoeists, gliding through the lake country at the Ontario and Minnesota border, are as likely to find a group of images on a lakeside cliff as are hikers in the dry canyons of Utah. Many of these rock art locations have been recorded. A few are rare rediscoveries of truly forgotten images. The density of rock art sites varies from region to region, with a general increase as you travel west across the continent. The presence of larger Indian populations in the southwestern United States accounts for part of the concentration. But the inspiration *behind* rock art production is more elusive.

▲ *Throughout the eastern half of North America, representations of thunderbirds or Thunder Spirits occur at rock art sites. A few simple brush strokes convey a wealth of cultural meaning at this site on Payne Lake, Quetico Provincial Park, Ontario.*

◄ *An accumulation of visions at Lac La Croix, Quetico Provincial Park, Ontario.*

In some tribal areas, events such as the spread of a new native religious practice could intensify the number of pictograph sites produced. In southern California, the *antap* cult of the Chumash gained widespread popularity, possibly just after European contact. The cult appears to be responsible for the unprecedented, complex panels of the most recent paintings hidden in caves throughout Chumash country. But in other instances, warfare or tragedies such as epidemics motivated new expressions on stone.

In culturally conservative areas, such as the vast northern wilderness of central Canada, rock art seems to have a long—though not prolific—history of creation. There, small bands of 150 to 300 aboriginal hunters and gatherers lived for thousands of years on the same lands, but the density of pictograph sites is erratic.

On Obabika Lake in northern Ontario, my wife and I had just paddled through a late-summer gathering of diving loons—a congregation of throat-chattering, wing-flapping birds brought together by the first impulses of migration. Did their spectacle distract us enough to make us wonder about a dark shadow on the shoreline, barely visible through the trees? Caves and rock shelters are rarely encountered in the Temagami wilderness, but the diminishing light and shadow hinted at a recess in the outcrops. We glided to shore, walked through the wall of protective vegetation, and stood under an overhang—face to face with the skeletal, flying omen of death known as Pagak.

The encounter with Pagak reminded me of a similar sighting I experienced in Prince Rupert Harbour on the northern British Columbia coast. My first view of a well-known carving called The-Man-Who-Fell-From-The-Sky remains a special event in my life. Standing in the drizzle with the scent of cedar filling the air, I beheld a life-sized petroglyph that looked as if a person had lain in soft schist rock and left a full impression. It was a lingering reminder of an old tale about travel to the sky world. I treasure the initial minutes at every rock art site I have seen.

There is a secret among archaeologists, seldom revealed among themselves or to the public. Discovery is a satisfying end in itself. The excitement of discovery is unsurpassed—suddenly standing face to face with a carefully rendered, ritual image from the realm of prehistory is an unparalleled experience. Romance dwells in discovery. For me, dozens of memorable moments remain personal treasures.

John Macdonell, a North American fur trader, recorded in his diary the exact words that would set a pioneer rock art enthusiast in motion. He described, in a single entry, both pictograph sites and lichen glyph sites. None of these particular sites or images has been relocated.

Some leagues below Derreaud's Rapid is the figure of a man standing over an animal that lays under him, with a sun on one side and a moon on the other side of him each surrounded by a large circle—a little farthur [sic] on, is at least 16 figures of different animals standing promiscuously together on the face of a steep Rock. Amongst them may be seen fish, flesh, and Tortoise, all of them painted with some kind of Red Paint. These figures are made by scratching the Rock weed [moss] off the Rocks with the Point of a knife or some other instrument. Two leagues from Lake Huron there is a figure of an ox which gives name to a fine long View of the river called Lad [Lac] du Boeuf.

EARLY ACCOUNTS

From the time of the French traders and Jesuits, in the 1600s, to the later exploration of the American west by pioneers and early settlers after the Civil War, Europeans and their descendants have encountered rock art on their journeys. In western Europe, by contrast, secretive cave paintings first attracted attention in the very late 1800s.

A fearless group of literate Europeans who chose to travel and live among the eastern tribes of North America noted many details of aboriginal life including

▲ *The Man-Who-Fell-From-The-Sky is a life-sized carving found on the edge of Prince Rupert Harbour in northern British Columbia. The figure is as deeply embedded into the shoreline as the mythology that inspired it long ago.*

rock art. Many Jesuit missionaries, educated in the colleges of France, entered the New World in the 1600s. Enduring long months of isolation in remote Indian villages, they kept detailed journals, called "Relations," which preserved portraits of native life on the cusp of history, before disease, warfare, and new economies forever changed the aboriginal world.

Father Jacques Marquette prepared himself for work among tribal nations by learning Indian languages, then satisfied his desire to travel deep into the continent. In the age of exploration, Europeans seriously expected to meet sea monsters of all descriptions as they approached the edge of the earth. As Marquette drifted down the Mississippi River near the mouth of the Illinois River in the company of Indian guides, he passed an area of limestone bluffs. There he saw an enormous image, produced by pecking and painting and made long before his visit in 1673. This frightening, composite animal appeared as a dragon-like great cat—the underwater panther so well-chronicled by the Ojibwa. A mask worn over the cat's head, showing a human face decorated with deer antlers, added visual strength to its demonic

demeanor. Who was this animal? Tribal voices tell us it was the guardian to the underworld. This image stood on the bluff wall near two favored shamanic earth openings—a nearby spring and a cave.

The energy inherent in great cats—whether a tuft-eared lynx standing amidst the snowdrifts of a Canadian winter or a mountain lion with a twitching tail perched on a canyon rim in the dry southwest—attracted shamans throughout the Americas. The Ojibwa blended lynx and ancient water dragon concepts to form Mishi-Peshu, guardian of Lake Superior. North of Detroit, at the Sanilac Petroglyph site, Mishi-Peshu has been carved—in a pose identical to those etched on birchbark medicine scrolls—with her long, spike-covered tail wrapped around her body.

The large-scale shamanic paintings found in Texas rock shelters along the Pecos River include numerous examples of cougars flanking trance-seekers. At Panther Cave, a cougar with bared teeth leaps across the wall. This powerful feline spirit helper is nine feet long.

Elsewhere in North America, permanent reminders of the great cats are less common. However, when

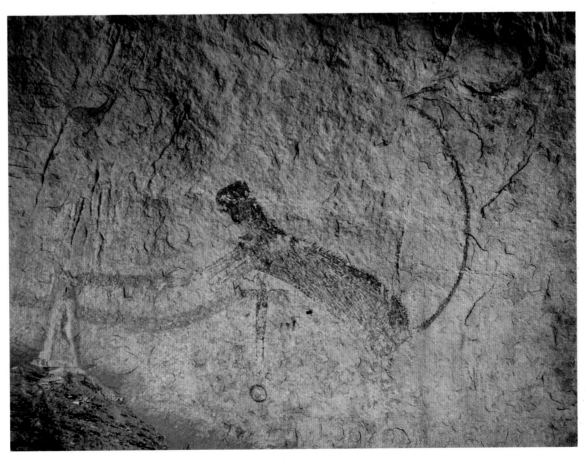

▲ *The dominant painted cougar at Panther Cave, Texas, is remarkable for its size—nine feet—jagged teeth, and bristling hackles. Only the most masterful shaman could assume this form, which embodies dangerous powers.*

panther or cougar images do occur, they are striking. An unforgettable mountain lion curls a whip-like tail above its back on a vertical sandstone surface within Arizona's Petrified Forest National Park. Exaggerated, curved claws emerge from the cat's large paws. This magical animal stares gape-mouthed. A fierce presence has been achieved by leaving the darkened rock surface untouched at the mouth and eyes—a contrast to the lightened rock body, legs, and tail exposed through pecking.

Marquette and his French companions were impressed with what they saw. He described "hideous monsters . . . as large as a calf," depicted in red, green, and black paints with a horrible look, red eyes, a "beard like a tiger's and face like a man's." Later observers added a "Body covered with Scales" and a tail "so long it goes o'er their heads, and then turns between their Fore-legs, under the Belly, ending like a Fish-Tail." Encounters with this creature continued well into the 19th century, while its image diminished from the ravages of gunfire and vandalism.

Benedict Arnold, famed patriot turned traitor, stopped at a bend in the Kennebec River to view the silent rock carvings at Embden in central Maine during his march to capture Quebec in 1775. There he found the pecked portraits of moose, gabled houses drawn into rock, thunderbirds, and sexually identifiable male and female human figures. These petroglyphs are among the few inland Maine river sites to survive inundation from logging company dams. The site lined a stretch of the Kennebec River famed in the past as an eel fishing site used by the Abnaki tribe.

Famous rocks have served as anchor points in American history. Plymouth Rock, which endured the heavy-footed landing of the Pilgrims as they arrived in Massachusetts in the 1600s, is remembered for its role in the drama of New World colonization. The helpful Algonkian tribes that shared their food and skills with the early English colonists also had a marker stone in the Massachusetts Colony, known today as Dighton Rock. Before its removal the worn stone, covered with mysterious, ghost-like, authentic aboriginal designs, was located on the Taunton River near Fall River, Massachusetts.

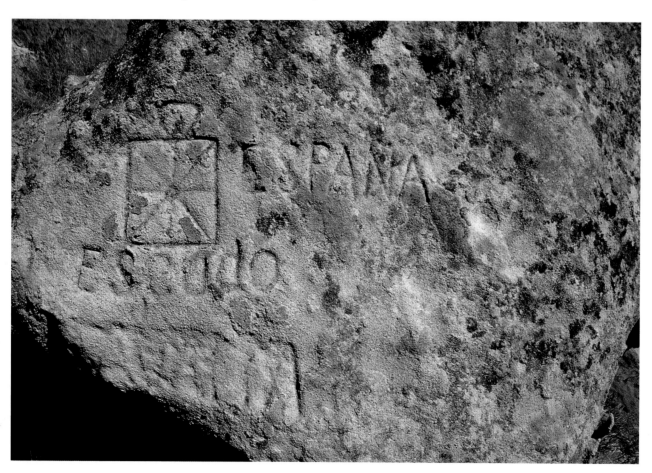

▲ *The presence of Chumash and Yokuts Indian rock art located at Painted Rock in central California may have inspired an early Spanish visitor to carve his family crest on a boulder beside the site.*

Travelers on the Oregon Trail left a list of their names, hometowns, and intended destinations carved into Register Cliff in Wyoming. A few decades later, during springtime logging drives, French Canadian river drivers chiseled the dates of their passage, their names, and colorful nicknames into sloping rocks beside small rapids on the Serpent River in northern Ontario.

The sons of Spanish nobility, working in California and New Mexico as military officers and land grant ranchers, made tribute to their origins by carving inscriptions with coats of arms into boulders and cliffs—also sites used for aboriginal rock art. An inscription on a boulder at La Piedra Pintada, The Painted Rock of the Carizzo Plains in central California, reads "ESCUDO, ESPANA, NAVARRA," along with a formal insignia. "Escudo" refers to a heraldic device such as a coat of arms, so the inscription translates as "The Mark Of The House Of Navarra, Spain."

There is a fundamental difference between aboriginal marks on stone and pioneer inscriptions, based on the separate philosophical relationships to the land evidenced by these two societies. One regarded land as a spiritual source of identity; the other saw land as property.

SERPENT ROCK

What is discovery? If we look at the history of recorded observations at Serpent Rock—a site guarding the waters of northern Lake Huron—we find not only references from 19th-century travel literature, we also encounter a microcosm of the process of unveiling a rock art site. These accounts move from a general awareness of the site's existence to the discovery of its origins, its mythology, and its role in the identity of indigenous people.

Because experienced Indian guides initially led European observers along timeworn aboriginal trails and canoe routes, the earliest accounts of rock art sites in eastern North America often contained firsthand information about the images. Daniel Harmon's travel diary offers a typical observation, written in the year 1800 as he journeyed west across the Great Lakes. While paddling along the north channel of Lake Huron, he made the following entry:

The wind has been so high that it has prevented us from sailing the greater part of the day. We are encamped on an island, of which there are many in this lake. On one of them, it is reported, that the Natives killed a snake, which measured 36 feet in length. The length and size of this astonishing serpent, they have engraved on a large smooth rock, which we saw, as we passed by. But we have often seen other engravings, on the rock, along the rivers and lakes, of many different kinds of animals, some of which, I am told, are not now to be found, in this part of the world, and probably never existed.

Intrigued by this reference, I began to search for more information about the mythic serpents. A few years later, while excavating among the ruins of the La Cloche Hudson's Bay Company Post, I read the fur trader's journals in order to more completely interpret the buildings slowly emerging from the weed-covered clearing. Most of the head trader's entries dealt with inconsequential changes in daily routine. But a few entries recorded visits by a local native leader named The Serpent. Several times each season, this individual appeared at the post. On one visit, the resident Scottish trader watched in awe as The Serpent performed rituals at the edge of the clearing. Although the evidence is circumstantial, there is reason to suspect that this medicine person had a connection with the sacred site called Serpent Rock.

I then uncovered an account of Serpent Rock in a yellowing newspaper from 1885, a time when steamships and bark-covered canoes vied for travel on the Great Lakes. An anonymous correspondent wrote this about the enduring rock art site:

Near the mouth of Serpent's River is a noted Indian landmark, probably now too dim to be seen from a passing steamer. It is the picture on the rocks of two great serpents— hence the name for the River. I asked an Indian if rattlesnakes were found there? "Oh no," he said, "there are none this side (west) of the French River." "Well, what snakes are these the pictures of?" "Of a great sea serpent some Indians saw sporting in the deep water of the mouth of the river." . . . In coming back we stopped our bark canoe, and I went ashore to see the sea serpents. The granite rocks rose up smoothly out of the water to a great height, about as steep as an ordinary roof of a house; and the snakes (for there were two, a few feet apart) were 100 or 150 feet long, with their tails in the water, and each with two horns thrown back from the top of the head, three feet long. The figures were made by scraping the rock clean of the dry black moss and lichens, which nearly covered it. When first made they would be conspicuous for a long way out . . .

Today, Serpent Rock accepts Lake Huron's fall storm waves as it has for millennia. The polished rock slopes down to the inland sea. Rock art designs, once

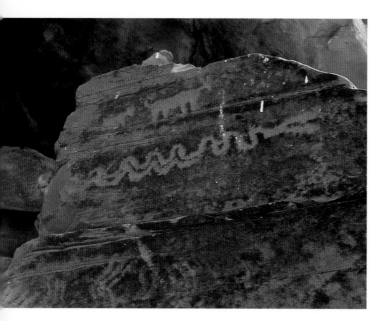

prominently etched in the crusty lichens, remain visible only in the memories of the Elders from the Serpent River band of Ojibwa, who in their youth passed by the site. One hundred eighty-four years after Daniel Harmon described Serpent Rock, an Elder of the Serpent River band of Ojibwa, Louie Meawasige, revealed the mythical origins of the lichen glyph images:

That rock with the markings is called Kinegikgoog-Sheebeeg. Serpents All Stretched Out. It's not painted either. It is marked on the rock. Snake. Just like the snake was laying down there. That's where the markings came from. The snake was there. The snakes laid there one time on the rock at the mouth of the Serpent River on the east side. The rocks slope into Lake Huron there. Some people know about this better than I do. But you can't see the marks anymore.

Another account, told by Fred Pine, suggests a slightly different origin for the images:

There is a beach in the Serpent River area where Ojibwa, Odawa, and other people used to gather for summer ceremonies. One year, they saw a serpent in the water of Lake Huron off shore from the beach. The next year there were two serpents there; and the big snakes began to fight. One serpent was killed and it washed up on the beach. Indian people had been watching from the hillside, so they went with buckets and gathered up the dead serpent's blood to paint a rock near there at the mouth of the Serpent River.

When asked, Elders will also share well-known stories of serpents that continue to reside near the famous rock. Accounts of sightings of these creatures, sometimes mistaken for swimming moose as their horns protrude from the waves, are deeply embedded in the mythology of the Lake Huron Ojibwa. The serpents embody the power of Lake Huron as surely as Mishi-Peshu represents Lake Superior.

The association between serpents and immense bodies of water is ancient. According to legend, in the 1600s, Ojibwa conjurers called upon these mighty serpent allies to help defeat Iroquois raiders in eastern Lake Huron. The fabled sea monsters coiled their scale-covered bodies around the enemy canoes and struck the watercraft with their tails.

Alexander Henry gained an abrupt lesson in cultural anthropology while wind-bound at Point Grondine, a promontory on Lake Huron east of Serpent Rock. While gathering firewood for an impromptu camp, the trader Henry spotted a rattlesnake coiled on the bare rock a few feet from his legs. The coiled snake waited with its head raised, ready to strike. No stranger to peril, Henry ran to his canoe to grab a weapon and kill the snake. When the native guides in his party learned of his intentions, they demanded that he stop immediately. The Indians lit their pipes and blew tobacco smoke to appease the snake, which they addressed as "grandfather." Perplexed, Alexander Henry reported that this act of respect continued for half an hour, at which point the four- to five-foot snake uncoiled, stretched for awhile, and slowly moved off "in visible good humour."

The Indians then followed the rattlesnake, while making pleas that it would not be offended by the insulting behavior of the Englishman. After departing the scene of this incident the following morning, Henry and the tribesmen encountered increasingly rough waves and gale force winds. The Indians prayed, asked the spirit snake to save them, and eventually sacrificed dogs into Lake Huron, followed by offerings of tobacco. Again, the natives explained to the snake that they were sorry for the insult. They pointed out that Alexander Henry was an Englishman who was not related to them or to the snake. The guardian spirit of Lake Huron let these travelers survive.

Serpent Rock has become a site whose origins are well established in written and verbal histories. Despite the fact that nature has reclaimed this rock art, Serpent Rock continues to inform us about the past. A far greater number of rock art sites have lost their

▲ *Serpentine forms, occasionally intertwined, may refer to real snakes or subconscious imagery. Red Tank Draw, Arizona.*

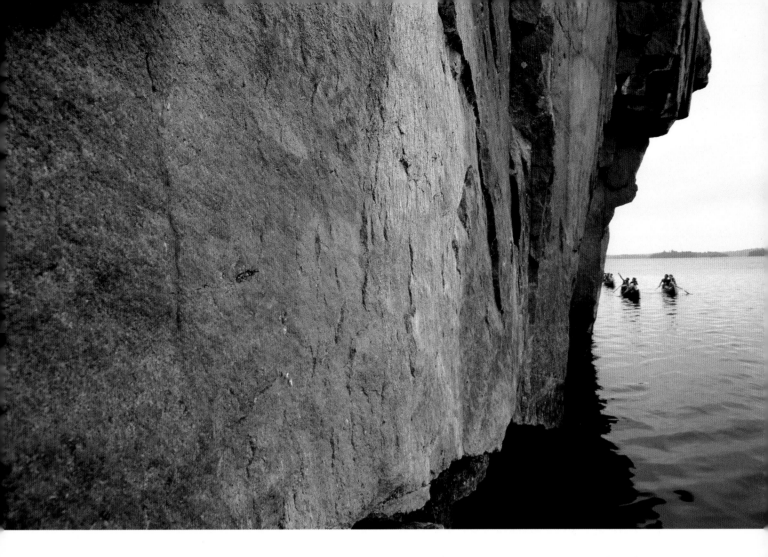

recognition or, as we shall learn, the traditions pertinent to their understanding have not been revealed to individuals outside the native community.

ACCIDENTAL DISCOVERIES

In the Temagami wilderness, near the Ontario-Quebec border, endless lakes, streams, and rivers lie nestled in a rugged cul-de-sac of pine-covered highlands. Here, native traditions and vital connections to the sacred landscape have survived for 6,000 years. This cultural heritage lends valuable insights into rock art. Until the 1950s, the indigenous tribe—a group of hunters and trappers known as the Teme-Augama Anishinabe, or the Deep Water People—lived in remote, single-family trapping centers and multi-family settlements, where they followed the lifestyles of their ancestors. Paddling canoes or trekking by snowshoe across the endless lakes, the Deep Water People traveled daily past the visible reminders of their heritage— dozens of rock art sites painted on spirit-inhabited cliffs

and ledges. Today, recreational canoeists follow some of the same routes, where they pause to view and contemplate the spirit of the wilderness at the often subdued, red-ochre thunderbirds, rows of tally marks, and the inevitable moose.

Although the swiftly flowing rivers, churning rapids, and deep lakes of the Temagami wilderness appear untouched, water levels in several waterways have been artificially raised by power and logging company dams since the 1920s. A few years ago, a team of archaeologists flew into Lady Evelyn Lake to investigate a rock art site last seen in the early years of this century. Drawings of the pictographs, published in 1906, show rows of tally marks, moose, and stick-like human figures. The lake is now several feet above its true water level. Using the somewhat vague directions given in the original report, one of the investigators spent hours in scuba gear, swimming below the cliffs that still lined the shore. After several days of intensive underwater surveying, the Lady Evelyn site remained hidden

▲ *By adopting the native mode of travel across aboriginal landscapes, canoeists often discover rock art sites. Lac La Croix, Minnesota–Ontario Boundary Waters.*

beneath the dark waters. Remarkably, during this systematic underwater viewing of the flooded outcrops, the divers discovered a completely unknown group of pictographs!

In the same Temagami forests, I gained a lesson in understanding the distribution of rock art sites. For over two decades, my wife and I had often visited Lake Temagami, a vast water paradise containing over 1,200 islands and 570 miles of shoreline. Working as a provincial archaeologist, I recorded numerous prehistoric camp sites and excavated seasonal Indian encampments. In the evenings, I patiently searched the frequent stone outcrops for elusive pictographs. I had moderate success.

Then a series of events completely changed my perception of rock art and my appreciation of the aboriginal landscape. In connection with a native land claim case destined for the Supreme Court of Ontario, I was asked by the local tribe to testify concerning aboriginal land use. Upon meeting the chief, band council, and Elders, I realized that these rock art sites were more than heritage resources. The spirits on stone, created by the ancestors of the individuals now struggling for control of their homeland and their destiny, were sacred reference points for tribal identity. I met Elder William Twain, a former chief and lifelong trapper. Over time, I became his student. He had spent his early years living off the land, and his later years working as a guide and trapper.

As my wife and I showed Bill Twain copies of the paintings that we had made on rice paper, we asked him if he could help us learn about pictographs. Had anyone ever mentioned rock art when he was young? His answer was a hesitant, "Yes." From this humble beginning, our association progressed over 13 years to a friendship built on trust and time spent together in the bush. During that time, a wealth of traditional lore became available. In addition to the cultural information he shared, Bill Twain took us on memorable voyages of discovery.

During one survey of Lake Temagami, traveling along channels and inlets we had previously visited while searching for pictographs, he pointed out dozens of seasonal camp sites—places of his youth, when Indians freely lived off the land. This respected Elder also gently glided his boat into small alcoves, beneath overhanging outcrops, and along narrow channels, pointing out the rock art sites that we had missed. "Here the lake is real deep. A good place for fat lake trout," he said as we passed beneath the shadow of a cliff on Granny Bay. "There are some markings along here, too," our guide added as we pulled into a maze of shoals and islets. Repeatedly, we caught glimpses of red ochre stars, moose, tally marks, abstract designs, painted canoes, and small human figures. But we also discovered something more important than the images—the context for each site. What we had rather naively regarded as a series of sites on a lake turned out to be colored by a carefully structured aboriginal world. These sites contained a richness that included native oral history, associations with historic individuals, delineations of specific family hunting territories, and connections to local mythology.

Our last stop was a natural travel camp shaded by cedar trees—a well-drained, level outcrop a few feet above the water level on a long arm of Lake Temagami. As we landed, I noticed hundreds of chipped stone flakes—the remains of prehistoric tool production—lying on the ground. Walking around to the back of the ledge, we found evidence of a prehistoric quarry site. Here, slabs of greywacke, a slate-like stone, were broken from the outcrop and refined into spears, knives, and scrapers.

An understanding of nature's forces further explains the shape of the land. During the last ice age, this part of Canada was redesigned under immense pressure as tons of glacial ice, up to a mile thick, scoured the terrain. As the ice cap retreated, it left in its wake boulders called glacial erratics—some as large as a small car. On this small camping area, a large boulder lay deposited atop two much smaller rocks creating, against all reasonable odds, a turtle-like configuration that appeared man-made.

I was busy picking up bits of broken tools when Bill Twain waved me over to the unusual rock formation. "My uncle showed me something here one time," he mentioned without special emphasis. "Take a look under this rock." In a crawl space just high enough to accommodate my head, I faced a pair of red ochre lines painted on the belly of the perched boulder. I probably will never understand why these two humble red streaks were done so secretively, forever sheltered from light and accidental discovery. But I am intrigued when I think of the hundreds, if not thousands, of Dreaming Rocks similarly hidden from casual observation—lying in secret recesses.

In my own research across the forest lands of northern Canada, about half the rock art sites I have visited and recorded were previously unreported. Long

miles of systematic paddling along the granite walled shorelines of northern Ontario's clear lakes, stopping to slowly check every rock exposure, were required to find pictographs. Our success has varied, without predictability, as sites turned up on seldom-visited, remote lakes as well as lakes that had long since lost their tranquility. Directly in front of a Lake Temagami cottage, we found a half-dozen clear pictographs on a low ledge—unknown to the vacationers who tied their boat there each year. At Dog Lake, we sought shelter in a hunting camp while a terrible electrical storm raged. The building sat across the bay from a striking, yet subtle, rock art cliff. After introductions and a description of our work, the lodge owner said: "I've lived here all of my life. And I never heard of any Indian paintings around here." He added: "I even fished off that rock for hours on end."

HIDDEN MASKS IN PRINCE RUPERT HARBOUR

Sometimes a delayed discovery can be embarrassing. In the early 1970s, I was working with several archaeologists and local Tsimpshian Indians at a vast series of ancient villages compressed together in a huge shell mound near the entrance to Prince Rupert Harbour in northern British Columbia. The Tsimpshian and their ancestors inhabited this large, protected harbor and its islands for thousands of years. They left behind a rich archaeological heritage of abandoned villages, still marked by cellar-like depressions where cedar plank houses once stood. Digging in these ancient house ruins for three months, we slowly peeled back shell and sea mammal bone-filled layers, uncovering 4,000 years of Tsimpshian prehistory.

This archaeological site, a large winter village, stood at a strategic narrows, where tidal currents surged and sightings of killer whale pods linked us with the past. Each noon hour, our field crew would leave the rainforest-covered excavation area to have lunch on the tidal flats at the base of the shell mound.

The daily tidal fluctuations were accepted by the local Tsimpshian tribes, but those of us accustomed to more moderate spans between high and low tides watched in awe as the cold, tide-driven waters rose to over 20 feet at their apex. At highest tides, when the flats lay completely submerged, this northwest coast village appeared to border a vast lake rather than a narrows. Moist clam flats, broken by all sizes of scattered boulders, greeted us daily during the lower water levels. Bedrock

outcrops of soft, layered schist formed the headlands and rocky beaches. For perhaps six weeks, we relaxed daily against the boulders and bedrock—generally trying to dry out from the incessant rains, drizzle, and heavy fogs that nurture the thick coastal forests.

The apron of low tide beach surrounding the home of the Tsimpshian's forbearers contained some interesting features. Amid the randomly scattered boulders, lanes carefully cleared of rocks can be found lining the flats like suburban driveways. These canoe skidways, probably built by slaves captured from neighboring tribes, were prepared to protect the carved cedar canoes from damage. Walking among the canoe ports, we often found parts of broken tools, carefully polished stone mauls left from woodworking, and finely ground bone implements that had washed out of the shell mound.

One lunchtime, I strolled from skidway to skidway among the boulder-lined canoe berths, trying to imagine this settlement a thousand years earlier. Unexpectedly, I saw a group of unfamiliar faces watching me as they lay hidden among boulders and schist outcrops recently exposed by the receding tide. Here, in our familiar oceanside lunch room, dozens of round-faced carvings, left from the days when this Tsimpshian village prospered, peered out from the boulders across the flats. A fortuitous combination of shadow, wet rock surfaces, and my viewing angle suddenly brought the petroglyphs out of hiding.

I called to the others. We began finding faces carved wherever the low tide had uncovered the shoreline.

▲ *Local Indians living in the 1890s near this site at Fort Rupert, British Columbia, told an anthropologist that the carvings came from a time "before animals were turned into men."*

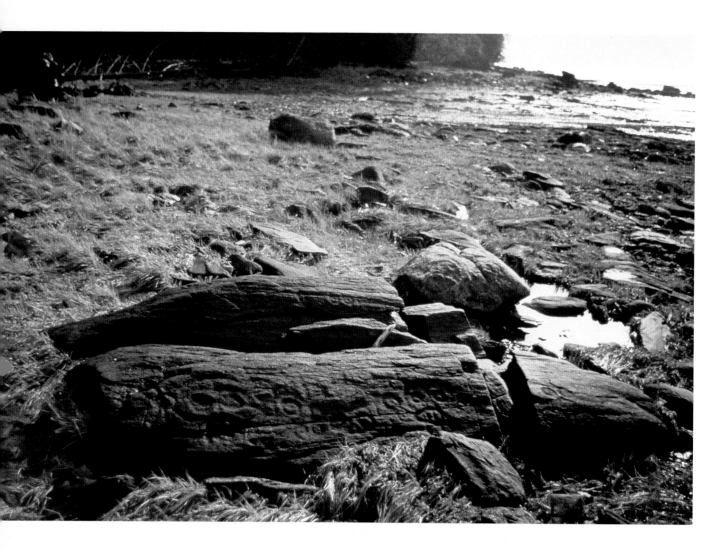

Without exaggeration, the minimal faces, indicated by two dot-like eyes and a horizontal mouth line, emerged like stars in a clear night sky. Many dozens of these trios, sometimes elaborated with brows above the eyes or a circular outline of a head, lay at every step.

Eventually, we located 11 separate concentrations of past settlements now covered by dense cedar forests at different parts of Venn Passage. Clusters of Dreaming Rocks lay adjacent to each of these winter villages, where Tsimshian families once feasted upon stored seasonal harvests. At some sites, a few elaborate carvings, showing more detailed faces surmounted by rays, are included with the three-mark faces. Although many of the seaside petroglyphs are rendered in the simplest possible style, the northwest coast aristocracy who dwelled on these protected shores celebrated some of the most lavish, ornate ceremonies in the Americas. Which part of this rich cultural life led to the creation of these

▲ *Inter-tidal zone faces, perhaps masks or spirits, line a north Pacific flat along Douglas Channel, British Columbia.*

distinctive petroglyphs? The answer remains a mystery.

SYSTEMATIC SEARCHES

For every accidental, dramatic discovery of a hidden marked stone, a far greater number of pictographs and petroglyphs have been located through systematic field work. In eastern Canada and the northeastern United States, rock art sites often show a sparse, irregular distribution. Each new find increases our understanding of this enigmatic heritage.

MALIBU CANYON

Walking into a more secluded section of Malibu Canyon north of Los Angeles, a team of rock art recorders crossed several dry ridges to reach a small group of Chumash paintings. They intended to document these paintings for the California Department of Parks. Climbing toward the high outcrop marked on

their topographic map, they were puzzled to find a military base established in the valley below the small rock shelter. No army facilities were marked on the map, yet the place seemed familiar. For a minute or so they tried to figure out if they had taken a wrong turn until they realized that they stood above the set used for the *M.A.S.H.* television series. In the opening scenes of the often-rebroadcast series, as helicopters fly over the unmistakable arid chaparral of southern California used as a stand-in for Korean hills, the rock art site appears far up in the background slopes.

The rock art site was successfully recorded that day. But this small adventure reminds us that the unexpected will always be encountered when exploring the landscape or the spirit world.

PORTLAND CITY HALL

Most visitors to Portland City Hall enter to pay taxes, purchase marriage licenses, or search property records. Located not too far from the Columbia River, this municipal center is no different than thousands of similar civic structures across the United States—with one notable exception. Visitors often pause on their way into the building to stare at a boulder mounted outside. This stone, divided by a crest reminiscent of an animal's spine, is covered with an intricate pattern of joined, carved circles and flowing lines.

The intriguing boulder was found in 1897 near railroad tracks west of Wallula. Stopping for lunch, a group of engineers sat on a convenient large rock. A member of the party noticed what appeared to be a carving on the only exposed part of the massive boulder, which was otherwise covered with moss or lichen. Soon the entire team was busy cleaning off the Wallula boulder. For their efforts, these curious individuals were rewarded with the sight of an unusual, densely marked rock. The substantial Wallula stone was later transported from its natural position to its current home near the entrance of the Portland City Hall.

The find aroused curiosity. A local historian questioned native people from the area about the purpose of the rock. He recorded an account stating that the rock served as an outer marker of tribal lands and as a location where young Indian men developed strength and courage.

INVISIBLE ROCK ART

In some settings, rock art seems to appear and disappear at will. This experience adds to the challenge

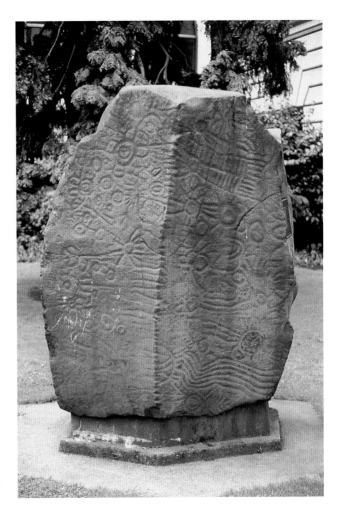

of locating ancient sites. Miles of nearly unbroken rock walls line Collins Inlet, a long, fjord-like channel on the north shore of Lake Huron. These vertical surfaces provide ideal settings for rock art, creating an overwhelming number of potential site areas. Passing boaters have occasionally noticed a small pictograph site. Selwyn Dewdney, a pioneer in Canadian rock art research, had visited the site and published a brief description two decades earlier. During our first attempt at finding the Collins Inlet pictographs, the small collection of painted canoes, a thunderbird, and a horned head may as well have been painted with disappearing ink. Our long boat trip was not a voyage of discovery. We searched the cliffs for two days and could not find pictographs. The site had vanished!

My wife and I landed in frustration at a cottage near the eastern entrance to Collins Inlet. Interrupting a cribbage game, we asked the hunters if they had seen pictographs.

▲ *The Wallulla Stone is now displayed outside the Portland City Hall, Oregon. Poorly understood imagery completely covers the upper surface of this rock, which once lay flat. A spine-like ridge suggests further lost meanings.*

"Oh, you mean that Chinese writing," one of them replied.

"Sure," I ventured. Rock art is so misunderstood that this description was not too strange.

"It's just over in the next bay. You can't miss it. Look on the cliff there," our guide announced. We thanked him and headed for the bay around the corner. Just as we had been told, there, on a classic rock art setting painted in blue, stood an inscription written in Chinese characters. We left, amused but disappointed.

A few years later, a friend sailed through the rock-lined passage and spotted the Collins Inlet paintings. He noted their exact location on his nautical charts and passed a copy along to us. This time we easily located the intriguing images. During a long day by the rock wall, recording the paintings and writing down our impressions, we watched with interest as the sun rose higher over the fjord. Gradually, the site vanished. For much of the afternoon, the Collins Inlet pictographs return to another world. This same situation occurs on sun-filled days across North America. Paintings are affected, but direct light especially fades petroglyphs that often gain their best definition under the low-angle, raking light of dawn and sunset.

We left Collins Inlet feeling satisfied about recovering a distinct rock art site. A decade later, while doing archaeological work for the Ottawa tribes on nearby Manitoulin Island, I met and interviewed a respected Elder whose family had lived in the Collins Inlet area since before recorded history. We spoke about the sacred earth that defined his world; and this member of the Osawamick, or the "Yellow Beaver" family, identified several important natural features that marked his visible mythology—the Lion's Rock, the Beaver Stone, the paintings made by fairies at Collins Inlet, and the extended image of a giant serpent that was painted near the top of the waterway's cliffs.

"Where's that?" I asked.

"Near the little men's home in the rock," he replied. "Where you were. By the other markings. But up high." Our journey of discovery continues.

BURIED ROCK ART

I suspect that numerous rock art sites must lie concealed—by accident or by design—on cliffs and boulders, or within caves and narrow recesses throughout North America. The Ojibwa of southeastern Ontario kept the existence of the now-public Peterborough Petroglyphs secret for several hundred years. After the site was accidentally discovered in the 1950s, access by non-natives accelerated as archaeologists, reporters, and later, provincial park staff members regularly visited the site. Eventually, the attention benefited both aboriginal society and the hundreds of thousands of visitors who, upon visiting the sacred site, have gained a better understanding of Indian spirituality.

In the late 1980s, Fred Pine journeyed to an area near northern Minnesota, where he spent several days with a group of distinguished Chippewa shamans. Upon

▲ *A canoe, thought to be painted in three-quarter perspective, with two deer or woodland caribou at the Agawa pictograph site on Lake Superior.*

returning to his home on the Garden River Indian Reserve, he explained to me that they had hiked into the forest; arriving at an open area, the medicine men and medicine women proceeded to sweep back a layer of gravel several inches thick, uncovering an expanse of holy images—petroglyphs that could only be viewed by a secret society of visionaries. As a guest, Fred Pine had an obligation to never reveal the location of this revered rock art. His account reminds us that wherever native peoples continue to inhabit their ancestral lands, no rock art site can truly be rediscovered if it has never been forgotten.

Although much rock art remains hidden—and a considerable number of illustrated stone panels have been lost to dam construction—a few reliable estimates exist to partially answer the question: How many Dreaming Rocks are present in North America?

In the state of California, researchers believe that up to 10,000 rock art sites exist. Even a conservative average of 25 images per site leaves us with 250,000 pictographs and petroglyphs in California alone! Other western and southwestern states also contain site totals running into the thousands. Along the northwest coast, where the artistically advanced Pacific tribes dwell from Washington state to Alaska's panhandle, about 700 separate rock art locations are known.

The density of rock art varies across the North American continent, which native people call Turtle Island. In the vastness of the Canadian Shield, an expanse of forests, lakes, and exposed bedrock covering half a million square miles across the four provinces of Quebec, Ontario, Manitoba, and Saskatchewan, about 400 rock art sites have been counted.

REDISCOVERY

Some of the native people with whom I have worked—Elders and younger individuals—become impatient with the highly publicized discoveries of western art and science. In many parts of the United States and Canada, where tribal populations continue to live on their ancestral lands, rock art sites and the rich cultural heritage that nurtured them were never abandoned or forgotten. Ojibwa commercial fishermen, the very individuals who have maintained personal relationships with Lake Superior, as well as other tribal members from northern Ontario, maintained their long-term association with Agawa Rock throughout the historic era. Traveling by land or water, they quietly visited this gallery of medicine images and left offerings along with their prayers. Several Elders scoffed at the idea that someone could claim to have "discovered" this holy place.

Yet in 1958, Agawa Rock did achieve national prominence in Canada when the pioneer of Canadian rock art studies, Selwyn Dewdney, located the site after finding it mentioned in a 19th-century literary reference. He did not realize that the direct descendants of Shingwaukonce, the chief who informed Henry Schoolcraft about Agawa Rock, continued to visit the site long after Schoolcraft's volumes were published in the 1850s.

A similar event occurred at the famed Teaching Rock, also known as the Peterborough Petroglyphs, when a party of geologists found the impressive carvings. They reported their find to archaeologists and, eventually, to the media. For 20 years, newspaper accounts, magazine articles, and scientific studies treated the Teaching Rock as a recently uncovered, ancient mystery. Unfortunately, the very people whose ancestors carved the dreams in the Teaching Rock's marble surface were not consulted until nearly 20 years later. When interviewed for an interpretive film about the site, Ojibwa Elders from nearby and somewhat distant reservations told of pilgrimages made to the once-hidden medicine stone. They also reported the existence of stone cairns, used as markers to guide their journey, which were located after the interviews.

From these examples, I have learned that archaeologists, tourists, and modern artists may make personal discoveries of the Dreaming Rocks—and we may be able to take credit for raising public awareness of the subtle wisdom left at these sites—but true discovery is not possible when the subjects are the personal dreams of entire aboriginal nations.

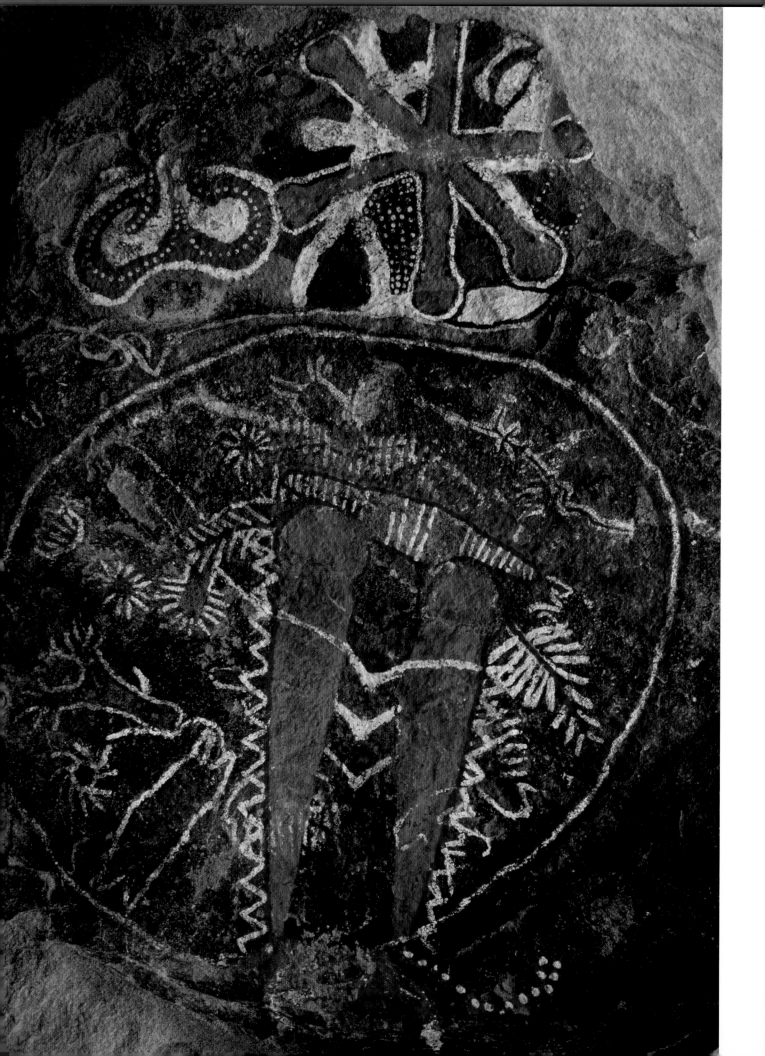

Pigments, Paintings, and Carvings

How was rock art made? The palettes of pictograph artists, composed of natural pigments, were obtained from unlikely sources. The tools used to create petroglyphs were probably as varied as the techniques employed. A broad range of petroglyph images exists, from true carvings with broad and deep lines to pecked surfaces and even lighter, engraved designs.

Although rock art has been exposed to the elements—from frigid Arctic winters to desert heat—centuries-old paintings on stone endure. How have these pictographs withstood such extreme conditions? How were they made to endure?

First, we need to consider the most common pigment, known to geologists as iron hematite and to artists and archaeologists as red ochre. In tribal worlds, colors carry inherent symbolism; red ochre was a sacred paint for numerous Native American groups. Legends say that *wunnumin*, red paint, came from the blood shed by giant beavers that, in far off dream time, changed the shape of the land. Other Algonkian shamans recall stories about the *chignebikuk*—huge sea serpents that inhabited the waters of the Great Lakes. What do these serpents have to do with red paint?

◀ *This portion of an elaborate Chumash cave panel shows multiple colors and highly developed imagery. The Chumash gained many of their visions through the use of hallucinogens—a practice reflected in their rock art at Pleito Creek, southern California.*

▲ *An abstract thunderbird at McKenzie Lake, Quetico Provincial Park, Ontario.*

When a dead *chignebik* washed ashore, tribal members collected its blood in tightly woven bark baskets. According to ancient tales, this substance dried and became the first red ochre used for special ceremonies. It is an old theme—supernatural forces manifesting in a physical form—an offering for use in rituals required to contact the spiritual realm.

The variety of color sources among aboriginal groups was phenomenal. In the interior of British Columbia, Salish tribes collected a fungus found on hemlock trees and earthen ochres for red and brown paints, and copper clay to create a blue paint. White pigments were produced by digging up white earth, or by burning deer bones. Wood charcoal was ground into a black, powdered paint. Each element was mixed with deer grease or similar binders and heated prior to use. Certain plants, whose blood-red roots contained abundant color, were also used for painting on stone.

RED OCHRE QUARRIES

Long ago, Indians colored their nets with red paint. Otherwise the new net, woven with freshly peeled bark, distracted the fish by showing itself too white and too bright. "Dig that paint out of the ground and break it up in the sun." That's what my grandfather told me. He said, "The sun must give the red paint its life and power. The color gets better when the paint gets older." A wine color. We found that ochre at Belleau Lake in a big cave. If you look around when you travel, you will find all kinds of indications of something greater than you in the bush. That paint is one.

—Fred Pine

Several ochre sources remain well-known today, thanks to the survival of native place names such as Red Paint Lake, Wunnumin River, and Vermillion Lake. Tribal lore also contains more specific information about these ochre sources. Archaeologists have documented two large-scale aboriginal ochre quarries in the boreal forests of central Canada. One location, veiled with connotations of resident spirits, is called Porte L'Enfer, or the Devil's Gateway; the other is situated in a natural fault cave on Devil's Warehouse Island in Lake Superior. Both locations suffer from poor translations made by early missionaries who were intolerant of all aboriginal beliefs. In a yellowed mission journal from Manitoulin Island, I once found native families listed in two columns as "baptized" or "infidels." As a result of this limited viewpoint, aboriginal place names originally containing the word "spirit" or *manidoo* were translated into the less appropriate term "devil."

At Porte L'Enfer, a darkened fault cave on the Mattawa River not far from the Ontario-Quebec border, luxuriant poison ivy surrounds the entrance into a narrow chamber, where red ochre deposits fill the walls. When government archaeologists explored the site in the early 1970s, they found evidence of a large-scale ochre quarry where blocks of stone containing veins of the prized red pigment were pried loose. The prehistoric Indians who worked this remarkable source carried the quarried blocks to the top of the bluff. There, the material was processed into a purer form and bundled for trade.

Facing great risks, native workers followed a vein of iron hematite deep into a fault cave on Devil's Warehouse Island. When I examined this site with the geologist who made the initial discovery, he told me he could not imagine a modern prospector who would have labored so long removing quantities of rock containing

▲ *These aboriginal canoeists, painted with red ochre, are immortalized in stone at Pictured Lake in northwestern Ontario as they ride above a sinuous underwater serpent.*

an economically "worthless" material. After I explained the frequent, ceremonial use of red ochre by prehistoric tribes, its anthropological significance became apparent.

How was this mineral transformed into the substance used for marking the Dreaming Rocks? For decades, people have wondered about the secret behind the mixture. It now appears that several traditions for obtaining and mixing red ochre co-existed among the Ojibwa tribes. Experimental evidence suggests that good-quality ochre, obtained from rock formations, could be used directly on rock, like chalk. However, Lake Superior Elder Fred Pine insisted that his people carefully made a liquid paint or stain from the ochre. He waited several years before telling me the ingredients, and gave me permission to share his wisdom. The cartilaginous spine from a sturgeon was boiled until a glue-like consistency was reached. Then bear oil was added to provide the binder for the paint. Powdered ochre was sprinkled into the pot until the mixture reached the desired color. If the paint was too thick, more oil or grease was added.

Red Fox, a female shaman from the Manitoulin Island area, reported another method for preparing red paint. She watched her relatives add white flowered plants, such as Queen Anne's Lace, to the fish glue and ochre blend. We have not determined what effect the juices from these flowers had on the paint mixture. She also said they would gather and burn white-topped wildflowers for purification prior to viewing pictographs.

Northern native people have been aware of the lasting qualities of red ochre color for generations. In fact, it has long been a source of amusement. Nearly a century ago, Indian trappers laughed about the long-lasting effects of the ochre paint they applied to their lower legs for a ceremonial dance. Despite considerable time spent in the water—lining canoes past rapids, retrieving fishing nets, and hunting ducks—their legs would remain ochre-stained for months. A retired chief of the Deep Water People told me that members of his family who dug the ochre-laden clay out of a stream bank were "red-handed" long after they had finished their work.

In comparison to the intentionally simple paint palette of the Great Lakes tribes, the Chumash developed the greatest variety of rock art colors on the continent. A rare and early glimpse of a Chumash artist came from a burial site excavated several decades ago on the Pacific coast. Among the human remains, carbon-dated to 1460 B.C., archaeologists found a paint palette containing three colors—yellow, red, and a light grey. Whether these pigments were actually used in the creation of rock art remains a mystery. The Chumash, like all Indians, decorated numerous items with earthen pigments. Their rock art climaxed with a display of colors, symbols, and patterns that can only be described as psychedelic.

Over time, the Chumash incorporated a dangerous but potentially revealing plant into their dreamscapes. Datura, the scientific name for what is more commonly called Jimsonweed or Loco Weed, grows as a vine with purple-tinged, white conical flowers. All parts of this deceptive plant contain alkaloids so strong that vision seekers risked comas and death when they ingested a carefully prepared brew called *toloache*. The potions were given to Chumash youths entering adulthood, so they could meet and understand their personal spirit guides. *Toloache* was repeatedly used by a unique cult called *antap*, whose members were the elite chiefs, shamans, and advisers of this California Indian society. Like many aspects of Chumash culture destroyed by Spanish resettlement and forced labor, the *antap* cult disappeared later in the historic era.

The Yokuts Indians, eastern neighbors of the Chumash, were less affected by Spanish changes. This group lived in the central valley of California north of present-day Bakersfield and in the Sierras. Until recent times, Yokuts Elders preserved accounts detailing the ritual use of datura. Members of the Yokuts and Chumash tribes inter-married, and so as anthropologists, we borrow this knowledge to reconstruct missing parts of Chumash life. In some instances, the two tribes shared sacred sites and participated in unique religious practices involving visions gained from the datura plant. While not an element of pigment production, datura acted as a catalyst to pictograph creation. The vivid dreams produced by this potentially lethal plant subsequently caused the Chumash and Yokuts to expand their rock art color palettes.

CULTURALLY DEFINED COLORS

Almost every native nation had a much wider range of colors available to them than those chosen for rock art. For many tribes, cultural beliefs dictated the choice of rock art colors. Among the Chippewa and Ojibwa First Nations of the upper Great Lakes, over 98 percent of the pictographs were rendered in red. Shamans reserved white pigments, readily available from pure clay beds, mainly to depict scenes showing the relatives

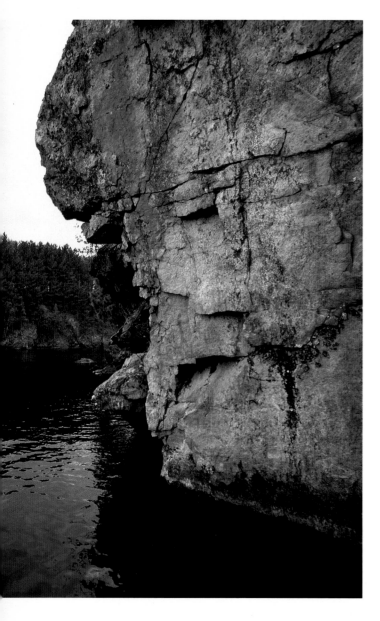

The military cartographer reported that the white earth was mixed with sturgeon oil to produce a paint. Recent archaeological field work at the extensive Indian settlement located alongside Manitou Rapids produced nodules of white clay pigment as well as red ochre. White clay was found in Middle and Late Woodland archaeological contexts, dating as far back as 1500 years ago. White pigment pictographs are rarely found in the Ojibwa cultural area; but two of the four known sites containing white earth paintings occur within canoeing range of Manitou Rapids.

One of the sites, at Namakan Narrows in northern Minnesota, was first reported in 1849 by the geologist Joseph Norwood. He wrote: "It must be highly esteemed by them [Indians], from the quantity of vermillion bestowed on it, and the number of animals depicted on the face of the rock." Norwood didn't mention the three white paintings recorded by Selwyn Dewdney over a hundred years later. In addition to several red ochre animals, a moose, drum, and drumstick are rendered in white.

The Ojibwa frequently used blue and black pigments manufactured from mineral deposits to decorate their faces, bodies, and wooden artifacts, but these two dark colors were never used on the rock walls of the Great Lakes region.

Although this sounds simplistic, a pictograph is more than paint. Wanting to learn more about the symbolism attached to the artist's materials, I asked Dan Pine about the paints used by his grandfather and other ancestors. He spoke about the prevailing use of red colors for spiritual purposes—whether as paint on rock art sites, dyes for special clothes, or naturally red stone ceremonial pipes. Dan Pine also revealed that the paint used to adorn rocks is a metaphor, imitating the colors nature provides to animals. The underlying idea tells us that an animal's markings provide power, just as a rock's paintings acknowledge and enhance its spiritual power. To the Ojibwa, rocks express life and soul just as trees, plants, water, and all animals do.

Oh, that's the paint that doesn't scrub off. Muskwa. Red. Red is a spiritual color. When I was young, women would make red dye from hemlock trees and tag alder bushes. They could dye skins and cloth with that. Red is a very spiritual color. Red rock is used for pipestone. My people collected red paint. They saw it seeping out of the bank at Island Lake just like mud.

The spirits have another rock that was used to paint and beautify the animals. The animals have a lot of designs on

of Wabanung, the Morning Star. In the summer of 1823, one Major Delafield, who was busy charting the international border between Canada and the United States following the bitter tests of the War of 1812, passed Manitou Rapids. This historic native settlement, where burial mounds lie covered by vegetation, is situated on the Rainy River, which divides northern Ontario from northern Minnesota. There, Delafield observed beds of white earth and noted that Indians used the white pigment as a paint for personal adornment. He also commented that voyageurs painted figures onto the bows of their canoes with the same material.

▲ *Several pictographs at Namakan Narrows, mentioned by a geologist in 1849, have since fallen from the cliff.*

▶ *These aboriginal dreams are carved at Agnes Lake, Quetico Provincial Park, Ontario.*

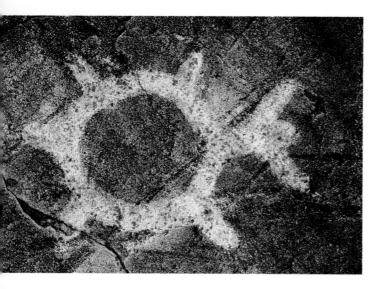

their fur and feathers. Our Mother, the Earth, beautifies all of creation. Look at birds' feathers. Look at the patterns in fur. Even the rocks wear her garments—streaks of black, of red, of white like dawn.

There is a black paint that seeps out of the ground and a red paint that comes from the earth. These were used years ago. Moist earth. Those paints seep out of pipestones. They are like a tattoo, when those rocks were painted. Those colors can't be washed off. That paint stayed there on the rocks from generation to generation. The spiritual people painted the rock just like the spirits painted the animals' fur. The red paint has a blend of power that overcomes the evil power.

When Dan Pine said, "The Earth beautifies all of creation. Look at birds' feathers. Look at the patterns in fur," he was alluding to the Dreaming Rock concept—where pictographs were nature's expressions borrowed by vision seekers. Just as the brush strokes of creation produced pleasing patterns in fur and wondrous plumage, our dreams and visions are natural phenomena whose images come from the depths of the earth spirit.

Dan Pine's reference to an ochre layer "just like mud" recognizes a second type of pigment source. In some parts of Canada, red ochre stains were used as recently as the 1940s. Bill Twain, the respected Elder of the Deep Water People who inhabit the Temagami wilderness, watched his grandfather and his father collect clay-like masses of red ochre from a stream bank near their family settlement at Indian Chutes. He described how large potato sacks were used to separate the ochre from the moist clay. Standing on the shore, the men would twist the heavy, clay-filled bags with strong sticks, eventually

squeezing out all of the fine clay and water. A dark mineral residue was left. If the ochre showed too much of a yellowish hue, these Algonkian tribesmen would heat the mineral sands in a frying pan, just as their ancestors had done on flat rocks, to oxidize the pigment into a bright red color.

Long after pictograph traditions had nearly vanished, local Indians were painting wooden tools with red ochre stains that acted as a wood preservative. By the late 1800s, pine logging had arrived in the Temagami forests. Few of the mainly French Canadian and recent immigrant loggers realized that their oars and long pointer poles were stained with a pigment once used for ceremonial purposes. More traditional items exposed to harsh conditions, such as the small wooden shovels used to remove slush ice from beaver traps set into frozen lakes, were also stained with this aboriginal mixture.

"It works into the wood and won't wash off," Bill Twain told me. He mentioned that his family "added fish oil to get the stain to penetrate; but the ochre already has an oil in it." To emphasize his statement, he took a small piece of ochre that we had excavated and ran it across his broad palm. He grinned at the red streak. "Ready to use."

A CARVER'S TOOLS

Carving stone has a long history in North America. Master stone workers carved sturdy soapstone bowls in the northeast several thousand years ago, only to abandon the craft when fired clay pottery was invented. In the Pacific northwest, beautifully sculpted stone bowls were part of the complex artistic tradition at the time of European arrival. Elsewhere, stone beads, pipes, and ornaments were produced from a variety of lithic sources.

An array of deceptively simple stone tools, used to create dramatic carvings, remained in place at the Peterborough Petroglyphs. When archaeologists first studied the shrine in the late 1960s, they found the very hammer stones—last used to make the final series of astounding petroglyphs—still present in crevices across the site.

The techniques employed to produce petroglyphs were as variable as the stone surfaces on which they were produced. Stone tools and, less frequently, historic-era metal tools, were employed by shaman artists to cut into the rock surface. Of all the techniques—true carving, fine-lined incising, bruising the rock through patterned pecking, and superficial scratched designs—

▲ *A well-preserved figure from the Jeffers site in southwestern Minnesota, possibly a turtle with horns on its head.*

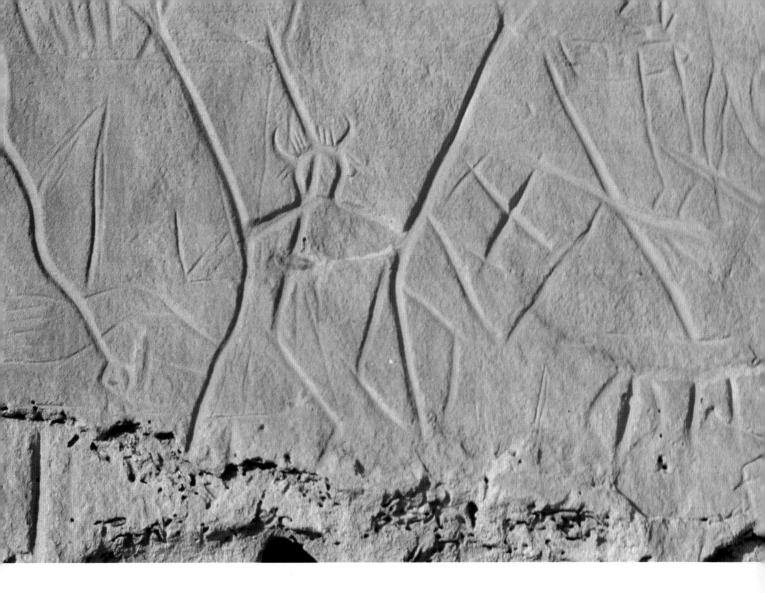

pecking was the most common method used. Images varied from sophisticated carvings that incorporated fissures as body parts to minimal expressions of spiritual concepts as shown in stick-like petroglyphs.

The words of Dan Pine returned as I stood above the great Teaching Rock near Peterborough, Ontario. I thought about the inspired and concentrated efforts of the visionary artists as they hammered the stone surfaces. *Tap. Tap. Tick. Click.* They patiently removed the outer rock in order to register their dreams. What were their thoughts as they worked? The answer came unexpectedly when I asked Dan Pine what it had been like to follow the medicine path for 90 years. He answered, "My every step—my every breath—is a prayer."

Ultimately, the image matters more than the medium. While working with Algonkian Elders, I noticed that even though they were very aware of differences in techniques, they would make interchangeable use of the terms "carving" and "painting." The same vagueness also appears in some Chumash oral histories. Just as few aboriginal groups in North America have a specific term for "art," the distinction between painted and carved was not as important as the effect—the image.

▲ *Depending upon the viewer's position and the angle of light, carvings can appear to be raised images. Low, raking light often enhances petroglyphs. This complex panel occurs at Cows Head Mountain, Texas.*

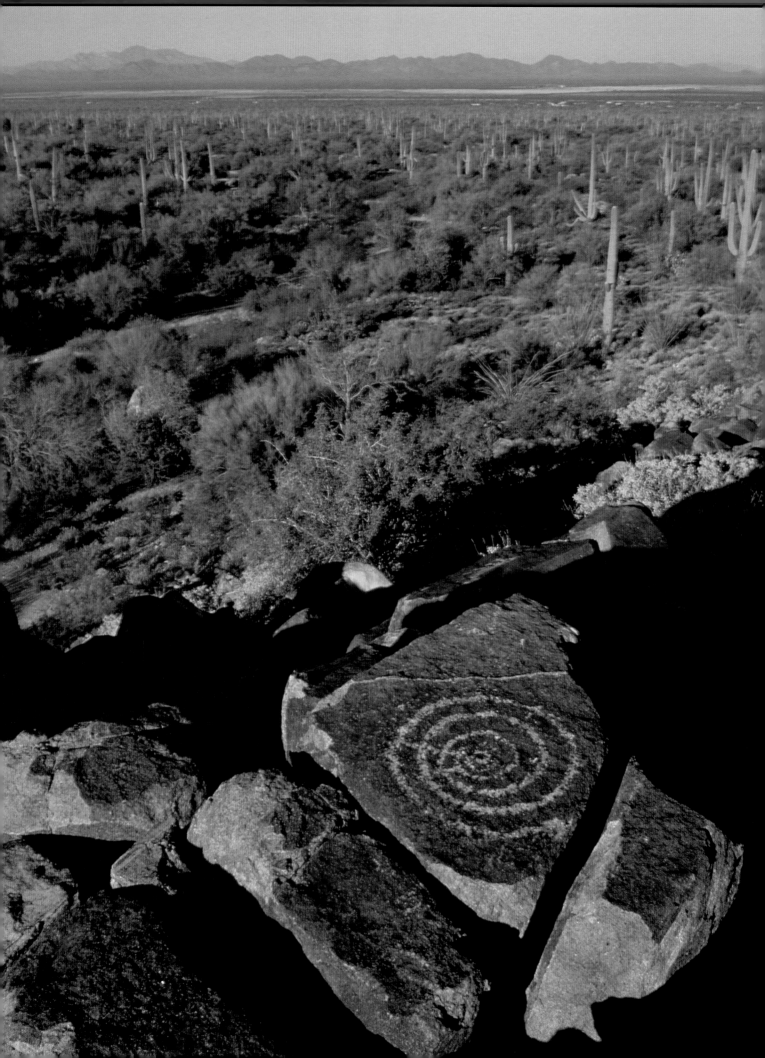

How Old Is Rock Art?

Downwind from the volcanic explosion that created Crater Lake, strange abstract petroglyphs lie beneath several feet of soil and ash. On the eastern edge of the Great Plains, distant ancestors of the Sioux left images of buffalo hunters holding weapons replaced over 2,000 years ago. Beneath the mist-laden canopy of America's northern rainforests, python-sized tree roots strangle and slowly crack deeply buried, carved stones devoted to the killer whale. These remarkable scenes offer us partial insights into the eternal question: How long have the paintings and carvings survived on the Dreaming Rocks?

The very nature of rock art—images left from rituals, visions, and primal mythology rather than narratives of historical events—often forces researchers to use indirect methods of age determination. Because a majority of carvings and paintings cannot be directly dated—they lack organic residues or readily dated subject matter—the strangest clues offer answers to the question of chronology. Several methods have been used for relative dating: the presence of artifacts at rock art sites; recognizable historical subject matter; the well-preserved oral histories of some North American tribes; and major changes in the landscape, such as fallen lake levels.

▲ *A motif from Shelter Cave in the Devils River drainage of Texas. It has been dated to a period between 1,000 and 2,000 B.C.*

◄ *Spirals of coiled energy often appear in visions as entrances to tunnels of light. Here is one of several spirals at Saguaro National Monument, Arizona.*

There are two basic questions relevant to the antiquity of the North American Dreaming Rocks. When facing a wall of tribal memories, a usual query is, "How old is rock art?" But we can learn much more about these mystical images by considering this question: "How recent are the final rock art creations?"

Some clues, starting with the undeniable representations from historic times, can transport us through time's maze. For many years, I fell into a perceptual trap when thinking about historic-era rock art. I erroneously thought that rock art rapidly disappeared after the Europeans' arrival created immense changes in aboriginal life. The low ratio of historic subjects to aboriginal images led me to conclude that most rock art originated in prehistoric times. However, a colleague explained that rock art produced since 1500 A.D. might just be very common. The low frequency of recognizable, historical subject matter had misdirected me. A handful of masted sailing ships, hunters with rifles, riders on horses and mules, and a few paintings of missions were discovered in some tribal areas amid thousands and thousands of thoroughly aboriginal dream images. Now I realize that the obvious historic paintings and carvings could have been created in conjunction with the shamanic figures of animals, thunderbirds, and other residents of the native pantheon. Vision questing continued—and in fact still proceeds.

HISTORIC SUBJECTS

Historic scenes and individual subject matter have opened up a chronological window at some sites, helping us place associated paintings and carvings into a general historic time frame. For example, masted sailing ships have been found carved on both North American coasts—from the slates of Kejimkujik National Park in Nova Scotia to the rain-washed rocks on the outer coast of Vancouver Island, northwest of Vancouver. In both instances, the ships have been represented accurately enough to determine their age. The maritime provinces of Canada have been visited by an array of seafarers from Basque and English fishermen to early French explorers, 19th-century whalers, and trade schooners. Each nationality built distinctive sailing vessels, and those ships changed their rigging styles and ship profiles over time, so the national origins of the ships depicted in rock art images can be traced and dated. At Clo-oose, Nootkan carvers left several distinct portraits of Yankee trading ships from the late 1700s and early 1800s.

Depending on particular tribal areas, easily identified historic figures may be rare or relatively common. The Algonkians, whose rock art was mainly religious expression, seldom included historic items. In the Great Plains area, where the narrative imagery found on painted hides, teepees, and paper was often reflected in local rock art, it was easier to identify and comprehend images of buffalo horn headdresses, teepees, horses, spears, shields, and rifles. Except for a few pictographs showing Spaniards on mules or horseback, the Chumash remained impervious to non-traditional motifs.

Recognizable religious structures have turned up at a few rock art sites. Prior to the arrival of the black robes, Algonkian artists left memories of Midewewin (Grand Medicine Society) lodges on the cliffs overlooking a few select Canadian lakes. From the cold Atlantic coasts of Nova Scotia to the dry hills of Texas, representations of churches occasionally appear at rock art sites. In California, the Chumash reversed the situation by placing their aboriginal designs on mission walls rather than creating images of missions in mountain caves.

MISSION-ERA CHUMASH ART

Hints of Spanish expeditions featuring riders on mules or horses lie scattered at a few sites across southern California in the Chumash territory. Again, the rock art record could mislead us into thinking that the Chumash virtually abandoned their tribal rituals at painted caves after the Spanish entered California. Careful studies made by pioneering southern California rock art experts now lead us to believe that rock art in southern California endured well into the 1700s.

Sparse but revealing information comes from a few key sources. At the beginning of the 20th century, an anthropologist named John Harrington recognized that he was one of the last people who would interview and travel with a final generation of southern California Indians. He ceaselessly sought out older native people and recorded every bit of cultural information he could learn from the patient Chumash and Yokuts Elders. The songs, folk tales, incidents of daily life, place names, and aboriginal cosmologies that he collected have enriched our understanding of rock art.

Although these remaining native groups were partially divorced from true tribal life—most had been raised under the shadow of the Spanish missions—they retained valuable, traditional knowledge kept alive despite the efforts of the missionaries to change the California tribes. As late as 1815, a priest at the Ventura

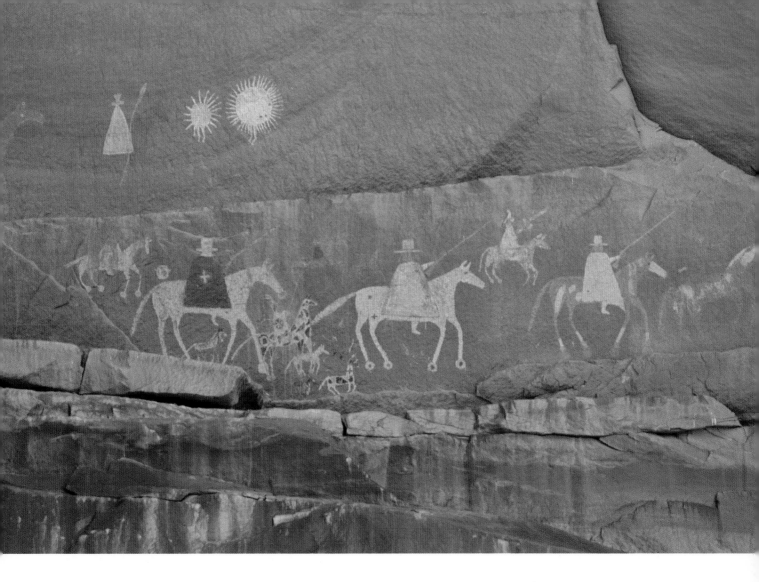

Mission observed that the Indians there traveled to nearby sacred locations and deep into the coastal mountains to offer their prayers for rain. If sacred sites were used at that time, rock art practices may also have survived.

In an ironic and revealing manner, we have learned that California Indians, who labored without freedom or choice in building large mission churches, often painted pictograph motifs in hidden architectural settings. Aboriginal pictographs were observed in the original bell tower of the Santa Barbara mission, which was subsequently destroyed by an earthquake. The triangular motif painted in the tower's plaster wall was identical to others found at Chumash rock art sites.

Native paintings have been reported at the San Miguel Mission north of San Luis Obispo. Upon entering the centuries-old adobe building, an ornate altar fills a visitor's view. According to historians, conscripted Indian laborers painted the elaborate

Christian scenes under the direction of Spanish masters. These Chumash and Salinian Indians kept their older religion alive by subtly painting aboriginal icons in obscure spaces. Whether in mere defiance or with the even stronger intention of disabling the conqueror's spirits, enough examples are known to indicate that California native religious art persisted into the 19th century.

Were these secretive pictographs—the work of shamans and Chumash spiritual leaders—done as acts of subtle rebellion? These paintings, carefully placed within the mission structures, suggest that *antap* cult members and other practitioners of native religion nurtured their spiritual practices long after the Spanish ruled the area. Parallel evidence comes from rock art traditions of the Pecos River in Texas, where a long, deadly arrow pierces a priest rendered as an animate mission structure painted on the wall of a rock shelter.

▲ *These lance-carrying Spanish riders are a record of the Narbona expedition, which was sent in 1805 against the Navaho into a part of Canyon de Chelly, Arizona. A Navaho panel at Standing Cow Ruin.*

▲ *Local Ojibwa Indians often identify diminutive human-shaped pictographs as May-May-Gwashiuk, "Rock Elves" or "Fairies." Lac La Croix, Ontario.*

BUMBLE BEE, THE PICTOGRAPH PAINTER

Rock art traditions survived wherever native societies remained intact. It was no surprise when the great-great-grandson of a 19th-century Indian named "Pictograph Painter" responded to my interest in the paintings of his ancestors. When I inquired whether his family traditions included knowledge of rock art sites, he looked at the ceiling of his small home and remarked that his father used to talk about the markings I had mentioned. He then proceeded to relate remarkable insights and histories about Algonkian rock art locations—asking only that I use this knowledge to seek a better personal relationship with his heritage. His instruction has guided my work as surely as anything I have learned. His directions were basic—reinfuse life into rock art with the legends of his nation.

Another Ojibwa medicine person connected with rock art was named Ahmoo, The Bumblebee, who lived in an area now encompassed by the boundary waters between Quetico Provincial Park and northern Minnesota. In 1909, conservationist Ernest Oberholtzer toured these rivers and lakes, where Canada and the United States share a wilderness connected by water. A local Indian called Billy Magee guided Oberholtzer and revealed that Ahmoo had painted many of the pictographs observed on their canoe journey. He also said that Ahmoo was a medicine man who painted the rocks whenever he obtained his powers. When the fur trade records and treaty payment lists for the region are patiently examined, Ahmoo may emerge as a recognizable historical figure from the early 1800s. For now, we have Billy Magee's recollections linking Ahmoo to several pictograph sites in the Boundary Waters area.

SORCERY AND THE INDIAN WARS

On occasion, dating and interpretation emerge as inseparable companions. Indian wars between the Iroquois and the Algonkian tribes, fought first as blood sport and later as organized battles for control of land, continued for over two centuries. These wars began in the 1650s, when the Algonkian hunters often concluded powerful rituals with a rock art record of the event. While I was collecting oral history narratives relating to the Iroquois wars in northern Ontario, Ojibwa Elders often mentioned rock art sites in their accounts:

Oh, they won. My people won. Well, at Agawa, that's where the old chiefs met. So Shingwauk said, "When the Iroquois come in, I'll perform a fog on them." He made a heavy fog. Shingwauk opened up the fog. He lifted the fog so he could see a long ways. That's what he did. He fogged up all of Lake Superior. Shingwauk made a large fire; and his people danced around the fire; and put tobacco in it. Then he performed the miracle. He had the power to affect the atmosphere and lift the fog.

When the Ojibwa tribes went out, they went and met the Iroquois out on the lake. They never landed. The Iroquois never landed here on the north shore of Lake Superior.

After that, Shingwauk and the other powerful headmen painted those markings on the rock at Agawa. You see, those were a warning.

Working with several neighboring bands near the Ontario-Quebec border, I noticed similar patterns in their stories. Careful recitals of accounts, dating between 1650 and 1700 A.D., preserved not only the memories of brutal ambushes, burning of villages, and captives taken by the united Seneca, Mohawk, and other Iroquois nations, but they also named specific battle sites and associated rock art cliffs. Intrigued, I probed further. The former chief of the Teme-Augama Anishinabe told me that previous anthropologists had

been mistaken when they reported that the Deep Water People attributed rock paintings on their lands to the Iroquois. He asserted that his ancestors made some of the pictographs in response to battles and defeat of their enemies long ago.

Brief replies can be misleading. Suppose you asked an Ojibwa Elder, "Do you know who made those paintings and why they were made?" You could easily receive a curt answer: "Iroquois." The full context might be as follows: "My ancestors drew the canoes on the spirit rock when they conjured against the Iroquois who came here to kill and steal." But it's not likely that the long answer will be immediately offered. I recall Bill Twain's insightful story of how he learned to speak English by working at a tourist camp when he was 12 years old. Bill told us that the first three words of English he acquired were, "Yes. No. And maybe."

Oral history not only enlivens the story of warfare-related rock art, it also identifies locations that can be cross-dated with written records. From journal entries of French traders who passed the massacre scene, the conflict between the Lake Superior Ojibwa and the Iroquois commemorated at Agawa Rock has been dated to 1662 A.D. It was a prelude to the Iroquois Point massacre at the entrance to Lake Superior. French traders frequently observed bleached white skulls scattered across the sand banks of the battle site.

Destructive magic was used by certain tribes. Among the fragmentary lore of the southern California Chumash, a lone story tells us that sorcerers tried to cause, through starvation, the death of their enemies. To accomplish this deed, the corrupt shamans would paint images of weak and sickened men and women onto a portable rock and carry it into the mountains, leaving it exposed to the hot sun. This was done to stop the seasonal rains. Medicine people from the afflicted community would finally locate the sorcery stone and immerse it in water.

The story also brings to mind a small boulder covered with abstract Chumash carvings now on display in the Santa Barbara Natural History Museum. With the exception of some pictograph slabs discovered with human burials, this portable rock is one of the few examples of true portable rock art in the vast territory once occupied by the Chumash groups.

OLDER ARTIFACTS

How do we push the dating of rock art images back past the threshold of European arrival in North

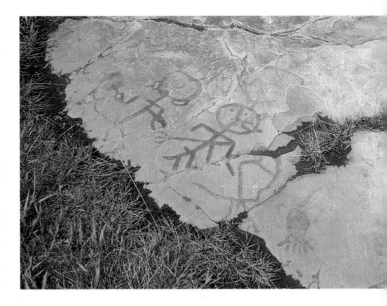

America? A handful of stone artifacts commonly unearthed at prehistoric Indian villages offers general dating clues. Although few people today would envision an Indian from the past without a bow and a quiver of arrows, the bow and arrow arrived quite late in North American prehistory. Dry caves and rock shelters sometimes provided ideal conditions for the preservation of wooden arrow shafts with their finely made points still lashed in place. By performing repeated radio-carbon dating of these sealed deposits, excavators have learned that the remarkable invention of the bow happened in the Great Basin around 500 B.C. and spread out to distant territories over several centuries. When rock art in western Texas shows a person with a bow, the panel realistically can be dated between 600 A.D. and 1,000 A.D.

At the sun-baked Jeffers Petroglyph site in southwestern Minnesota, Indian hunters stand with weapons at hand on the busy carved surfaces. They hold unmistakable spear throwers called "atlatls" by archaeologists—devices that predate the bow and arrow in the midwest and the eastern woodlands. Nearby, bison gallop with spears embedded in their sturdy backs. From these scenes showing spear throwers, which rapidly went out of favor when the bow arrived, some of the Jeffers site carvings have been interpreted as dating back to distant years—between 3,000 B.C. and 500 B.C.

In some areas of North America, the ability to date rock art benefits from the site settings. Across the southwest, amid cliff dwellings perched above narrow canyons, numerous paintings and carvings appear on

▲ *Figures holding atlatls, Jeffers site, Minnesota.*

▶ *Rock art often shares the same dramatic settings occupied by cliff dwellings. This well-preserved example occurs at White House Ruins, Canyon de Chelly, Arizona.*

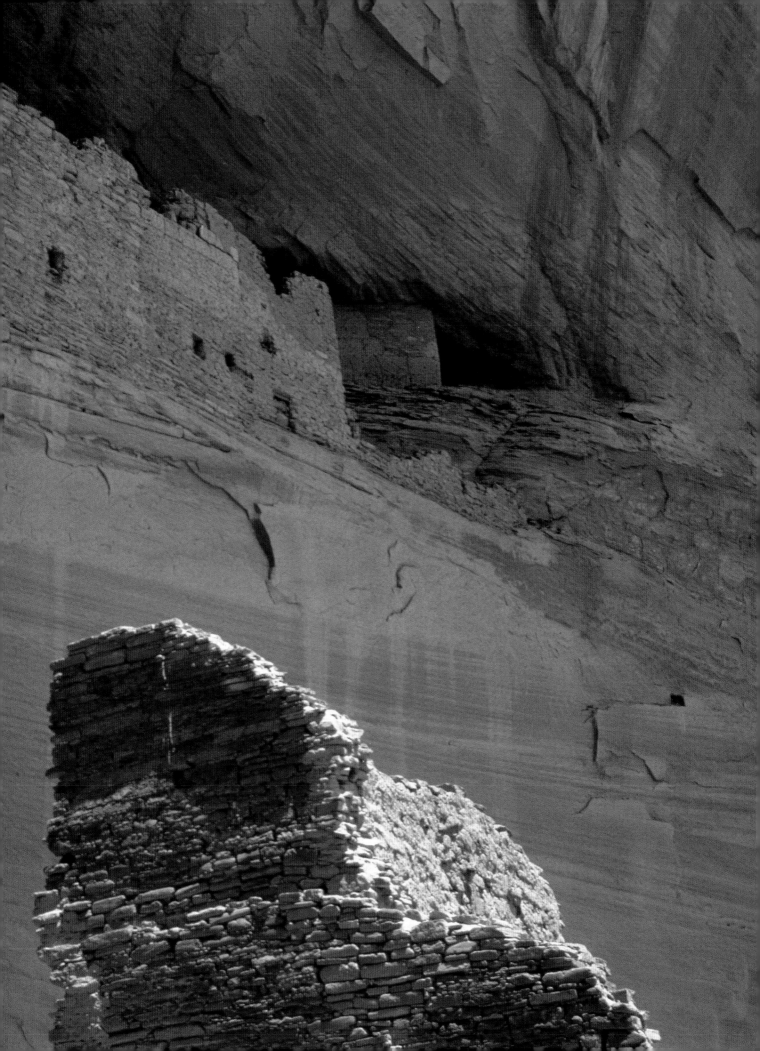

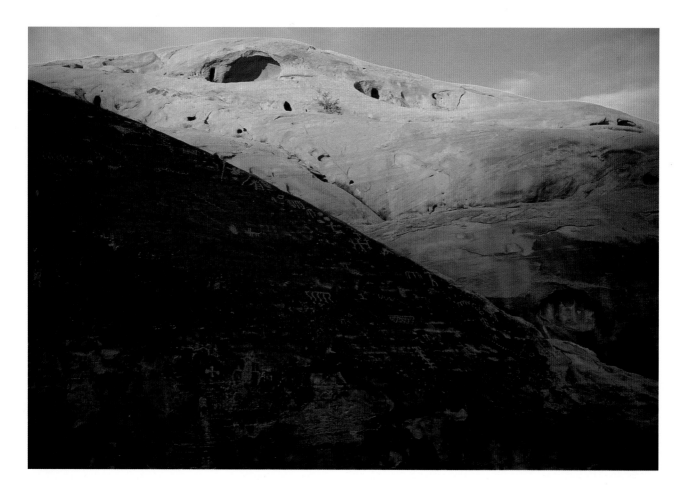

building walls or on canyon rock beside the structures. Wooden rafters offer reliable dating for these homes of the ancestors of contemporary tribes—known archaeologically as the Anasazi and the Basket Makers. Dry conditions preserved the wood often enough that scientists have assembled a catalog of datable tree rings spanning several centuries. The wood gives an age to the house, and by association to the rock art. Of course, potential errors can be caused by reuse of beams from older houses or collecting trees already dead for decades. But this is quibbling in the rock art world, where precise dating is a rare occurrence.

THE MOAB MASTODON

Is there a possibility that ancient animals portrayed in paint and stone can serve as datable subject matter? If we look at the animals hunted with bow or spear on so many rock walls, we will find some fantastic creatures along with scores of mountain sheep, moose, deer, and bears. These extraordinary animals, resembling everything from sharp-horned rhinoceroses to dragons and dinosaurs, come from the subconscious realm. In western Europe, portraits of extinct Ice Age mammals line the recesses of rock shelters and caves, offering evidence of great antiquity; however, using extinct fauna to date North America's Dreaming Rocks is a method unlikely to succeed.

A few striking images, such as a rather suspect "mastodon" carved in the Utah desert, may appeal to our imaginations—art possibly left 9,000 years ago by hunters carrying spears tipped with fluted flint points— but hoaxes and misinterpretations are quick to grow in ground fertilized by romantic notions. It was not Paleo-Indian weaponry that slew the Moab "mastodon." This quest for Ice Age art has fallen to the sharp edge of careful research and a healthy dose of common sense. The carving was not nearly as weathered as a group of nearby, undeniably Indian petroglyphs known to be no more than a thousand years old. Further research into the area's recent history uncovered an account of a circus that toured this same part of Utah in 1869. So the Utah "mastodon" grew remarkably younger as time

▲ *Anasazi petroglyphs, Valley of Fire State Park, Nevada.*

progressed. The pecked petroglyph does appear to be a genuine example of local Indian rock art, but it apparently commemorates a circus elephant. If circumstantial evidence is verified, this lone carving has the distinction of reverse dating. Instead of marking an Ice Age event, it may be one of the last images on stone created by a Ute Indian during historic times.

The timelessness of mythology has created another problem in the quest to identify renditions of long-lost mammals. Mammoths, camels, huge beavers taller than a person, and other mega-fauna once roamed parts of the North American continent. Yet as recently as the summer of 1992, while collecting oral history and accounts of traditional land use from the James Bay Cree hunters and Ojibwa trappers of Canada's sub-Arctic, I met individuals who were as knowledgeable about the giant beaver of Algonkian legends as they were about 20th-century technology. After all, what northern Lake Huron Ojibwa resident would forget the role Chi-Amick played in shaping the landscape, or the time this gargantuan beaver slapped her tail onto a single, massive island, creating the thousands of fractured reefs and islands of Georgian Bay? These creatures lived when the land was young—at a time when the massive skunk Chi-Kahg sprayed Wolverine's eyes, causing such agony that Wolverine shed rivers of salty tears, forever turning James Bay into a sea of salt water.

The grandparents of these same individuals walked the cold northern forests at a time when rock art was a vital, living tradition. They could easily have created rock art panels depicting animals—alive in thought and story but long gone in the flesh—readily mistaken for Ice Age creatures.

There is one painting of a creature from a time far earlier than the Ice Age. It is a portrait of a giant spider that could be a link in dating part of the Algonkian rock art story.

SPIDER CAVE

Other than science fiction writers, few residents of the United States are concerned today with giant spiders. But the skills of *Subkainshee*, the Net Maker, played a role in dating a small cave containing a few faint pictographs above Lake Michigan. Spider Cave, an isolated rock art site in the Upper Peninsula of Michigan, was formed at a time when water levels reached high up the limestone cliffs. In past centuries, relentless storm waves—generated on an immense lake,

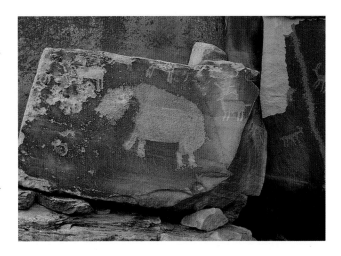

the direct ancestor of Lake Michigan—gradually cut into the soft stone, leaving a row of inland sea caves that later attracted native people as places of shelter and mystery.

Archaeologists from the University of Michigan probed into the floors of several caves in the 1960s and discovered temporary camp sites dating back to the first and second centuries A.D. Spider Cave, though, was different. Instead of finding the usual traces of daily life in the form of debris left over from sharpening stone tools or charred animal bones left from past meals, the excavators uncovered an unusual pattern of artifacts—a shell ornament, two projectiles made from antlers, three bone harpoons, and 83 flint projectile points that were once fastened to arrows or spears—all of this in an enclosure the size of a modern living room. After sorting the numerous pieces of flint weapons, the archaeologists discovered that the tips had been broken off. Incredibly, the missing tips of these projectiles were found at the base of the cave wall.

Why were these aboriginal hunters firing their bows or spears at this limestone outcrop? It was not an ordinary limestone exposure. The secrets possessed by this sanctuary could easily be misunderstood. Several red ochre paintings line the cliff near the mouth of the cave. Others, fainter, occur within the cave. Three of the cave paintings are now indistinct, but one of the more unique examples of aboriginal art lies at the entrance of Spider Cave, where a large version of its namesake has been portrayed by spiralling lines connecting the giant spider to the navel, wrist, and thigh of a horned human figure. What follows is an ancient tale of environmental destruction, as meaningful today as it was at the time of its original

▲ *Odd animals, inspired by dreams and mythology, are easily misinterpreted outside of their cultural contexts. A carved group from the Moab, Utah area.*

telling several thousand years ago at Spider Cave. This is Fred Pine's interpretation of the Spider Cave image:

The Indian, nobody knows where they came from, but we came from the moon. They lived up there. That's where the Indian was put in the first place. Indians used to talk about that story years and years ago. The Indian people originally lived on the moon, but the atmosphere dried out. There was no more rain there. The moon was once like here on the earth. Lakes, trees, and full of life. The earth breathes. It gives off moisture. The plants catch the moisture and refresh the air we breathe.

Everything had dried up on the moon. Everything was dried out, and the animals were starving and dying out. The animals were bigger than they are today. Great big creatures. The Indians would go out and hunt these animals, but all of the game was dead from the drought on the moon. All of these animals were friends to the original people. You see, the animals were raised with the people. Indians understood the animals. Soon, the people were starving. Out of desperation, they even ate lichens off the rocks. The medicine man said, "We'll have to do something. We can't live here anymore."

But up on the moon there were huge animals. A spider was as big as an elephant. But the Indians were friends with them. At that time, the Indian could touch the animals. They were friends with all the animals where they were living.

The medicine man saw that there was no more life left in the moon. He thought, "I must do something else to save my tribe." The Holy Spirit came to the medicine man. "Look around," the spirit said. "You'll find a place for these Indians—your tribe." The medicine man strolled across the rocks of the moon, all around, until he found a big hole. The Hole-In-The-Sky. The hole went right through the moon like a ravine. Down through the stars.

And the medicine man looked down this hole, and he saw North America—Paradise. "Green, everything is green. Lakes, beaver, other animals, and everything." He said, "This is the place, the place for my tribe."

Now the medicine man couldn't bring all of the people down, so he picked out the best people. The ones that obeyed everything. Spiritual people. Wise men. You're looking at one right now.

You know how he got the Indians down here? The medicine man used a huge spider. The medicine man hired the spider to let them down with the web. A spider never runs out of web. That's why I'm here now.

Spider Cave was a shrine—a sanctuary where an opening into the earth allowed access to the spirit world—perhaps mimicking the Hole-In-The-Sky. From the combined evidence of shattered stone projectiles fired toward the rock art, we can not only date the paintings back nearly 2,000 years, but we have a rare opportunity to trace Algonkian mythology into the distant past. The distinctive shapes of the flint points provide firm chronological clues dating the cave to a period of Great Lakes prehistory called the Middle Woodland. It was a time when new ideas and ceremonies swept across eastern North America. While such dating is relative, archaeological studies at the combined group of caves demonstrated that the sites were not used later in time. Even the most elevated painted ledge at Spider Cave would have been submerged prior to 1,500 B.C., when these archaeological sites lay well below the depths of the Great Lakes.

RECEDING WATER LEVELS

The rise and fall of the Great Lakes is a story of diminishing water levels from the Ice Age to the present. The elevations of past lakes—often appearing today as sets of giant, step-like beach ridges covered by forests—offer a broad dating scheme for a handful of rock art sites. Post-glacial lake-level dating can suggest that a site is not older than the age of the associated past shoreline, as the site setting would have been submerged during the time of higher water levels. Radio-carbon analysis of logs found buried in the sands of the former beaches has in turn dated the century when the ancient water levels lapped the relic shorelines.

This lake-level dating method worked at a now-faint pictograph site near the small community of Killarney in Ontario. Collins Inlet extends as a fjord-like arm of northern Lake Huron between Killarney and the mouth of the French River. Eleven barely discernible paintings mark a reddish cliff that plunges into the dark inlet waters. An elaborate head or ritual mask, painted at the waterline, peers out between the waves, while the remaining pictographs extend less than two meters up the rock wall. According to present understanding of lake level fluctuations, the Collins Inlet site would have been submerged prior to 150 B.C. Consequently, the rock art must be more recent than that time—not a narrow time frame, but a clue to the extent of this site's antiquity.

Farther north, on Lake Superior's shores, the timeless walls of Agawa Rock were covered by stormy seas around 1,000 B.C. Some changes in the shape of the land have been so profound that it is difficult to imagine

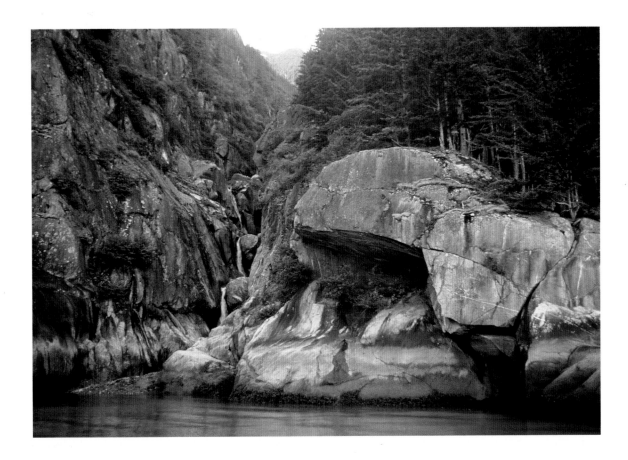

past settings. Again, it is safe to conclude that Agawa Rock's images could not be older than 1,000 B.C. Were there paintings higher up the cliff when the lake was more elevated? So far, we have not encountered examples of potentially ancient art.

Similarly, at Raven Rock, a scattered series of pictographs emerges from an inland lake six miles north of Lake Huron. In the 1980s, we drove miles of dusty logging roads before finally reaching the lake. Yet 4,450 years ago, the upper reaches of Raven Rock stood on the shores of an immense, never again equalled Great Lake—larger than the combined capacity of modern Lake Huron and Lake Superior.

On the coast of British Columbia, changes in water level fail to provide useful dating techniques—this art was intentionally placed to receive daily blessings from the sea. Scores of rocks, exposed by low tide for a few hours each day, carry carved minimalist faces, finely wrought salmon, and images of sea creatures.

AN ANCIENT VOLCANO

While lake level information can be used to determine the earliest use of rock painting sites, layers of volcanic ash, which have sealed and preserved some very early carvings, indicate the time frame of a few petroglyph sites. There is a certain irony in using rock pulverized into ash to help date carvings in stone. One still day around 4,900 B.C., long before the first pyramids rose skyward and ages before Mount Etna buried Pompeii, a volcano erupted in Oregon with such magnitude that its ash spread for thousands of miles across the North American continent, reaching as far east as present-day Iowa and the Mississippi River. Crater Lake in south-central Oregon remains a jewel-like ghost of the former volcano called Mount Mazama. The volcanic ash fell in such quantity when Mount Mazama blew skyward that recognizable layers survive in buried soils. Archaeologists regularly use this now-compacted carpet of geologic activity as a bookmark for developing chronologies. In rock shelters and stratified, open air sites, artifacts and hearths found below the Mazama ash layer pre-date 4,900 B.C., while those remains of aboriginal camps situated above the ash are obviously more recent.

In time, many researchers felt that somewhere in the vast terrain downwind of the Pacific Northwest's best known prehistoric volcano, an archaeologist would be

▲ *Changes in tidal levels transform this brooding pictograph site situated beneath the overhang. Gardner Canal, Kitimaat–Kemano, coastal British Columbia.*

lucky enough to discover rock art sealed by Mazama ash. An incredibly rich concentration of rock art has been found around Long Lake, Oregon, not far from the California border. Extensive walls of basalt carry the legacy of past native foragers who once dwelt in the uplands of Warner Valley. From the 1930s to the present, archaeologists have contemplated the mile-and-a-half-long rimrock gallery of petroglyphs and nearby remains of Indian camp sites. In historic times, native families made yearly journeys from their lowland winter camps to harvest the camas and biscuitroot plants that flourished at higher elevations.

The plants remain. The Indians are gone. But tell-tale evidence of their tenure has survived everywhere—bedrock grinding stones, left from generations of pulverizing roots and pounding edible seeds, lie across the bedrock exposures. Debris from chipping hard stone into sharp tools litters certain camps, and complex petroglyphs cover the rock walls. Previous studies developed a chronology based on frequent overlain images—the last carvers active at Long Lake left easily decipherable human figures and animals similar to those found at numerous sites across the Great Basin between the Sierra Nevada Mountains and the Rockies. A middle-aged layer of more weathered rock art is contrasted by its worn appearance and its contents—abstract subject matter in the form of dots, grids, and meandering grooves.

The combination of certain light conditions and a very discerning eye enables searchers to spot faint traces of another style of carving. Although the earlier layer of petroglyphs appears on the rimrock, it is so worn from exposure to the elements and obscured by later artwork that it remains enigmatic. During a re-study of the Long Lake area, excavators from the Bureau of Land Management and Portland State University were fortunate enough to locate a group of carvings that, buried by long accumulation of soil, remained protected. Partially hidden by millennia of soil deposits, this petroglyph wall was carefully exposed by removing many layers of soil.

Digging into the upper strata yielded some evidence of prehistoric hunters and gatherers. But below this ground surface, excavators hit the sort of buried treasure that separates archaeologists from artifact collectors. A grinding stone and grinder, or metate and mano, lay near a distinctive notched arrowhead or spear point. Someone interested only in fine artifacts might have hastily shovelled these finds out of the deep pit, probed

a bit further, and left. Such actions would be the archaeological equivalent of tearing pages out of a rich book. To a trained eye, the freshly exposed mixture of volcanic ash and clays encasing the artifacts, followed by a pure volcanic ash stratum, offered a remarkable story—people had camped there not long after the eruption of Mount Mazama. Like footprints in fresh mud, the more subtle evidence of dwelling on Mazama ash meant that this layer dated back to a time nearly 7,000 years ago.

Certainly, older archaeological finds are known throughout the northwest corner of the continent, but here was an undisturbed layer of Mount Mazama ash nestled against a complex wall of strange, abstract carvings that extended below the bottom of the volcanic fingerprint. The pristine surface of this early rock art had been sheltered from the effects of open air weathering, and from expressions by later carvers. This window into the earth allowed us to gaze at a stone tapestry composed of subtly sculpted dots contained in curved line enclosures, resembling textured ice floes broken and regathered in a frozen sea. Here at last was the absolute kind of evidence needed to firmly establish rock art far back into North American prehistory—direct clues, datable from several sources, and literally grounded in fact.

ROCK ART STYLES

Rock art styles are based on widespread, repeated phenomena sometimes linked to our universal subconscious. Notable changes in style work quite well in some tribal areas as general, indirect aids to dating rock art—especially when numerous, overlaid paintings are available for study. In small Chumash ceremonial caves, researchers have found a repetition of three basic styles: first, abstract drawings, rather than paintings, produced in charcoal; second, true paintings rendered in a single red or white color (monochromes); and third, a burst of multi-colored, artistic creativity unmatched elsewhere in North America and painted from an extensive palette of bright colors (polychrome paintings).

A glimpse of this California heritage can be viewed through a set of iron gates protecting a magnificent Chumash cave nestled against a steep cliff high above Santa Barbara. Today, the Painted Cave of San Marcos Pass is part of California's state park system. In the past, the small cave served as a Dreaming Rock for members of the widespread *antap* cult and earlier Chumash visionaries. In overlapped succession, the ends of the

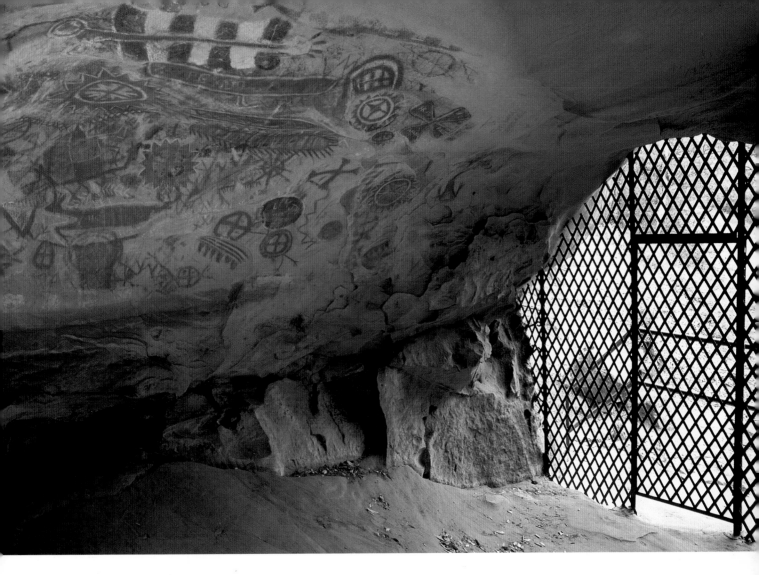

earliest charcoal images—a series of linear drawings—extend out beneath a busy array of white paintings that, in turn, have been covered by red and black compositions. This serial ordering of styles is repeated at other Chumash sites, but such schemes are never simple. One of the few Chumash pictographs panels displaying Europeans—a party of Spanish explorers riding horses or mules—was rendered in a single red pigment. This raises the question of whether distinct styles sometimes coexisted. There is evidence that certain combinations of pigment colors and motifs may have been reserved for specific ritual art.

The relative nature of using styles and superimposed images for dating has inherent problems. During periods of change, new religions and exciting rituals swept across prehistoric North America, in some instances replacing distinctive indigenous images. Some popular native religions such as the Grand Medicine Society, or Midewewin, of the Ojibwa and Chippewa, borrowed

existing aboriginal icons and continued their use, while adding symbols of their new religions including outlines of the medicine lodge, cross-poles, and bear tracks.

In the Great Lakes area, strong evidence exists that certain motifs were selectively used by specialized shamans. Members of the Midewewin placed most of their ritual art and prayers on birchbark scrolls. From the dozens of preserved specimens, we know that Midewewin practitioners favored depictions of large circles or spheres identified as "prayers," outlines of the distinctive Midewewin lodge, cross-poles used in the higher degree lodge activities, and other specialized pictography. These images were commonly depicted on birch bark, and more rarely on the Dreaming Rocks. The Midewewin was traditional shamanism verging on becoming a more organized priesthood. A handful of pictograph sites in northwestern Ontario show unmistakable Midewewin rock art—confirmed by contemporary Midewewin followers. Elsewhere in the

▲ *Chumash Painted Cave State Historic Park is a national cultural treasure meriting protection. Near San Marcos Pass, above Santa Barbara, California.*

northern Algonkian rock art area, in regions where the Midewewin did not occur, Midewewin pictographs are rare to non-existent.

Another Algonkian shamanic healer was known as the *Mushkiki-Innini*, or herbalist. *Mushkiki* means "herbs" and *Innini* translates as "person." Its plural form is *Inninik*, or "people." These men and women, who possessed skills as advanced as any pharmacist, did not include rock art in their rituals. From their carved wooden "prescription boards," we do understand that the *Mushkiki-Inninik* maintained a series of plant motifs used as memory aids and teaching references.

Such plant designs are extremely uncommon at rock art sites—in contrast to the highly abstracted rock art of the *Wabeno* shamans. These Algonkian medicine people were concerned with human and animal fertility, reproduction, and the reincarnation of souls. The images reflecting these practices occur frequently on Algonkian rock art galleries. The *Wabeno* shamans also specialized in time keeping with lunar calendar sticks and the observation of stars and planets for prophecy and predicting seasonal changes.

Fred Pine, like his great-grandfather, Shingwaukonce, was a *Wabeno-Innini* as well as a master of the more widely distributed form of shamanism called *Djiski-Innini* or "Soul Man." From his dual training in both specialized fields of shamanism, Fred Pine was able to identify rock art panels produced by either specialist. The *Djiski-Inninik* were far more numerous than *Wabeno* shamans in early times; and while most *Wabeno-Inninik* had also acquired the skills and powers of the "Soul Men," the reverse was not true. The *Wabeno* did practice the marking of rocks as part of their calendric record keeping, and less often rendered celestial subjects onto stone walls. Their painted sky lore, often done in uncommon white pigments, appears as humanized suns, lunar crescents, single and grouped stars, and comets with tails. In keeping with the low incidence of *Wabeno* shamans—a hunting band of 150 to 300 individuals might have one *Wabeno-Innini* and five or more *Djiski-Inninik*—celestial pictographs are not very common. According to Fred Pine and other Ojibwa Elders, the *Wabeno* also painted the perplexing rows of tally marks—short vertical lines used to record time—that are found at many northern rock art sites. These permanent records supplemented similar tallies in the form of notches cut into calendar sticks.

The Soul Men and Soul Women shamans are mentioned most often by tribal Elders in reference to rock art. *Djiski-Innink* regularly fasted for their visionary powers, used spirit helpers in the form of animals, practiced transformation into animal and pure energy forms, dealt with sorcery, and performed curing rites in public by drawing foreign objects out of the bodies of their patients. Numerous rock art motifs—including human figures with power rays or horned heads, individuals shown in the process of transformation, and animal assistants—have been associated with the "Soul Shamans." Among the northern Algonkian tribes, rock art showing X-ray style humans and animals with prominent heart lines or kidneys is purely *Djiski-Inninik* work. These are the shamans who could see into a body to find the source of illness. The same medicine men and women lived their complex lives under the metaphor of death, transformation, and restoration of life.

From this review of Ojibwa shamans and their associated rock art, we can envision a scene from the past where a Djiski-Innini and a Wabeno-Innini, alive at the same time, could separately visit a tribal rock art cliff and leave records of their distinctive imagery. Several hundred years later, an archaeologist might approach this painted rock in an attempt to find temporal differences between the highly abstracted art and the more naturalistic renditions of humans and animals left there. These lessons from the northern tribes temper our enthusiasm for dating styles with a *caveat emptor:* "Let the viewer beware."

The use of style for dating is similar to looking at an old family photograph. While you can easily determine that the parents are the oldest and determine the relative age sequence of the brothers and sisters, their actual ages remain unknown, floating in time without a firm year for an anchor. Their clothing styles might indicate in which decade or century they lived. Fortunately, archaeologists pursuing rock art studies continue to use whatever current, direct dating techniques are available to date the Dreaming Rocks. Their success is intermittent, but occasionally encouraging.

CARBON 14 DATING

For some pictograph sites, archaeologists have waited decades to unlock a secret held inside most of the paintings—the minute traces of carbon left from whatever living matter was used to mix with the dry pigment. Fortunately, Indian shamans in certain areas mixed their paints with an assortment of organic items

including blood, boiled fish cartilage, juices from crushed flowers, and roots.

Students of Chumash rock art stand on the verge of a dating revolution. Simple charcoal drawings left on cave walls of the coastal mountain ranges—often non-representational collections of lines—were once dismissed as the work of modern campers until enough charcoal line drawings were found extending beneath undeniably Chumash paintings to suggest their relative antiquity. After several decades of refinement, laboratories are now capable of making carbon-14 age determinations based on minute samples of organic matter. Currently, attempts are proceeding to use carbon dating on these charcoal sketches.

CATION-RATIO DATING

Lacking better methods, we were stuck with style-based dating of petroglyphs until a few proponents of hard science were drawn to the field of rock art. For decades, researchers in the western states grappled with weathering differences in rock carvings. Exposure to the elements gradually changes the freshly pecked appearance of Indian carvings into weathered icons distinguished by a natural covering of darker varnish. Petroglyphs become visible based on the depth of the carving and the contrast between the surrounding weathered rock—usually darker—and the lighter, fresh surface exposed by carving or pecking. Most of the cliffs, boulders, or level outcrops in the western United States, chosen by Indian artists as petroglyph sites, bear a patination called rock varnish or desert varnish. This re-patination of the rock art images offers a wildly precarious approach to dating for several reasons: it is subjective; it lacks absolute dating standards; and the styles have been defined in such a broadly inclusive manner that they may not be based on aboriginal reality.

In the 1980s, a complicated procedure called cation-ratio dating, which measures the systematic leaching away of clay minerals, iron, and manganese elements, was used to date the rock varnish on petroglyphs. The idea is simple enough. After a petroglyph was created by breaking through the dark, outer surface of the parent rock, desert dust gradually accumulated on the freshly carved surface as chemical changes took place. The annual effects of sun, limited rain, and wind eventually revarnished the carving. The cation dating method, one of a small number of direct methods for assessing the age of rock carvings, measures the leaching of manganese and iron oxides from the varnish.

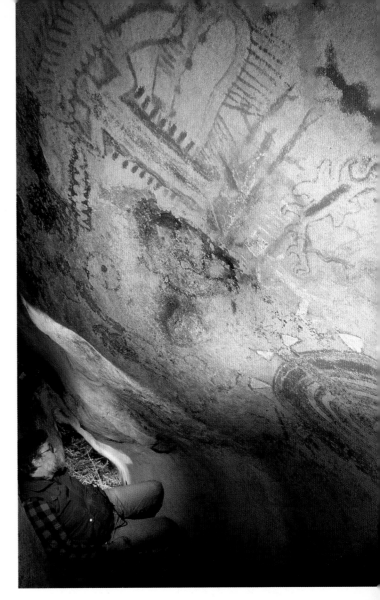

In the Great Basin of the United States—that dry depression of western land saddled between the Rockies and California's Sierra Nevada Mountains—rock art is very common. Archaeological digs inform us that life in the Great Basin followed a series of repetitive routines over thousands of years, across lands now covering Utah, Nevada, southeastern Oregon, western Wyoming and western Colorado. There, Indian families collected seeds, killed rabbits and, whenever possible, hunted larger game. Out of this broadly uniform tribal base, certain widespread artistic trends developed across the ages.

Three rock art styles reappear with great regularity in the Great Basin. When the cation studies were applied to the three established styles from youngest to oldest—Great Basin Representational, Rectilinear, and Curvilinear—the previous assumption that relative weathering was useful as an age determinant was

▲ *This Chumash rock art is hidden inside a narrow chamber in southern California. The multi-colored, dramatic images create an ideal setting for entering a trance state.*

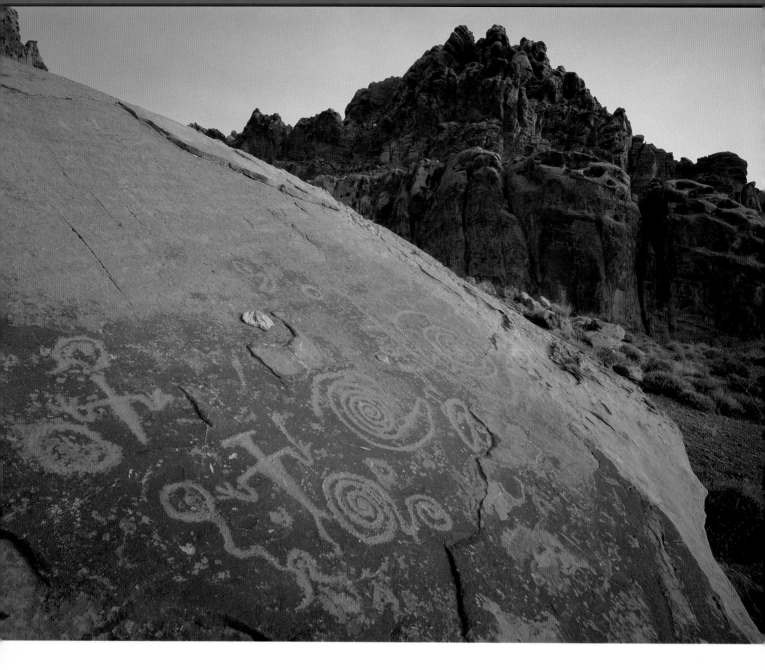

supported. The chronological sequence remained intact. More revealing, however, were the ages of these styles. Previous "best guesses" proved to be off by several thousand years. The cation-dated petroglyphs, while a slim sample, nonetheless pushed the antiquity of the older Great Basin Curvilinear style back by 3,400 years, dating such petroglyphs to 4,450 B.C.

Cation-ratio dating, still in an experimental stage, may develop into the long-sought reliable method needed for determining a petroglyph's age. Many rock art investigators have remained frustrated by the lack of a dating device. Like most new scientific procedures, cation dating needs refinement; but it is a breakthrough similar to radio-carbon analysis.

ROCK ART BECOMES LITERATE

Along the rivers southwest of Hudson's Bay, Cree hunters left numerous, small rock art sites. The presence of the distinctive Cree syllabic writing in red ochre, found painted beside conventional pictographs at one of these sites, can be firmly dated after the year 1841, when the system was invented by James Evans. Syllabics, a series of unmistakable linear and curved symbols—jokingly called "axe writing" due to their resemblance to chop marks in a log—were used as a writing system for hymns and missionary purposes. Today, this system has become so successful that syllabics are still used as a complete written language among the Cree and Innuit nations of northern Canada.

▲ *Petroglyphs in the Valley of Fire State Park in Nevada evidence harmony with the surrounding landscape.*

In the same region in 1861, a Cree congregation painted its wooden church with red ochre, perhaps the only church of its kind on the continent. It makes sense. If the soaring rock art galleries are natural, tribal cathedrals adorned with red ochre images, why not paint a wooden spirit house with the same sanctified pigment? The noted durability of red ochre did not fail. Forty-seven years later, a Canadian government surveyor found that the building remained both red and weather-protected.

ROCK ART WITHOUT RITUAL

The final episodes in the history of North American rock art seem to merge into graffiti-like motifs. In the land of the Navaho, images suggesting recent activities are pecked and scratched into traditional rock art sites. Portraits of loves lost or gained, a locomotive, and early automobiles co-mingle with older, perhaps less secular designs at various sites in New Mexico. In northern Ontario, even the well-dressed Mr. Peanut of peanut jar fame, wearing his formal top hat, has made an appearance on an outcrop that was formerly used for ritual art. While these designs can qualify as rock art, since they were done in authentic media at traditional sites, the images come from common, rather than sacred, inspiration.

A CAUTIONARY TALE

The northern Indians tell a story about a journey of the soul to a land beyond the western stars. I learned the tale one evening while standing in a clearing with Dan Pine, Sr., the Ojibwa holy man.

"See those stars, *Chibay Meekaun*, the Soul's Path?" he asked, pointing to the Milky Way. "Do you know what those *Anunguk*, stars, teach us?"

"I know that at the time of Creation, when turtle dug her nest on a sandy beach and kicked millions of grains of fine sand into the sky, the Milky Way was formed. And ever since that time, a trail extends across the heavens for us to follow after we leave this world," I replied.

Dan was silent for a long time. He kept looking skyward. "True. But our Mother, Spirit of the Earth, formed the 'Soul's Trail' so we would be reminded of another lesson."

Now I was lost. Dan Pine pointed to the horizon and traced the progress of the Milky Way across the night. "It is like the handle on a pail," he said. "A great arch. A wide trail. But all of those branches along the Milky Way are forks in the trail. If you forget the reason for your journey, you will wander off on a side trail and be lost." He paused. "If you ever need guidance, look at our Mother all around you. The stars. The rocks. Even the shape of the lakes. She has left her wisdom so that you can learn for yourself what I told you." He looked piercingly into my eyes. "I will teach you. Someday you must teach yourself."

The study of rock art also contains many misleading side trails. It is fascinating to actually discover the age of a painting or carving using obscure evidence or advanced science; but age can become an obsession—a fork in the trail off the true path of discovery. Our journey through the Dreaming Rocks continues with a look at how these spiritual documents in stone have endured through time.

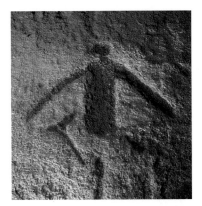

Rock of Ages: How Does Rock Art Survive?

"You mean to tell me that these Indian paintings are several hundred years old? Well, I'd like some house paint made out of that!" a visitor to Agawa Rock once observed.

How do rock art images survive centuries of weathering? And, considering the distracting graffiti applied to rock art sites with modern paint or chiseled into the bedrock, we also need to ask: How will these images outlast the threat of vandalism? These are the dual challenges of rock art conservation.

To understand the physical make-up of rock art, we must converse with a specialized group of scientists devoted to the conservation of our cultural heritage. We enter a technical world of laser guns, electron microscopes, and ice-shattered rocks, as well as a more human realm where patience prevails.

Rock art conservators literally face mountainous challenges. Their endeavors range from protecting entire sites—where the elements fracture great masses of rock through erosion and frost—to individual paintings that are slowly but inevitably flecking apart. Just as the problems vary in size, the

▲ *A thunderbird from the Teaching Rock, Petroglyphs Provincial Park near Peterborough, Ontario.*

◄ *A canoe, Mishi-peshu—the guardian of Lake Superior—and two giant serpents at Agawa Rock, Lake Superior Provincial Park, Ontario.*

solutions span a spectrum from the mundane—concrete and steel bar reinforcements and the chemical removal of modern paint—to the miraculous, such as the introduction of a climate-controlled building that covers an entire, fragile petroglyph site. In the course of their work, conservators have made unprecedented contributions to our basic understanding of rock art. One such revelation began with a dragon that had a skin problem.

A DRAGON UNDER THE MICROSCOPE

Agawa Rock rises as an exaggerated representative of Canadian lake country rock art sites. The cliff looms higher than most, above the often-raging Lake Superior. Here, fall and early winter storm waves can crest at up to 30 feet high, completely washing over the pictograph gallery. During the winter months, thickly glazed ice builds up along the site's exposed walls. This is followed by the erratic return of spring and summer, bringing weeks of searing heat followed by below-freezing temperatures, creating inevitable freeze-thaw cycles.

The granite cliff, or "cut rock" as the Ojibwa prefer to call it, carries the life and death of the paintings found at its base. Just what magic has enabled these images to survive? The answers come from two directions—the inward view of conservation scientists armed with electron microscopes, and the outward, time-tested approach of uncovering the ochre paint recipe. A diverse and keen group of cultural caretakers work at the Canadian Conservation Institute in Ottawa, Ontario. These senior conservators—who may spend an afternoon with the old masters searching with X-ray diffraction machines for clever yet fraudulent works—examine rock art under their inquisitive, high-technology umbrella.

The tourist who expressed amazement at the durability of the Agawa pictographs displayed a common reaction. Unfortunately, he did not realize that the "paint" visible in the form of an underwater panther was really a persistent stain. Red ochre, a fine-grained mineral, penetrates minute spaces in bedrock. Until conservators began to examine samples of exfoliated pictographs, we did not know the true relationship between pigment, bedrock, and painting. The story is dramatic for its intensity. It ranges from the closest possible scrutiny of a pigment sample to a larger-than-life subject—the demi-god, Mishi-Peshu.

The supernatural feline guardian of Lake Superior, Mishi-Peshu is an amalgam of a tufted-cheek lynx, a dragon with spines running from head to tail, and a minotaur with curved horns. Mishi-Peshu represents a bold abstraction of Lake Superior's power and fury—the unrivaled forces of the world's largest freshwater lake. The composite mythological animal mimics the tension between natural elements.

To Algonkian speakers, the generic peshu can conjure up cat, lion, panther, or lynx, depending upon circumstance or a well-chosen adjective. Following a native world view, where interrelatedness is more important than divisions between living creatures, they are simply "cat." Even artistic conventions are reinforced by folklore in the case of Mishi-Peshu. Over half of the Ojibwa and Chippewa tales describing the underwater lion mention its spine-covered tail. The three dream portrait pictographs of Mishi-Peshu marking Agawa Rock strongly emphasize this feature of the lord of the depths.

The grand cat also wears a translucent veil of white minerals deposited by water trickling down its vertical panel. Tree roots and groundwater on the forest floor above Agawa Rock dissolve minerals that are then washed down the massive cliff. These patterns of natural streaking and staining of rock precipices occur across the country. The whitish deposits that remain on the stone walls, called silcrete, are not unlike hard-water deposits found on plumbing fixtures, and they build up layer by layer on the exposed rock face. When the silica deposits covering a pictograph are thin, the painting remains visible. As time passes, the layers build up, eventually becoming opaque and obscuring the rock art.

The silcrete can act as a protector by sealing the ochre pigment from direct exposure. On softer rocks, it actually cements the pigments to the rock. However, silica deposits also become destroyers of ancient paintings. There is evidence that after silcrete deposits reach relative, varying thicknesses, they scale off from their own weight or through natural processes. If a pictograph is painted on an existing layer of the white coating, it too will be lost. The most elemental questions need to be contemplated: What is the physical nature of rock art? How does pigment interact with its stone canvas? The Canadian Conservation Institute has begun to study these questions.

By the 1970s, conservation scientists were examining a small percentage of the continual supply of ochre-painted rock chips on the verge of flaking off their parent rock. A team of researchers from the Canadian Conservation Institute focused on the physical

relationships between pigments and rock. Traveling to a representative sampling of sites from Ontario to British Columbia, they gathered the small chips released from pictographs by frost and other natural forces. When these bits of skin from Mishi-Peshu, along with small samples from over a dozen other sites, were placed in cross-section under an electron microscope for the first time, the physical life of a pictograph became public knowledge. Micro-photography revealed a layer cake consisting of silica mineral deposits resting on granite substrate (the cliff), followed by a thin pigment layer (a cross-sectioned pictograph) undulating and conforming to the shape of the initial mineral layer. A subsequent mineral deposit sealed the pigment. Experiences such as these demonstrated a need for more enlightened planning when implementing site access and conservation.

Other questions remained: What bound the pigment so forcefully to rock? Despite concentrated efforts, no trace of the organic binding agent could be found in Algonkian pictograph samples. By comparison, infrared spectroscopy of carved wooden dance masks made by the Haida and Tsimpshian tribes of British Columbia's northern coast gave clear evidence that crushed salmon eggs were the organic substance used as paint binder. When the conservators turned to a stone mask decorated with red ochre and a natural green pigment from the same cultural area, the infrared scan for an organic binder was negative. Apparently, dry pigments were applied directly to the stone. Was this the practice at these rock art sites?

The most accurate responses are the standard replies to complicated questions favored by Ojibwa Elders—"Yes. No. Maybe." Theoretically, the answer is yes. Red ochre can be procured in such a pure, chalk-like state that it will work either dry or mixed with a little water. During our excavations of prehistoric camp sites on Lake Temagami, we often uncovered nodules of red ochre, collected several centuries ago by the ancestors of the local Indians. At Witch Point, a revealing archaeological site filled with stone tools, ancient hearths, and broken shards of decorated native cooking pots, red ochre appeared so often that the field crew had ochre-stained hands by the end of the day. Informal experiments done on beach cobbles with this long-buried ochre demonstrated how the pictographs across the bay could have been made as easily as marking a sidewalk with chalk.

If dry ochre was used by Algonkian tribes, its application was not universal. When asked about the production of ochre paint, Fred and Dan Pine insisted that the pigment was mixed with a thick, stringy soup made from the boiled spine of a sturgeon.

The sturgeon is a strange fellow. As a fish, it is very primitive—its frame is entirely cartilage rather than bone, and it swims in a suit of armor plates. The Pines' ancestors often made this glue and used it for sealing the seams on birch bark canoes. The sticky substance was

▲ *Pictographs of a fish and a mythological creature at the Agawa site, Lake Superior Provincial Park, Ontario. Barely preserved earlier paintings—a canoe under the horned creature and a thunderbird above—are seldom visible in photographs.*

study of the site in 1958, showed that nothing had changed except that the large initials of a youthful visitor, brushed on with house paint in the 1930s, had disappeared!

Frost cycles, lichen growth, and natural weathering of rock surfaces inevitably encroach upon pictographs or petroglyphs. Rock art sites have a finite life span. Their longevity largely depends on the quality of the stone used for the images. The pre-Cambrian granites of the Canadian boreal forest generally survive the harsh seasonal changes and can endure for centuries; but the softer sandstones of the northern Great Plains lose their painted cultural memories much more quickly.

REPAINTING AT ROCK ART SITES

A voice floated across the lake. "So that's how you do it." My wife and I turned to find a pair of fishermen sitting in their outfitted canoe, watching us copy vivid ochre shapes onto clear acetate.

"What do you mean?" I asked.

"The paintings. You're touching them up. So that's how they stay so clear," he responded. Having paddled slowly toward Fairy Point, these men did not notice our nearly invisible acetate, a transparent plastic that we placed over walls of pictographs while making reproductions. They had assumed that the famed Indian rock art at Fairy Point could not have endured centuries of exposure and, to our amusement, they thought we were retouching the native images.

Actually, the fishermen's suspicion leads us to an interesting, poorly understood aspect of rock art—the renewal of certain images by aboriginal artists. It also explains the presence of a six-legged animal on a narrow lake at the headwaters of the Mattagami River in the Arctic watershed of northern Ontario. Upper Grassy Lake lies just north of the height of land, the imaginary boundary between lakes and streams either flowing south to the Great Lakes, ultimately reaching the Atlantic, or waterways leading north to the reaches of the Arctic Ocean. Among the dozens of pictographs on Upper Grassy Lake, a few evidence changes made by the original Ojibwa shamans.

Across the surface of a pictograph, intense, careful pecking apparently done by an aboriginal shaman—the site is obscure, free of graffiti, and contains further evidence of native alteration of rock art—has destroyed the original image. Only faint traces of an earlier work on another panel at Upper Grassy Lake are left beneath

produced by removing the cartilaginous backbone from the sturgeon and throwing it along with a handful of bear grease into a pot. Both Elders insisted that the same method was applied in making pictograph paint, with the addition of red ochre and more grease and water to achieve the right consistency.

Park managers and repeat visitors to rock art sites commonly observe, "These pictographs are fading. They were much brighter the last time I came here." This apparent deterioration of rock art has caused concern for cultural caretakers across the United States and Canada. What can be done?

Actually, the first solution is not finding a cure for fading. We need to determine if the paintings have suffered reduced visibility. In my own experience, the well-remembered pictographs at Agawa Rock on Lake Superior and Fairy Point on Missinaibi Lake were identified by individuals in the Ontario Ministry of Natural Resources as having "lost their color." With Agawa Rock, early color slides on file in the park offices, coupled with sketches made during the first

▲ *At East Lac La Croix, painted footprints lead to an individual smoking a ceremonial pipe near an hourglass-shaped pictograph. Elsewhere, apparently authentic initials and a date (LR 1781) are pecked into the rock at this site.*

a deep-toned red ochre wash. But the oddest change occurs on a generalized profile of a mammal that, when repainted, was shifted forward a step, thus creating the impression of an extended, multi-limbed creature.

Renewal of central panels at Algonkian sites partially explains the low incidence of superimposed pictographs in the land of the Cree and Ojibwa. From limited but telling evidence, we know that an ancient shaman artist applied an ochre wash over earlier pictographs on the Mishi-Peshu panel at Agawa Rock prior to painting the underwater guardian of Lake Superior. And on certain mornings, when the right balance of light, cloud, and moisture in the rock allows, grand Mishi-Peshu casts a ghostly shadow beneath his body, telling us that the great cat was also repainted in years past.

Was this a never-ending cycle? A few of the pigment samples taken by scientists from the Canadian Conservation Institute suggest that direct repainting, or cancellation of previous works with red ochre washes, may have been a common practice. Under the electron microscope, some of the samples viewed in profile offer a layered sequence, starting with the granite bedrock, followed by a layer of calcite, then displaying a wine-colored streak of ochre from an early pictograph. In turn, the first rock painting was covered by calcite deposits; then a layer of orange-colored ochre from a superimposed pictograph was visible. Additional calcite deposits flowed over the more recent painting.

If we could peel away the laminations of time at numerous Algonkian rock art sites, we would find more examples of earlier paintings. A few intriguing hints exist. The only two examples of corn plant pictographs discovered in the northern Algonkian area occur at Keso Point on the French River. One stalk protrudes out from a deep ochre wash that partially covers it and other obscured pictographs. A second, identical corn plant was then placed just beyond the edge of the wash. I think such findings may be reminders of past rituals that included deliberately obscuring an existing painting and producing a new pictograph.

RESTORATION

Conservators battle graffiti and related vandalism at rock art sites; they also attempt to soften the relentless forces of nature. In the upper Great Lakes—where lakeside cliffs are warmed by temperatures as extreme as 98°F in summer months and frozen by the desperate cold of -40° in winter—even enduring granite

eventually yields to weather cycles. In 1878 at the famed Agawa Pictograph site, a returning group of sports fishermen passed the fabled cliff and lamented the loss of a fine pictograph panel over the previous winter. A great slab had fallen into the unforgiving waters of Lake Superior. Today, a relatively fresh-looking scar, about 115 years old, marks the part of the cliff where the panel became detached.

When I first visited Agawa Rock in the early 1970s with Angus Kakapshe, "Barred Owl," an Ojibwa commercial fisherman and trapper, he too mentioned the fallen paintings. His family carried long ties to aboriginal settlements behind the broad beach and valley named Agawa. Any changes at the cathedral in stone remained firmly embedded as part of the Kakapshe family lore. Although the slab had fallen in his father's era, Angus Kakapshe knew that it bore images of a woodland caribou and other animals.

Native trapper Bill Souliere experienced a similar event on Dog Lake, a vast northern waterway at the headwaters of the Michipicoten River in northern Ontario. My wife Julie and I had just recorded the seldom-visited, painted cliff near the center of Dog Lake. On an endless July afternoon, with ospreys hovering overhead and blue herons stalking frogs amidst reed beds, we traveled down the eastern arm of the lake and visited the remaining native families living there—the last people from a much larger earlier settlement. We found Bill Souliere and his aged mother at their home. His interest in the art of his ancestors was obvious as we explained our work. Bill Souliere asked us to wait a moment as he gathered his outdoor equipment, for he wanted to visit the pictographs with us.

A short time later, as swells and passing rain washed against our aluminum boats, we neared the cliff. We cut the motors and looked at the dark-hued thunderbirds, moose, and abstract artwork painted under the shelter of the overhang.

"Bill, have you ever heard stories about this place?" I asked. He gave a barely audible affirmative reply, and said nothing more. I let the question pass and redirected our conversation. "It's amazing that these paintings survive here," I said. He half-smiled, and again said nothing. But this time, Bill Souliere bent down and unwrapped something on the bottom of his boat.

He used a paddle to draw nearer until the sides of our boats joined in the undulating water. He explained that he regularly stopped to look at the pictographs in all

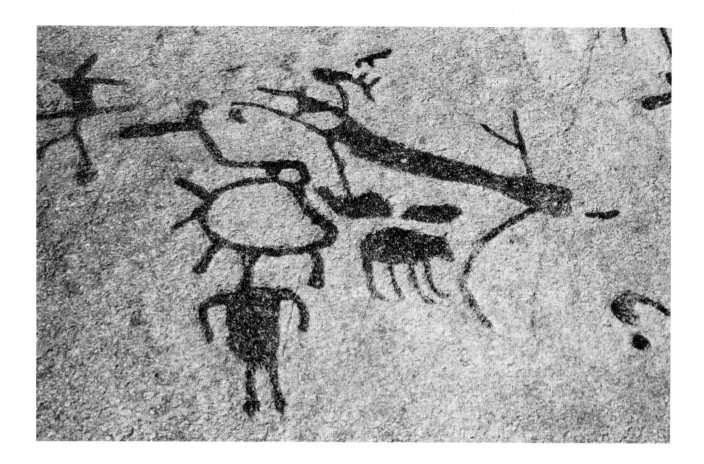

seasons. A few winters ago, he had approached the cliff by snowmobile. Slowing to look at the small pictographs, he noticed a piece of rock on the ice in front of the gallery. When he turned it over, a fine painting of a soaring human figure appeared on the opposite side of the detached stone. Bill Souliere kept this fallen fragment of rock out of a sense of duty to the spiritual achievements of his ancestors, who created the Dog Lake pictographs. As the head of one of the last remaining native families on the lake—the once-populous native community had been decimated by past epidemics, and others later moved away seeking employment—he kept a bond alive between nature, aboriginal people, and the Dreaming Rock.

Detached rock art has been reported elsewhere. Two rocks containing Chumash images were unearthed in California. One sandstone slab—showing minimalist, pelican-like birds and two human figures with raised hands outside a hypnotic spiral with a red dot at its center—was discovered when archaeologists excavated an infant buried far offshore from southern California on isolated San Nicolas Island. The other intriguing

image appeared unexpectedly during a routine testing of an inland Chumash village near the Santa Ynez River. There, archaeologists unearthed a slab carrying four symmetrically placed pictograph frogs and geometric designs. Did both instances involve detached Dreaming Rocks rescued by the Chumash from natural destruction, nurtured with rituals, and then buried so the spirits were calmed? Only further excavations and a lot of luck will supply better answers.

A grand, Algonkian dream world, carved to recognize the powers of regeneration, is located in an isolated pine forest a few hours from Toronto. Today, the whitish marble outcrop—covered with both visible and nearly invisible carvings—forms the main attraction at Petroglyphs Provincial Park. Because the site is near the county seat, it has also been called the Peterborough Petroglyphs. Prior to the arrival of outsiders at this ceremoniously inscribed rock shrine, the place of mystery was a Teaching Rock. It remains so. According to tribal traditions and limited archaeological evidence, the site of the carvings existed for several millennia as an active native spiritual center.

▲ *Distortion and transformation of carved images are reminders of dreams gained during vision quests. The Teaching Rock, Petroglyphs Provincial Park near Peterborough, Ontario.*

Between the 1950s and the late 1970s, something went wrong at the Teaching Rock—the hard, marble bedrock was crumbling like brown sugar at an alarming rate. Fortunately, the Canadian Conservation Institute, encouraged by previous successes at challenging pictograph sites, decided to lend expertise to identifying the problem and finding a solution. Conservators arrived at the Teaching Rock wondering what forces had triggered such unprecedented environmental changes to weaken the petroglyphs. The first question to answer was: What is the real environment of a carving in stone?

Tiny clues, in the form of fired clay pot shards lost in crevices on the Teaching Rock, attested to the stability of the site over time. Indians had been present as far back as the Middle Woodland era, around 200 A.D., judging from the early styles of decoration found on the prehistoric pottery. This tied in with the presence of hundreds of earlier, barely visible carvings that were found beside and beneath the dramatic final images so visible today. The earlier petroglyphs appeared to have weathered over the years, but they remained intact. What recent events threatened the 2,000-year-old Teaching Rock at the time of its greatest prominence? What vital clues would help the conservators solve this pressing mystery?

Acid rain was suggested as the culprit, but careful testing removed it from the line-up of suspects. Next, conservators investigated an odd, dark color that had spread across the surface of the carved rock. Nearby, unworked exposures had retained their characteristic white marble hue. Extensive colonies of blue-green and green algae—microscopic plants that thrive in moist settings—had invaded the Teaching Rock. Despite the availability of an arsenal of the most current testing equipment and the back-up support of research laboratories in Ottawa, the apparently recent invasion of the destructive algae was explained by using the oldest, most effective problem-solver available to us— common sense.

After plotting the shadow patterns that fell across the Teaching Rock, two mature red pine trees were identified as the catalysts for increased algae growth and subsequent dampness on the carved stone surface. Forest conditions near the site probably varied over the centuries. In past decades, these two trees slowly spread their needle-filled limbs each year. The maximum extent of shadow coalesced with increased activity at the petroglyphs, so that within a single generation,

individuals familiar with the magnificent carvings were observing their rapid decline.

Solutions to the shade problem were not difficult to find. However, other complications needed attention. The carvings had been filled in with wax crayon. How did this affect their longevity? And what consequences would result from opening the site to the public?

The wax crayon application carried two lingering effects—one a conservator's problem, the other a lasting curse on the interpretation of the petroglyphs. With a protective and aesthetically pleasing structure in place over the Teaching Rock, the problems of excess moisture gradually abated. Today, the climate is carefully monitored and controlled to ensure the longevity of this national treasure.

Next, scientists refocused their efforts on problems affecting individual carvings. When the most obvious carvings were filled using dark wax crayons, the Teaching Rock was completely changed. The original subtle play of light, shadow, and broken rock surface that once created this site's personality vanished. Instead, rigid and often erroneous presentations remained, obscuring the original creations. As detailed examination of single images progressed, conservators also found that the crayon wax acted as a trap for minute particles of loose rock, airborne dirt, and debris from the dreaded algae. How could the wax be removed without causing any further destruction? How could the spiritual tone of the Teaching Rock be restored?

Conservators always work within constraints. They have an obligation to solve a problem with the highest possible standards of care while also considering its economic feasibility. Routinely recommended, successful treatments used elsewhere to clean stained or discolored stone surfaces include pressurized water spraying, sand blasting, chemical cleaning, and laser cleaning. It was the latter process that offered the advantage of selective application to individual petroglyphs—lasers do not intrude into the rock art. They can also be set to emit a mixture of infrared pulses mixed with wavelengths affecting the green part of the color spectrum, an ideal blend to remove wax crayon and algae in one application. Unlike chemical washes or blasted grit, laser cleaning leaves no residues on the artwork.

Unfortunately, the laser cleaning technique was not very practical. Only an area one centimeter square— smaller than a small postage stamp—could be cleaned at a time. The conservators reviewed a litany of possible

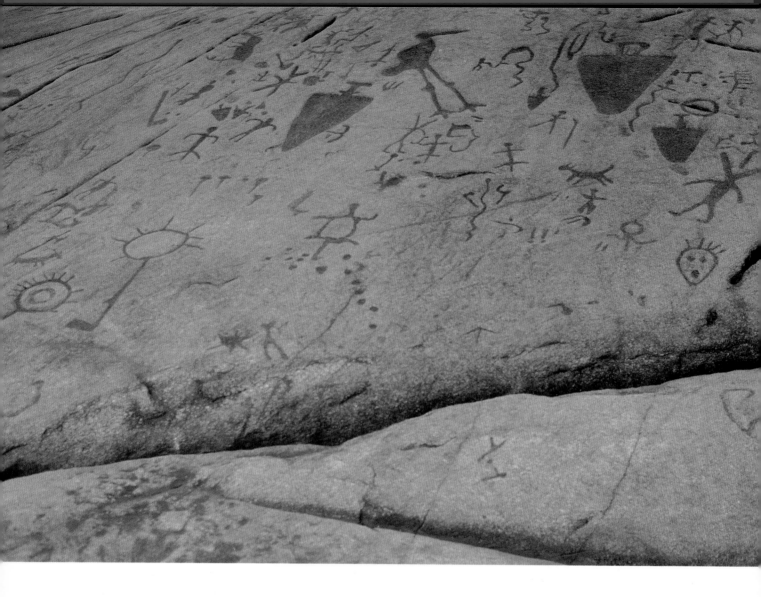

treatments. High-intensity electronic flash systems, water sprays, wax-dissolving solvents, manual removal with brushes, and even air polishing techniques borrowed from modern dentistry were tried and abandoned as either ineffective, abrasive, or too technically demanding.

Finally, a non-destructive, economically practical conservation method was discovered—dry air abrasion. Sample restoration began with a conservator holding a pencil-like jet not too different from the dental air gun used to dry a tooth's surface, kneeling over a crayon-darkened petroglyph, and gently blasting the crayon material with glass fragments so tiny they appear as a fine powder. These glass beads emerge from a muzzle so small—one-half millimeter in diameter, the size of a period on a newspaper page—that it is easy to work within the confines of the petroglyphs. The glass abrasive is firm enough to dislodge the unwanted wax,

but leaves the surrounding rock unchanged. In three to 10 minutes of dry air treatment, a gloomy veil had been lifted from the carvings that were used in the test—a turtle and a snake.

Conservation procedures operate with a logic built on the minute and ascending to the grand. At the Teaching Rock, Canadian Conservation Institute scientists had been able to identify and solve the algae problem and experiment with methods of removing the wax filling from the carvings. Now they needed to shift the focus of their studies to the largest possible scale—protection of the entire site.

A long list of requirements was considered before a final recommendation was made concerning the conservation of the Teaching Rock. Much of the site had been enclosed by a fence that violated every aesthetic rule for treating a sacred site. The algae continued to grow and weaken the marble. Moisture

▲ *Some rock art sites are devoted to specific concerns—the Teaching Rock displays imagery related to fertility and abundance, such as the turtle with eggs. Petroglyphs Provincial Park near Peterborough, Ontario.*

from rain and snow also affected the carvings. Visitors wanted to view the artwork in a more natural state, yet their presence also brought micro-climatic changes. If the site was sheltered by a roof to eliminate moisture, the natural dampness from the springs below the fissures might accelerate existing problems.

Finally, the team assigned to provide solutions for the conservation of this cultural treasure reached their conclusion: The Teaching Rock required a protective building that would be completely enclosed to ensure climatic control. Ample glass was required to let in sunlight. This would reverse the algae growth and also retain the vision of the original setting—mysterious religious art glistening on white marble.

The resulting structure honors the site, its conservation requirements, and most importantly, the experience of confronting the Teaching Rock. A cathedral-like, glass-walled structure was built. Its insulated roof acknowledged heat and cold considerations. The glass walls let the carvings be viewed in a reasonably natural state, by allowing the interplay of light and the surrounding landscape. The age-old problem of rock art sites—access—was ingeniously solved through the use of steel catwalks suspended from the ceiling framework of the building. Visitors can walk completely around the expanse of carvings, viewing the images below. A poet might say the completed structure is a garment protecting this treasure—a gift from our Mother, the Earth.

A FRAGILE HERITAGE

On the mirage-shrouded shoulder of the Carizzo Plains, where eerie whirlwinds dance along the barely visible San Andreas Fault and lake beds filled with soda, lies perhaps the single most spectacular rock art site in North America. Painted Rock shimmers in the afternoon sun. This massive, U-shaped rock enclosure survives as a Chumash shrine created to honor solar gods and to record the hallucinatory visions of *antap* cult members. Multi-colored panels extend across its shaded interior walls. Here the psychedelic visions of native Californians have remained immortalized on stone for hundreds, if not thousands, of years. Painted Rock holds many lessons for us. The first one is respect.

Until the first settlers began to build ranches amidst the dry grasslands behind the coastal mountains in the late 1870s, the paintings were seldom-seen reminders of forgotten Chumash and Yokuts tribal life. Soon, the widely scattered ranch families began to relieve their isolation at Sunday picnics within the protective arms of Painted Rock. A restless father from New York City, who sailed with his wife and daughters to California via Panama, began a new life in a land that could hardly have been more different from his native Brooklyn. Chester Bromley reached central California's long-established center, San Luis Obispo, met a banker with vacant property, and ventured to the eastern limits of the county, to a ranch near Painted Rock.

Growing up at the Willow Springs Ranch, his daughters, 12-year-old Nellie Bromley and her older sister Mary often visited Painted Rock, which was just a few miles away. In those years, their father periodically herded sheep inside the natural enclosure formed by Painted Rock. Mirroring our society today, what the father disdained or ignored, his daughters intuitively appreciated—the silent, artistic richness of Indian designs that covered much of the rock's surface.

When interviewed in 1955 at the age of 90, Nellie Bromley spoke of her family's life on the remote ranch, and also of her personal discoveries at Painted Rock. She recalled a rock art site so pristine on her first visit in 1876 that nodules of the natural pigments used by the Indians to create the multi-colored artwork still lay on the ground in front of the stone walls. The young girls also found something more notable and spectacular—several hundred perfectly preserved paintings.

Large portraits of the California Indian trickster Coyote stood next to the powerful and dangerous Bear. A grizzly bear track was carefully pecked into a sloping rock below a dazzling array of multi-colored paintings. Nellie Bromley has been the envy of all who are intrigued by Chumash rock art, for she and her sister gazed upon what I consider the single most remarkable example of aboriginal rock art in North America—a 40-foot-long panel of interconnected figures representing an extraordinary vision—the California Dream.

When the Bromley sisters rode to Painted Rock in the late 1870s, the Chumash dream panel stood fully preserved. Lines of painted dancers looked as if they had been brushed onto the rock only a few months earlier. A huge portrait of a shaman, complete with a human-like figure inside his torso, stood at one end of the panel. This amazing composition was flanked by several vertical lines resembling rattlesnake rattles—although they could have been stylized presentations of the datura vine, or a shamanic device unknown to us. Another unique human figure—goggle-eyed with raised arms and crossed legs—may be a supplicant receiving an

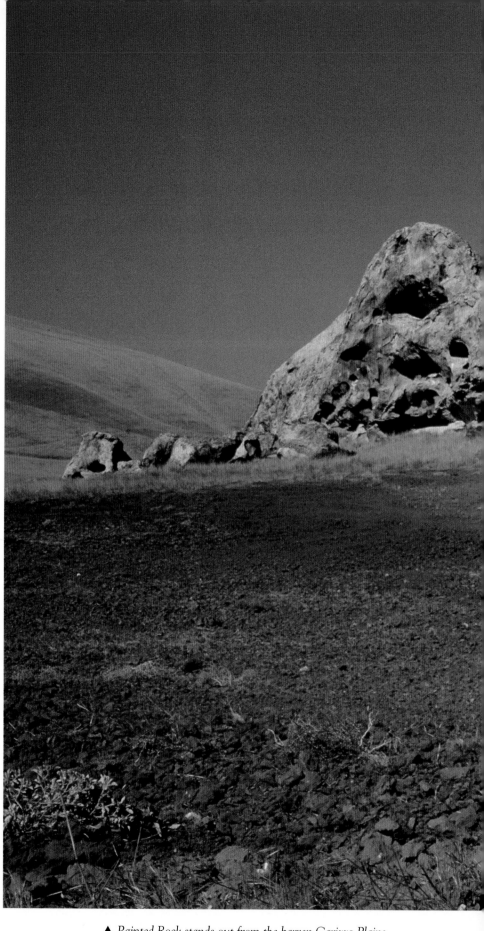

▲ Painted Rock stands out from the barren Carizzo Plains. It is a monumental rock art site situated beside the San Andreas Fault.

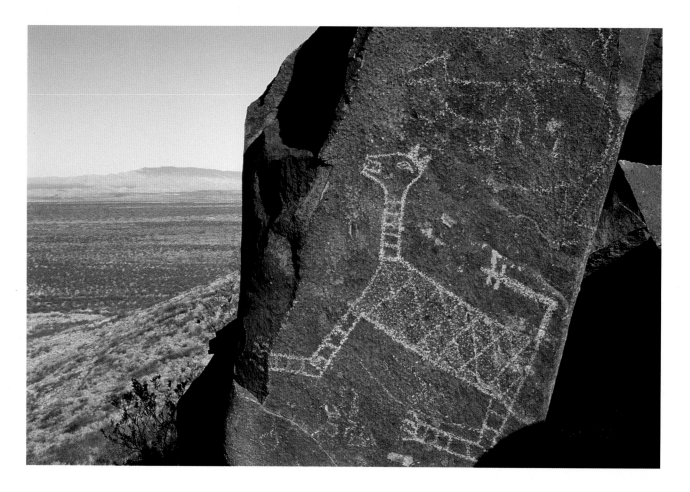

intense vision. Zig-zag power lines emanate from his distended eyes.

One line connects to a stylized animal shape which, although not positively identifiable, may be one of the undersea keepers of wisdom, the swordfish. A single long projection curves out from the animal's head toward the goggle-eyed person. This section of the California Dream panel brings to mind the customs of the coastal Chumash, who revered swordfish. Many Chumash believed that swordfish controlled other salt water creatures with powers so immense that they could drive migrating whales ashore to feed the Chumash.

In recent years, divers have recovered precious carved-stone bowls from the depths of the Santa Barbara Channel. Originally dropped by the island-dwelling Chumash who traversed the channel in plank canoes, these containers may once have contained offerings similar to those described by a central coast Chumash Elder. The last woman who spoke the San Luis Obispo area Chumash language reported that her ancestors regularly presented offerings of beads, bird feathers, and tobacco to the swordfish at nearby Avila Beach. According to myths, Coyote met the swordfish tribe—the supreme sea dwellers who tossed whales into the air like balls—living in comfort in houses at the bottom of the sea.

Part of this respect for swordfish continues today as modern Chumash have revived their ancestral culture with the swordfish dance. Archaeological excavations at a late historic period Chumash settlement revealed evidence of an individual who had communicated with these commanding spirits. Undoubtedly a person of vision, this Chumash dancer was buried with a swordfish's long beak, thought to be part of a striking mask, placed in front of his face. An array of abalone shell adornments was found nearby. Carefully manufactured, the iridescent shells lay in an overlapping pattern suggesting that they had once decorated a special costume. Each was drilled for attachment to a costume. Because the bill was found adjacent to the skull, archaeologists believe that it was once part of a ceremonial mask, long since deteriorated.

▲ *Jornada-style animal with body hatching at Three Rivers, southern New Mexico.*

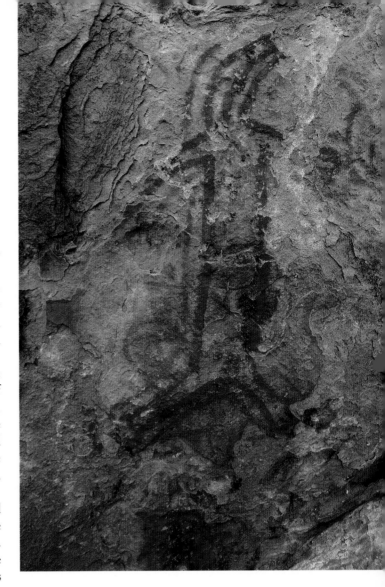

Returning to the California Dream gallery, the dramatically woven sequence continues with an image of the Sun—believed by the Chumash to be an old man who walked across the sky holding a torch. About the same time Nellie Bromley enjoyed Painted Rock, the wide-ranging anthropologist John Harrington collected a Chumash story about gambling against the sun. This ancient tale gives life to the dominant solar panel at the center of Painted Rock by telling us that our lives are controlled by the sun.

In the world above us, the Sun plays a deadly gambling game against Sky Coyote. Each night, the players gamble until dawn's glow. Night after night, the game continues until the year ends with the winter solstice in December. Then, Sun must change his path for the new year. At the day when Sun stands still on the horizon, both sides stop to count their points.

Sky Coyote wants the same winnings that people enjoy on earth. He convinces Sun to bet trees full of hard acorns, herds of fat deer, great flocks of ducks, noisy geese, and small plants full of tasty seeds. By the end of the game, after hundreds of evenings of gains and losses, the stakes are high. If Sky Coyote wins the gambling game, these foods fall to earth with the rains, and the Chumash live well.

But Sun is a clever player. Some years he wins. And Sun counts his winnings in human deaths. Sky Coyote tries to protect us. "Take the old ones," he tells Sun. "They lived their days." But Sun argues back. Just like the game that determines our food and fate, this argument affects those dwelling on earth. When Sun wins the argument, young people die as well as the elders. When Sky Coyote persuades Sun, only the old people are taken as winnings.

The following year, when Sun wins, the hills become drier each day. Birds fail to arrive. Plants give no seed. People die day after day, while Sun takes his prizes. Each evening, Sun returns home with those people who have died from the drought. Sun tucks the adults into his belt. But Sun, a mean old man who walks across the sky, carries children under his feathers, held tight by his headdress. Reaching home, Sun and his family cook them all.

This is our fate, determined in a game played by the immortals. Each day we try to figure out who has won, and if we are wise, we try to influence the sky dwellers. They hear our small voices on the wind as we speak to them from the sacred rocks.

When Nellie Bromley first entered Painted Rock's resonant chamber, she stood in the presence of the Sun Dancer panel in its full glory. Today, this scene is barely discernible. Enduring sketches done by Nellie Bromley's sister preserve memories of the undisturbed galleries. These drawings, along with a fortuitous visit by a turn-of-the-century photographer, have left us with a memory of California Indian art now diminished by vandalism. In slightly more than a century, the Sun Dancer panel and the California Dream panel have nearly disappeared. It was not the natural scouring of wind-driven sand that scrubbed Chumash caves and galleries clean of their dreams. At Painted Rock, dozens of rifle and shotgun blasts—the work of contemptuous visitors—shattered these most elaborate Chumash dream images. Along with these scars, literally hundreds of names are chiseled, scratched, carved, and painted across the inside walls of Painted Rock—once a sacred Chumash shrine.

▲ *The Chumash portrayed coyote with a long snout. This pictograph has been painted over an earlier coyote image. Willow Springs, California.*

GRAFFITI AND PRAYERS

Despite its malicious appearance, much of the graffiti at rock art sites originated from innocent intentions. I have spoken with the person who, in the 1930s, painted her name across the great Mishi-Peshu panel at Agawa Rock. She was the daughter of a fishing family living on a nearby island. Like many individuals, she thought the pictographs were a form of graffiti without particular merit. The urge to create monuments to ourselves is a basic instinct. Pioneer families meeting the challenges of the Oregon Trail marked their passages on Inscription Rock. Near the remote Royal North West Mounted Police outpost at Writing-On-Stone, Alberta, the troops left their names carved into Signature Rock. The dated, personal roll call of mounted policemen endures on the same sandstone outcrops once used for tribal purposes. During long periods of inactivity between quelling Indian raids and capturing Montana whiskey traders, the men relieved their boredom and honed their marksmanship on the images of their foes—the Blackfoot horse raiders and shield-bearing warriors carved into Writing-On-Stone.

Today we look back and regard some of those worn, carved names as part of our national heritage. But graffiti generally signals a decline in a rock art site's integrity. Just as litter invites more litter, a painted or scratched modern name often incites a frenzy of

▲ *Graffiti at Writing-On-Stone, Alberta.*

▲ *Extensive, intentional damage from gunfire at Painted Rock, California.*

unwanted inscriptions. Conservators have made remarkable, yet time-consuming and expensive, attempts to remove painted vandalism. Carved graffiti is more serious—it generally cannot be removed and may further weaken the rock.

COLORING OUR PERCEPTIONS

Even though rock carvings appear permanent, they deteriorate over time. Petroglyphs, by their very nature, contain the seeds of their own destruction. Through nature's abrasive forces, the hardest rock can be reduced to the finest sand and gravel—today's sandy beaches are mountains undone.

Along with the forces of nature, the desire of curious individuals to see rock carvings more clearly has led to irreversible losses. In every state and province that is rich with rock art, petroglyphs have been forever disfigured. Visitors have filled the venerable grooves with chalk, paint, and wax crayons to create a better contrast for photography. Unknowingly, these acts of "enhancement" were consumptive—they greatly reduced the lifespan and informative value of each altered petroglyph, and obliterated its aesthetic value in the process.

Sadly, the legacy of the chalk-wielding enhancers is not limited to carvings. At the Tule Indian Reservation, a group of well-preserved, easily visible paintings in the Sierra foothills was outlined in white chalk. Since past native artists employed white pigments in their multi-colored creations at this site, the modern chalk outlines distract the eye from the real images—a truly fascinating collection of animals including a coyote or panther pushing the sun with its snout, an owl larger than a person, and other characters from Yokuts tribal mythology.

At the Peterborough Petroglyphs, the vast Algonkian dreamer's site situated a few hours from Toronto, the marble rock outcrop bearing hundreds of lively images remained pristine for nearly 2,000 years. Maintained as a religious shrine by local Indians, the site, also known as the Teaching Rock, came to the attention of the uninitiated in the 1950s. The discovery was exciting, and parties of interested people hiked to the site. At first they simply took photographs, but then, perhaps trying to improve the contrast or imitate archaeologists who studied the site using powdered charcoal to temporarily fill the grooves, visitors started filling in the carvings with black crayons. Unknowingly, the crayon-wielding admirers colored the rock with their own

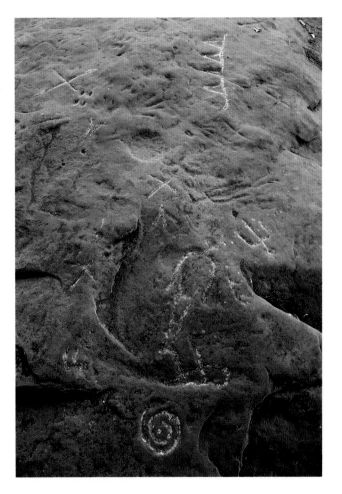

perceptions. Later, we will learn how a number of false interpretations resulted from mistaken identifications made during this time. The coloring party has been over for nearly 40 years, yet the black crayon continues to mask and alter the carvings.

A sunny afternoon is perhaps the worst time to study many petroglyph sites. When the sun shines, petroglyphs fade. Shallow carvings and older images slightly worn by time are best revived by the low light and shadow of early morning or evening. When the crayons were used at Peterborough, we were left with a permanent and often inaccurate interpretation of this complex site.

A striking, human-like figure with a radiating halo of short lines stands surrounded by several suns, a turtle, thunder, and other recognizable spirits. This unforgettable solar image has been featured in several books about shamanism, used for comparative purposes, and generally adopted as a logo for aboriginal rock art.

A careful piecing together of evidence by a group

▲ *Chalked petroglyphs, Sanilac County, Michigan.*

called Friends of the Teaching Rocks has raised doubts about several petroglyphs at the site. The early filling-in of the carved areas effectively froze one person's interpretation, regardless of its accuracy. The true solar deity may be different from the popularly shown figure. There is some suspicion that the body may actually be a spear-throwing device, but the problem remains unresolved.

Another controversial carving at the Teaching Rock, an elaborate canoe with an anchor and an apparent ship's mast topped with a solar figure, has been interpreted by some individuals who ignored the achievements of Native Americans as a Viking ship—supposed evidence that Norse traders were responsible for this rock art site and others. This false viewpoint relies on weak evidence and arrives at an absurd hypothesis. Fortunately, photographs from 1961, collected by the "Friends," clearly show a plain canoe with vertical line occupants, similar to hundreds of painted and carved Algonkian canoe images across the Great Lakes. By 1967, photographs of the same petroglyph document a water craft enhanced in size and detail by black crayon. This is the fate of rock art changed by modern hands—interpretive controversies are created that only distract us from the art's native wisdom.

FLOODING ANCIENT GALLERIES

At Diamond Lake, one of the first pictograph sites formally recorded in Canada, a sparkling wall of quartzite contains a series of exceptional paintings. In addition to its inherent cultural interest, this site enables us to document the effects of flooding. The Diamond Lake site was recorded in 1907, prior to the flooding of the lake by logging companies. Sketches show dozens of animals, canoes, human figures, and abstract designs, all clearly visible at the time. Then, without concern for the native families resident on the lake—this unbelievable treatment of aboriginal groups

occurred in the *1950s*, not the 1850s—the local government allowed the timber barons to raise the water level. For several decades, old-growth white pine logs were floated away to distant sawmills. During that period, most of the Diamond Lake site remained submerged.

Selwyn Dewdney, the pioneer of Canadian rock art research, made the second scientific visit to the paintings during the time of high water and noticed several submerged red ochre figures. By the later 1970s, the wooden dam had rotted, and Diamond Lake fell to its natural level. On sandy points and rocky islands, prehistoric campsites emerged from the former flooded zone. The formerly inundated rock art panels had withstood many seasons beneath the lake without change—thanks to the durability of ochre and quartzite.

With the unforeseen preservation of Diamond Lake's painted heritage, similar results were expected at the site on Horwood Lake, an extensive Y-shaped body of water at the southern edge of the Arctic drainage basin. Horwood Lake was dammed for hydroelectric power in the 1930s. Since then, the water level has fluctuated enormously—it was raised in the fall and lowered during the late winter, when power demand peaked. Unfortunately, out of the hundreds of spectacular images once found at the Horwood Lake Dreaming Rock, only a single painting survived 60 years of annual submersion and emergence along with springtime scouring by shore ice.

Power companies have envied the free-flowing rivers of the sub-Arctic since the 1930s. Horwood Lake was a small-scale precursor to the later James Bay projects in Quebec—where entire tribal harvesting territories became submerged because of power dams.

Despite the hard work of restoration specialists and careful planning by tribal and non-native government agencies, one more ingredient is necessary to preserve the painted and carved visions of the past—better public awareness and education.

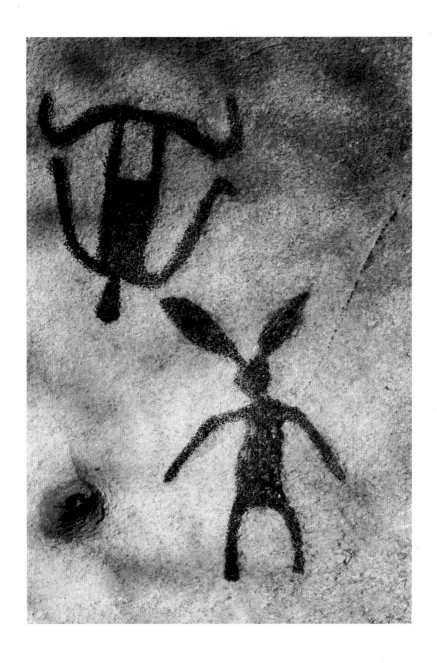

▲ *Petroglyphs filled with wax crayon. The Teaching Rock,*
Petroglyphs Provincial Park near Peterborough, Ontario.

Sacred Landscapes

In the northern woodlands, the erratic distribution of rock art has perplexed anyone who has searched for the elusive pictographs. Why has it been so difficult to predict the distribution of rock art sites? The Ojibwa and Cree shamans obviously preferred to record their dreams on sheer lakeside walls, but why would so many seemingly ideal locations remain unmarked, while the same type of cliffs and ledges only a few miles away bear red ochre symbols?

The solution becomes simple when we learn to recognize sacred space, and then complicated again as we ponder the clever metaphors so poetically spoken by tribal shamans. For a long time I, like many others, treated rock art sites as distinct phenomena—unique expressions of native spirituality. My isolationist view was changed when the Elders revealed that pictographs and petroglyphs are a part of the detail woven onto the fabric of a spiritual landscape—a dream world filled with shrines, vision quest locations, animate rocks that spoke, immortals turned to stone and brought to life through mythology. Rock art sites suddenly became links in an entire spectrum of sacred sites.

▲ *Bowman with peaked cap carved at the Sanilac Petroglyph site in Michigan.*

◀ *One of the most spectacular Chumash pictograph sites lies within a low cave on this hillside at Pleito Creek, California.*

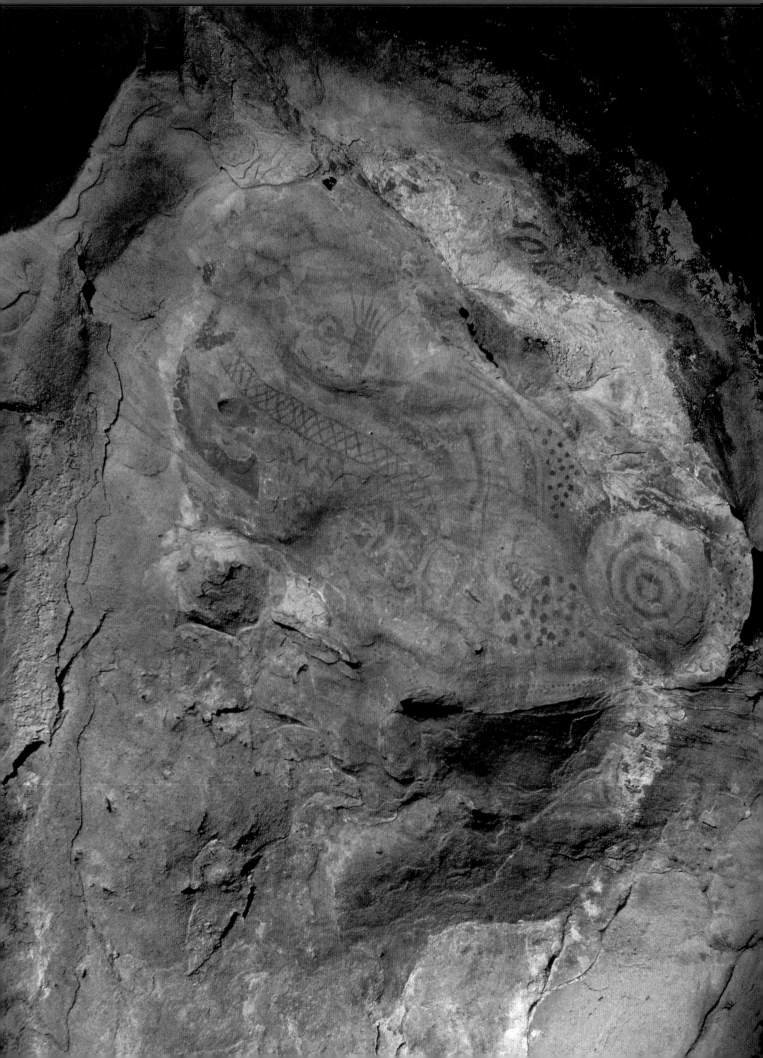

LICHEN DRAWINGS

Lichen glyphs were rock art in its most perishable form. Only the short-lived sand drawings of medicine people in the southwest and southern California are more ephemeral. Lichen drawings remain one of the many mysteries about rock art—an entire, nearly overlooked group of sites. Since most of the dream images engraved onto vast, lichen-covered cliff walls disappeared from view nearly 50 years ago, we must rely upon descriptions left by observant travelers.

The seemingly sporadic distribution of pictograph sites north of the Great Lakes might demonstrate more continuity if we could include the unknown lichen glyph locations. The descendants of Shingwaukonce, who held the secrets of rock art, also revealed the background behind images in lichen. On the lower St. Marys River, in the channel between St. Joseph Island and the mainland, a cluster of picturesque islands once contained shamanic images etched into the crusty, lichen-covered cliffs. The drawings are gone, but Fred Pine pointed out a deep, red-colored wall that once bore the portraits of spirit animals. It still supports abundant lichen growth. Fred affirmed that the presence of naturally red rock covered with a layer of plants was connected by legend to Nanabush, the Ojibwa trickster. This mythological setting was recognized by medicine people as a place for dreams.

Lichen drawings remain enigmatic. We can only imagine the impressive impact they had on travelers passing through the ancient waterways. Oral history and written accounts preserve their powerful presence in our mental landscape.

SACRED SPACE AT ARROWHEAD SPRINGS

As researchers begin to understand the cultural and ceremonial reasons for rock art site choices, better models for analyzing site locations evolve. The presence of the sacred is the essential condition for a rock art site. When sacred qualities were recognized, rituals—whether individual visioning, fertility rites, coming of age ceremonies, or even sorcery—took place at the site, followed by the creation of permanent images cast onto stone.

Hidden within the chaparral-covered slopes high above Santa Barbara, a few of the numerous sandstone boulders hold evidence of secret, ritual retreats of the Chumash Indians. When the first Spanish explorers leapfrogged their ships from point to point along the California coast in 1542 and again in 1602, they met a tribe responsible for creating some of the finest rock art anywhere. The curtain of history then dropped over the Chumash for 167 years until, in 1769, the military, clergy, and settlers returned from Mexico to establish missions and ranches. In the interval, disease and perhaps warfare forever changed the Chumash landscape. Sometime during that span, the walls of Arrowhead Springs may have echoed the last sounds of the shaman's flute and rattle.

Change came with a vengeance, including forced relocation of Chumash groups and the suppression of aboriginal ritual life—although mission records suggest that the Chumash succeeded in maintaining sacred shrines until the early 1800s. One such sanctified setting is called Arrowhead Springs.

Today, two rounded, pregnant-looking boulders are joined together at Arrowhead Springs where they rest, almost defiant of gravity, on a steep slope overlooking Santa Barbara and the Channel Islands. Droughts in the 1990s temporarily silenced these springs, but Chumash memories linger in the form of a thoughtfully composed panel of once bright, now fading red paintings. When the paintings at Arrowhead Springs were rediscovered in the 1960s, a stone pestle used to grind seeds was found in a bedrock mortar hole above the stream—a lone item perhaps hinting at an anticipated return.

The Chumash, who once inhabited the coast of southern California from Malibu to Morro Bay, occasionally created panels of rock art in which dozens of interrelated figures were confined within a limited space—dreamscapes playing out the dramas of mythic tales. The painted compositions remind me of a cathedral's stained glass windows or the walls of Asian temple carvings. Like so many rock art panels, the painted sea creatures of Arrowhead Springs give an impression of Native American cosmology frozen across the centuries. Here, a story—possibly several tales—remains locked in the rock wall.

Sitting on a level outcrop a few yards from the pictographs, letting the sense of place enter our minds, a notable presence—sacred space—fills Arrowhead Springs. Although Chumash lore relating directly to this site has not survived, enough indirect hints can be assembled to understand part of the saga. In addition to local lore, part of the answer comes from the universal language of shamanism.

Thousands of miles away in Ojibwa country, where I searched for sacred sites in the vast forests and lakes of northern Ontario, tribal Elders and aged shamans

◀ *Chumash dreams, and possibly a creation myth, are immortalized at Arrowhead Springs near Santa Barbara.*

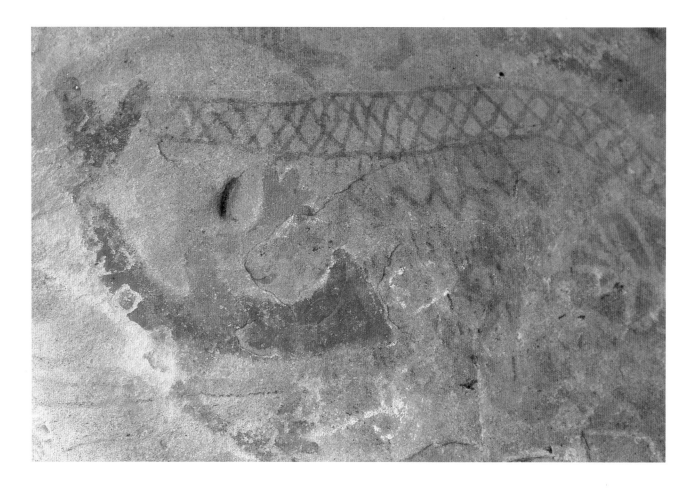

guided me to unexpected locations. Often the hand of nature—through an odd rock formation, a cave, a crevice, or unusual wind sounds—transformed the ordinary world into a ceremonial space. Standing beneath towering stones named *Mindemoya* and *Mishomis Wabkunguk*, "My Grandmother and My Grandfather Rocks," I listened, almost entranced, as "Man Who Sleeps A Lot" told of voices emanating from deep within ancestral rocks. His words formed a bridge between the eternal sentinels and his tribe's identity. In a general manner, this connectedness to the landscape can be applied across native America. "These are my ancestors," he explained, and continued by telling of a connection to the land that was so ancient that the original animals and people were now turned to stone—reminders of timeless legends.

Periodically, we can achieve a better understanding of a rock art setting by considering the larger environment rather than focusing only on the artwork. The paired boulders at Arrowhead Springs overwhelm the unique, triangular panel of amassed red creatures.

About seven feet in height, the painted surface stands out first because of the well-designed, natural white triangle of mineral deposits on the boulder. When mineral-laden water continually seeps down a rock surface, the bone-white calcium particles often remain as a hard-water tapestry.

"I just knew the site had to be here," one of my hiking companions said upon reaching the paintings, after searching the vicinity for 40 minutes trying to relocate the spring.

"Why?" I asked.

"It's different here," he replied. "There's a different feeling." An intangible sense of sacredness surrounds Arrowhead Springs. Other great boulders rest in maze-like concentrations in the vicinity of Arrowhead Springs, yet none bear the same collection of features— a naturally prepared stone surface, a bubbling spring, and an issuing forth of the earth where surface life and underworld energy merge. The earth suggests a story through special settings. Shaman artists acknowledge and express this story through sacred imagery.

▲ *A closer view of the Arrowhead Springs panel shows an unusual creature falling or diving into a sea of paintings.*

To many Native Americans, water itself contains life and soul; springs contain the energies of the earth. Fred Pine advised anyone with a physical ailment to bathe in a spring at dawn—"That's living water, not the still water of lakes"—while Ojibwa medicine keeper Dan Pine told his apprentices that a glass of spring water held high with proper intentions to the rising sun can be a powerful cure.

For some, the gentle seeping of water over pictographs continues to impart life to the prayers and dreams signified by the paintings, long after the rituals leading to their creation have ended. At Arrowhead Springs, the barely perceptible movement of water over the shaded rock wall leads to the entryway of another world. Although abundant wall space is available for rock art, the pictographs are restricted, overlapped, and confined within the limits of the naturally whitewashed wall.

One Chumash account tells how a spring was controlled by two aged men, "the fathers of the water," who sat facing each other with bent knees. These resident guardians, described as having flowing white hair that hid their faces, stopped the running water by straightening their legs. To appease the "spring fathers," the Chumash left offerings of seeds, acorns, and a special painted stick decorated with feathers in a cave.

Chumash rock art is often characterized by a core group of symbols—numerous mandala-like sun disks, images showing shamans flanked by vertical plant-like chains, outlined animals, and thin insects. These images were generally painted symmetrically. It is the ocean animals such as dolphins that come to life in Chumash art. The red ochre representations at Arrowhead Springs embody the same lively movements as the Chumash ocean creatures found at other sites. At first glance, a dark red, blunt-headed pictograph—reminiscent of a salamander—commands our attention. Its forked tail lies across a hatched figure resembling a snake's body. Curving, diving, swimming, the salamander-like figure moves, with its arms extended, toward the center of the panel. Closer scrutiny of this swimming or diving animal reveals an added, fine white outline around its head and hands. From the right hand, a white line ending in a pinwheel design darts out, while a faint white triangle in front of the blunt head points to the center of a weathered sun symbol.

Additional scrutiny leads to another discovery. Among the busy, less perceptible central paintings, another salamander-like animal, outlined and painted

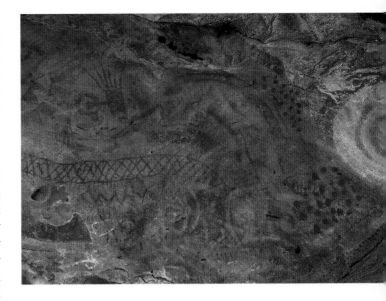

to incorporate negative space, swims or crawls down the rock face. It, too, turns, with an arm overlapping the opposite end of the long, hatched body, to the center of the panel. The head of the second creature is connected by a red zigzag line to the head of the first. Who are these creatures? What are they doing?

The careful composition suggests a union of opposites. Immediately the Yin and Yang concepts of balance, so firmly embedded in shamanism across the globe, come to mind. Are we looking at male and female? Why show polar opposites—full-figured versus hollow-bodied—balanced at each end of an intermediate image, the cross-hatched body? Why is the final composition centered around this hatched figure that may be a snake's body? Before we speculate further, we can collect more clues.

Placed in the upper corners of the Arrowhead Springs mural, thoughtfully balanced circular motifs enhance the symmetry. To the upper left, a classic Chumash sun symbol shines its triangular rays encircling a similar inner design. Four concentric circles, the shaman's vortex, fit into a natural hollow marking the upper right side of the calcite deposit. What balanced energies are these? Sun and moon? Sun seems certain—the Chumash developed an obsessive relationship with the solar power. Moon—perhaps. The balance is more apparent in the Ojibwa language, where moon is called *Debik Ghesis*, or "The Nighttime Sun." We may also be viewing a trance metaphor—vision seeking at the entrance—and vision gained from the luminous Great Spirit. Whatever their meaning, these

▲ *Arrowhead Springs close-up.*

symbols add to the cohesive symmetry of this mystical setting.

Related color symmetry and design appear in a southern California Indian sand painting, illustrated in an early study of initiation rites. Two serpents—one black, the other red—lie on either side of a long oval identified as the Milky Way. Various circular shapes indicate the moon and constellations. While this creation in sand may have illustrated a separate belief—it appears to be a diagram of the sky world—the work also supports the idea of a purposeful arrangement of elements at Arrowhead Springs.

A poorly preserved figure, suggestive of a human shape or an animal, enters the concentric circles at Arrowhead Springs. Is this the seeker? Alice at the mirror? Or a shamanic initiate at the tunnel of light so frequently encountered during near-death experiences? The same imagery rises again and again from the sacred journey, always colored with metaphors of death, light, and rebirth.

Native American lore is filled with stories about springs. Here is a northern shaman's brief account of entry to the dream world through springs. It rings with metaphors of death and renewed life:

I turned to death in the spring's waters. My flesh softened, until I was bone. My spirit, freed of skin and frame, flew through the earth. At the end of my journeys, I reemerged from the spring. Life returned from the sacred waters. I was whole again. Soul joined body; but shadow lingered at the portal to the nether world.

If such interpretations seem too elaborate, consider scenes from stained glass windows where figures represent established legends, abstract moral concepts, and the larger dimensions of faith.

In this complicated rock tapestry, a sense of depth, of images superimposed on earlier episodes, of immense age, also prevails. The calcite sheet is stained from the many applications of complex red ochre images. The final images left at Arrowhead Springs seem to be the grape-like clusters of red dots painted on top of several pictographs. By reference to medical and scientific literature describing trance experiences, fields of dots can be interpreted as evidence of dreaming. Shamans frequently describe entry into the dream world as an experience accompanied by colored lights or rapidly moving points of light.

I have a strong suspicion that the Chumash vision seekers personally experienced this imagery. In one folk tale, a Chumash medicine man captured glowing light at a cliff, entered a tiny hole, traveled through a tunnel, and reached the home of many spirit animals. While there, he saw "a beaver with a cloud of hail around his head." This curious statement can be interpreted as an allusion to being in a trance state, especially since the Chumash sometimes painted human figures surrounded by clouds of white dots at sacred sites such as Condor Cave and Painted Rock.

A few more realistic pictographs add to the overall water theme at Arrowhead Springs. A long dolphin, complete with the characteristic Chumash-style forked tail and forked head, leaps downward beyond the end of the hatched body and just below the hollow-bodied salamander's arm. A long line overemphasizes the dolphin's dorsal fin in a manner consistent with expressing power. Above the dolphin's tail, a squid with an egg sac connected to its body also swims down to the spring. Dozens of nearby paintings fade into the past, while necklaces of tiny red dots cross beneath this activity, followed by rows of zig-zag lines. The lower two-thirds of the Arrowhead Springs panel is nearly lost to us—faded by the elements of time.

Arrowhead Springs suggests a larger question. Why portray sea creatures so far into the mountains, when ample stone formations lie near the edge of the Pacific? The answer seems to be centered on the concept of Arrowhead Springs as a portal to the nether worlds, where the sea creatures can be contacted.

Arrowhead Springs is a reference point for sensing the nature of Chumash spirituality. We visit the spring yearly with friends, to renew our ties to this link between the outer world and its inner forces. In 1992, during the arduous hike leaving this shrine, our group stopped on the trail for a moment. We had been discussing the rock art metaphors we had just viewed and the universal imagery of shamanism. On this stretch, the trail through the thick chaparral widened to provide an unimpeded view of Santa Barbara far below, the broad expanse of the silvery Pacific, and the channel islands covered in bluish shadows. We stopped talking and enjoyed the sight of the heart of the Chumash world.

According to legend, the Chumash originally lived on Santa Cruz Island in the Santa Barbara Channel. Eventually, a powerful spirit created a rainbow bridge to connect the island with the mainland. Chumash families crossed over the bridge to settle along the coastal mountains and sweeping shoreline. A few of the ancestral Chumash lost their balance, falling from the

bridge into the ocean far below. As they fell, these people transformed into dolphins that continue to reenact their magical leaps. This event, which happened so long ago, established the close ties between dolphins and people.

As I looked across the channel to the mountains of Santa Cruz Island, I was able to recreate in my mind a multi-colored bridge arching over the sea to this mainland range. At that moment, I wondered whether the panel of paintings took its theme from the rainbow bridge story. Did the odd creatures, which I describe as "salamanders" for lack of a better term, actually represent Chumash people in the process of falling from the bridge? This would explain their lively diving postures, their forked dolphin tails replacing legs, and their human arms and hands.

Was the hatched, serpent-like painting actually representing the rainbow bridge? Did this site reveal larger metaphors of transformation, of kinship with sea creatures, and of life sources indicated by the bubbling spring waters? The other sea creatures—the recognizable dolphin arching over the end of the possible "bridge," carefully tucked alongside the outlined composite dolphin and person—all these images supported the aquatic theme. These are the possibilities of interpretation when mythology survives to reveal the messages in ritual art. In a scientific sense, this interpretation can never be proven. However, using an intuitive, personal approach—in which visual clues trigger mythological connections and site settings precondition us for a special experience—this magical blend of image and place can be understood.

Other insights into the aboriginal context of rock art sites arrive in the best traditional manner—seemingly by chance. Place name inventories compiled from the last Chumash language speakers on the West Coast were missing for half a century—lost in a museum amid crates of an anthropologist's field notes. When rediscovered, a few names for springs were included among hundreds of landscape designations.

Although the original Chumash designation for Arrowhead Springs is gone, we do realize that the Chumash used both ordinary names for springs, like *Mishtahiwah,* "The Leaker," located somewhere in San Marcos Pass, and "The Emerger" at Santa Barbara, as well as more revealing identities such as the "Song Bird's Waters." Another spring, recognized as a shrine, was colorfully named the "Deer's Urine." Terms like "Emerger" and "Leaker," while descriptive, also hint at

the reason that springs became sacred settings—these normally unreachable, sustaining forces deep within the earth have risen to the surface of the land as life-giving blessings.

ENHANCEMENT

To achieve the impact they desired, artists inspired by trances relied in part on proper presentation. At numerous Dreaming Rocks, paintings and carvings are enhanced by the artist's choice of natural setting. The Chumash were fond of placing their recurring, elaborate paintings of sun disks, concentric circles, and spirals in the recesses of caves and rock shelters. At Piedra Pintada, Arrowhead Springs, and many other Chumash Dreaming Rocks, these rounded images snuggle into concave, bowl-like depressions. The added depth pulls the viewer toward another world.

For the Ojibwa and their neighbors, the long quartz veins so common on granite walls represented places where the Thunderers had struck the earth. The quartz lines attributed to lightning acted as both a blessing and a permanent record of intense spiritual forces. They marked a stone outcrop as sacred earth, in many instances serving as a precondition for rock art. Once the Elders explained these beliefs, we reviewed several pictograph sites and found what we had previously

▲ *A view to Santa Cruz Island from the hillside above Arrowhead Springs.*

overlooked—the heads of horned serpents, favorite prey of the Thunder Nation, had frequently been placed on quartz veins. At Wizard Lake, a broad, glistening diagonal vein of white quartz strikes across the pictograph gallery to intercept a sinuous horned serpent. This intentional placement repeats itself often at Algonkian rock art galleries, and the message becomes apparent: Evil forces are neutralized by the powers of goodness.

On an obscure pictograph wall at Scotia Lake, the paintings seem placed along the multiple quartz veins in a carefully balanced pattern. At such sites, it is easy to remember Thunder, whose voice reflects off the rock art cliffs and rolls down northern lakes. Recognition of Thunder's presence led to a more intensive understanding of native perceptions of rock art sites. Once we learned that Thunder left its mark at many of these locations, the Elders revealed their understanding of Thunder's invisible presence at sacred sites. This breakthrough came, at first, from a study of aboriginal place names.

PICTOGRAPH SITE NAMES

Language carries the fingerprint of our perceptions. Among Native American groups, languages vary tremendously. Yet even a partial understanding of at least one indigenous dialect can sometimes crack the hard shell of our own perceptions. A linguist who worked an entire lifetime on the study of North American Indian speech once described the parent family of Ojibwa and Cree languages with the statement: "Single Algonkian words are like tiny imagist poems." After working with Ojibwa tribal elders and shamans for over 20 years, I appreciated these words, but I still wondered how they applied to rock art sites.

One calm summer day beside a northern lake, with darkened haloes of black flies hovering above us, Elders answered questions about the naming of rock art sites. It became apparent that there are two ways to refer to rock art sites—a general name, *Muzzinabikon* or *Mazinahbeegun*, meaning "Markings On Rock," or less literally, "Writing On Stone," along with specific names for individual sites. Speakers of various dialects gave the term slightly different pronunciations. All Elders knowledgeable about rock art used a root of the word *Mazinahbeegun*—*muzin* or *mazin*, meaning to "mark" or "write" in Algonkian dialects. However, those Elders who understood the nuances of both English and Ojibwa stated that the rock art should be referred to as "marking" rather than "writing" because "marking" implies a symbol or picture-image.

The term *Mazinahbeegun* was familiar, since it has survived as a general place name at Mazinaw Lake in southeastern Ontario, the location of the extensive Mazinaw Lake pictograph site. The Agawa pictograph site on Lake Superior is known as *Mazinaubikiniguning Augawong*, which translates as "Marked Rock by the Lake at Agawa." Similarly, any Ojibwa rock art site could be referred to as *Muzzinabikon*, with a local place name attached as in the Agawa example.

The second method for naming rock art sites includes the specific, individual names for specific locations. While conducting studies among the Ojibwa, I recorded place names of rivers, lakes, mountains, village sites, shrines, quarries, travel routes, and portages. This place name research led to the discovery that all pictograph sites were once individually named. Seventeen rock art sites have been specifically identified by native Elders in this manner.

Cliffs, simultaneously soaring into the sky and dropping precipitously into the darkness of northern lakes, provide a figurative bridge between aboriginal worlds. The immortals dwelling in the sky realm, far above the visible blue vault, soar down to earth through the Pleiades, known as Hole-In-The-Sky. A majority of the specific rock art site names refer to birds of prey or other large, high-cliff nesting birds. Several Algonkian shamans have explained how they regard the birds residing at pictograph sites as metaphors for thunderbirds. Ravens, hawks, and eagles continue to inhabit several of these rock art sites. Their presence may have contributed to the original selection of a rock art cliff. Shamans speak of these soaring birds as links between the physical world and the spirit realm.

Two rock art sites in the Lake Temagami area, and another on the Lake of the Woods, are called *Kah-Kaw-Gee-Wabikong*—Raven Rocks. The name is very simply constructed. *Kah-Kaw-Gee* identifies raven, while *Wabikong* means a white cliff on the water. The white in the word *Wabikong* refers to bird droppings on the rock. Whenever ravens or hawks nest on a cliff ledge, the area below the nest is streaked white by their excrement. Ojibwa shamans gradually revealed that the word *Wabikong* works as a metaphor as well as a direct description. The active nesting sites of hawks and ravens are easily located by the white stains below the ledges. To shamans, active nests indicate the presence of unseen thunderbird spirits. In a broader application, the

▶ *At times, unusual rock formations have inspired native mythology. Writing-on-Stone, Alberta.*

large, natural deposits of white calcite, which often streak the cliffs, could only have originated from some powerful, mystical source—unseen thunderbirds. Stories of the Thunder People—another term for thunderbirds—were often told by Ojibwa Elders. It was said that the Thunder People intercede like warrior angels into the affairs of tribes on earth.

The thunderbird metaphor extends to other aspects of the eastern woodlands' sacred realm, in the form of prayer pipes. The long ceremonial pipes, carried with reverence by medicine men, often wore a bird-skin mantle, so the ascending smoke appeared to come out of an eagle's or hawk's mouth. Thunder resounds throughout the lands of the Algonkian and Iroquois tribes. In fact, thunderbirds are a common feature of rock art in the Great Lakes area and the Ohio River valley. At the northern range of Cree rock art territory, a site on the Churchill River shows a keyhole-shaped human head and skeletal neck with a long pipe near its mouth. Thunderbirds are displayed on both sides of this medicine person, one directly over the pipe.

The Algonkian habit of naming rock art sites after large birds is not surprising, since many of the physical locations represent invisible nesting areas for the resident thunderbird spirits. Other bird names recorded for rock art sites in northern Ontario include *Kekekonce-Agenda*, or "Home of the Little Hawk," and *Wabi-Se-Gong*, which can be translated as "White Swan Rock" or "Shining Rock." A spirit-haunted cliff on the Ottawa River was ominously named "Vulture Rock." Rooster Rock, where Indian medicine men heard strange clicks and crowing sounds emanating from the stone, may have once referred to an indigenous, chicken-like bird, such as the ruffed grouse or the prairie chicken. The latter lives only in a small area of eastern Canada within 50 miles of the site.

True chickens arrived in Ontario during the historic period; but the native term for ruffed grouse, *pinesi*, also served as the generic word for "bird." Native tribes, whose skilled use of language offers the most subtle nuances, could have subsequently substituted the English word "chicken." In a similar manner, the generic *peshu*, meaning "lynx" or "cat," was often translated as "lion" once the Ojibwa learned about lions from the British coat of arms and other sources.

Across the Ojibwa homeland, large, dome-shaped rock formations resembling immense beaver lodges have been named after Misamicko, the giant mythical beaver who roamed the land at the time of creation. Indians regarded this creature, which lived prior to the first destruction of the earth, as responsible for shaping the land. As the age of creation ended, the giant beavers and their lodges turned into mountains. At least two pictograph sites are associated with these mythological landscape features. Both are named *Misamickenda*—literally, "Home of the Giant Beaver." Several other Beaver House Rocks, such as the suggestive profile of a swimming beaver south of Agawa Bay on Lake Superior, were never marked with ritual art, but they represented sacred space pre-conditioned by tribal lore for ritual treatment.

Other rock art site names are more difficult to interpret. On Upper Grassy Lake, in the Mattagami band's territory, a small pictograph site is named "Pike Cliff." I have been unable to uncover the cultural implication of "pike," a voracious fish common to northern lakes. Pike does not appear in mythology or religious symbolism. In the same area, a large rock art site has the puzzling title, "Gateway of the Windigo." This site may have some connection to tales about a greatly feared ice giant who devoured Indians, but direct evidence has not been collected.

SAPAKSI—HOUSE OF THE SUN

Concerns about the sun fill the surviving examples of Chumash mythology. The Chumash sun is not the illuminating giver of wisdom honored by the Sioux tribes in the holy Sun Dance. The sun personage who affected Chumash lives was a harsh master who balanced blessings with destruction. Despite the Chumash image of the sun as a hungry old man with victims tucked tightly underneath his belt and headband, the Chumash retained a poetic sense of this imponderable creation. The stories of Fernando Librado, one of the very last Chumash Elders connected to the past, provide a key link between mythology and the rituals that inspired rock art. He called the sun the "beauty of the world" and reported that the Chumash saw dawn as the "breath of the sun." Another of his observations, jotted down prior to his death in 1915, has intrigued rock art researchers. At night, he wrote, the sun enters the hole of a sand dollar. Before resting until morning, the sun places its rays outside of the sand dollar's opening. This image was inspired by the sand dollar's sun-like design, and by Pacific sunsets and sunrises so poignant that the flags of Japan and British Columbia continue to honor this sight—a lush, glowing sun with long rays cast outward.

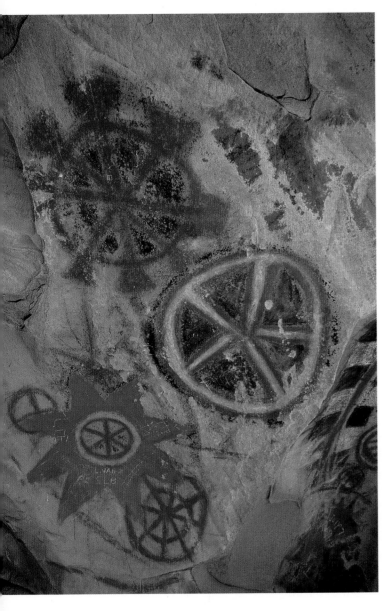

Archaeologists took this description of *Sapaksi*, searched the high ridges and natural clearings in the Sierra Madre mountains near Santa Barbara, and located a cave in the area described as the setting for The House of the Sun. There, numerous pictographs, varying from well-preserved red and black images to partially intact examples of bears, lizards, a dolphin, and several other animals, lay gathered together in a small cave.

The portrait of the sun, painted over a jumble of earlier works, remains visible on the ceiling of this cave. Surprisingly, for a sun symbol at the very House of the Sun, this representation looks like a wagon wheel with numerous spokes. More dramatic suns have been recorded at other Chumash caves. But the image and site remain one of the few directly mentioned by the last generation of Chumash partially following aboriginal ways. For the other examples of Chumash heritage, we rely upon more indirect identifications.

Intriguing Chumash caves—still undiscovered and possibly filled with painted dreams—tease us with their suggestive names: "The House of the Wind" near Gaviota Pass; a second "House of the Sun" on Red Mountain; a hilltop shrine called the "Eater of People" near Ventura; and the long-lost "House of Dogs." While we may never share the traditional wisdom of these special settings, *Sapaksi* offers one window through which we can look back several hundred years into the central part of the Chumash world. Its story reaffirms our assumption that mythology also illuminated the Chumash Dreaming Rocks.

ADORNED ROCKS

Sometimes, rock art offers the subtlest hints about ceremonial lives. The dazzling pictograph composition at Arrowhead Springs contains a few lines of a natural tar called asphaltum. This black, sticky substance washes ashore on beaches along the Santa Barbara Channel. Chumash crafters used this easily collected adhesive for a variety of purposes. At the twin boulders of Arrowhead Springs, traces of tar run across the top of the painted rock face. Did a woven mat, a veil of secrecy, once hang across the red ochre images? Like ruined castles left barren without their original tapestries, candles, music, and elaborate costuming, the sacred sites we see today can only hint at what most likely existed—elaborately decorated ceremonial settings.

Again, remnant place names suggest that these

In the cosmological world of California's Chumash Indians, very few rock art site descriptions have survived, frozen in a language now extinct. One of the locations mentioned by the last individuals to speak the Chumash language was The House of the Sun, the famed *Sapaksi*—a place where, according to legend, the sun retired each evening. Although the person interviewed had never seen the site, she told of a fabled place where eagles, falcons, bears, and ravens could be recognized as rock formations near a cave called *Sapaksi*. The same animals were reportedly painted in the cave, where the sun was also prominently displayed on its wall.

▲ *Imaginative solar symbols illuminate the east wall and ceiling of Painted Cave near San Marcos Pass, Santa Barbara, California.*

▶ *The horse and rider panel, painted by Fred Pine's grandfather, Shingwaukonce. The physical setting mirrors the earth spirit encountered by shamans. Agawa Rock, Lake Superior Provincial Park, Ontario.*

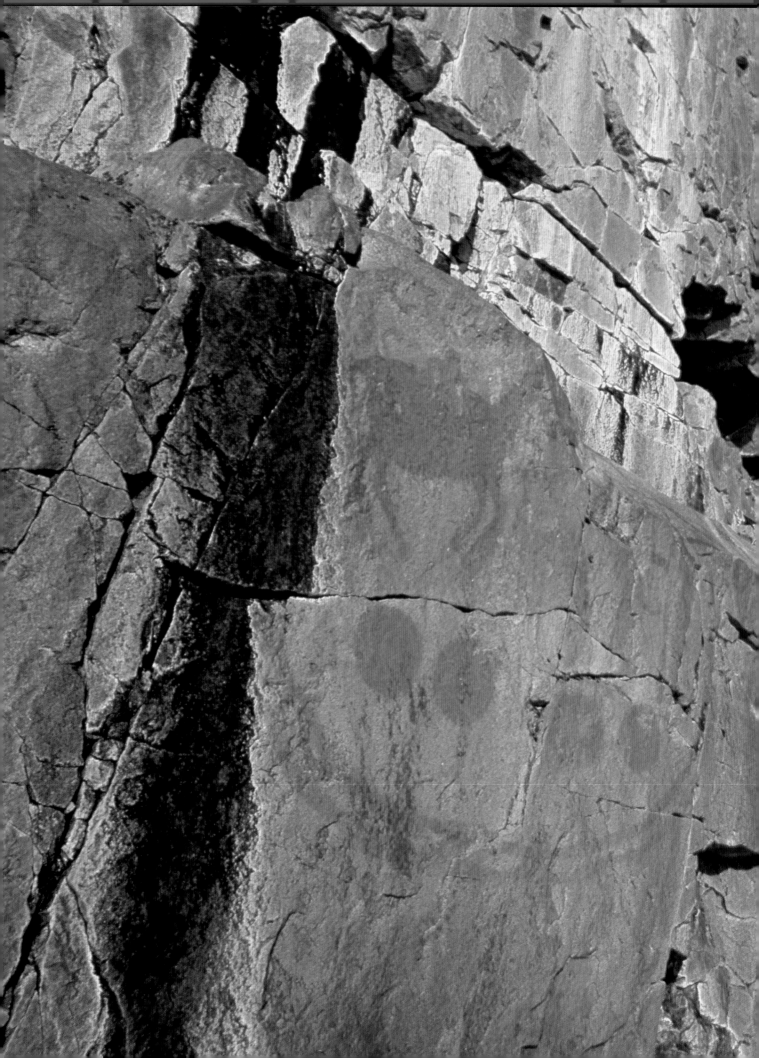

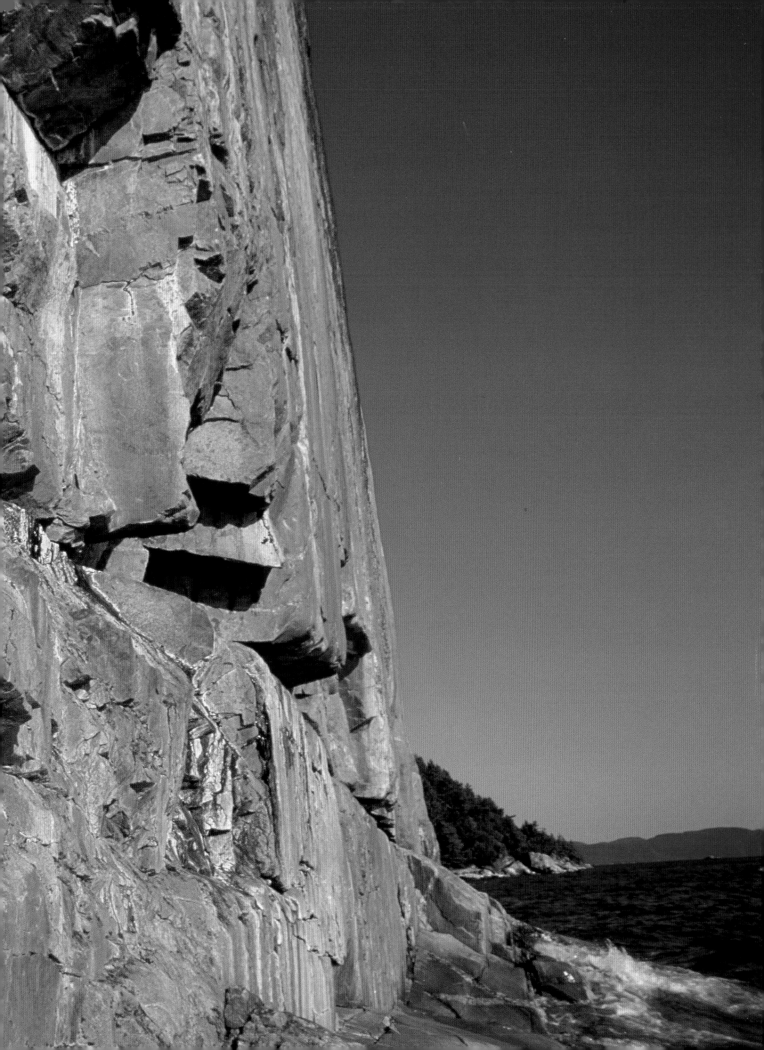

natural shrines and holy grounds once wore ritual garments. Parallel evidence comes from a place name used by the Santa Ynez valley Chumash, who called a mountain shrine *Owotoponus,* "Adorned With Plumes." At the very edge of the Chumash world, west of the San Fernando Valley, another mountain shrine was called "The Banner Is Waving." These lingering names add dimension for those attempting to understand shrines.

Far to the east on the Great Lakes, the daughter of the last Hudson's Bay Company fur trader to live among the Agawa band of Ojibwa dictated her memories to a newspaper reporter in the early 1900s. She included a vital clue to the adornment of Algonkian rock art sites. "According to custom," she said, "the Indians used to take the bones and heads of the bear they killed out to Agawa Rock and decorate them." This meager account opens a door to images of rock art sites filled with tribal activities.

Pictographs showing bears are not particularly common in the rock art legacy found north of Lake Superior. At Agawa Rock, where bear cult ceremonies took place, a mirrored pair of diminutive bears faces each other on the still, grey cliff. Did the "bones and heads" of black bears once hang from this wall? Ojibwa and Cree hunters continue to follow this custom in remote areas.

FAIRIES

Wherever doorways to the supernatural appear on the landscape, fairies will be found nearby. In California, tribes spoke of "brownies," a race of elves who magically made rock art appear overnight. The Micmac of the Atlantic coast believed that tiny people called *Hamajalu* produced the sharp-lined carvings at Kejimkujik Lake. Ojibwa paddlers frequently met a race of elves called *May-May-Gwashiuk,* whose lives were filled with hunting, fishing, dancing, and rituals—lives similar to those of the Indians. These supernatural creatures, identified as Little Wild Men or fairies, were the subject of much folklore at rock art sites. At least three pictograph sites in northeastern Ontario—Horwood Lake, Fairy Point, and The Maymaygwashi's Door—have been identified as *May-May-Gwashi-Wabikong* or "Fairy Cliff on the Water." All are associated with these little people, who act as intermediaries between the spirit world and the physical realm.

Reports of fairies certainly preconditioned a rock outcrop for recognition as a segment of the sacred landscape. John Fisher, who has lived on Lake Nipissing

for nearly 90 years, recalled stories about native people sighting the *May-May-Gwashiuk* at a cliff across the lake from his home. He believed that the straight, grey cliff in the sandy bay was a spiritual location:

The only place the May-May-Gwashiuk lived around here was a high rock in Campbell Bay. It's called May-May-Gweys-Wo-Kung. My mother used to tell me about it. Tales. I know they used to be there. People used to see them. The Indians could never talk to the May-May-Gwashiuk, or see them close enough. When the May-May-Gwashiuk see other people, they go right in the rock. That's the way. The Indians were trying to see them, but they couldn't.

A few years after our meeting with John Fisher, my wife and I traveled long miles up the French River to reach the south side of Lake Nipissing without crossing its gusty, open waters. One of the finest potential pictograph site settings stood at the base of Campbell Bay, where a cliff possessed the attributes favored by Algonkian shamans—it was well-lit, and it had smooth, vertical rock walls. As we slowly cruised along the base of "The Fairies Cliff on Water," as John Fisher had called it, we were not surprised by the absence of pictographs. John Fisher would have known if rock art once existed, for he had described the locations of each red ochre painting on Lake Nipissing. But the visit to the barren walls was important, for it established a link between rock art sites and closely related spirit rocks.

When French explorers came upon the natural pot holes bored into bedrock by glacial waters, the Europeans exclaimed, "Les Chaudiere!" Translated today as "Kettle," in the 17th century a *chaudiere* meant

▲ *Cupules cover a rock at Dug Bar in Hell's Canyon on the Snake River, Oregon.*

a steaming pot. The analogy was suitable, as most of the pot holes occur beside present-day waterfalls whose cool spray resembles steam from a distance. Native people also nicknamed the pot holes after their clay cooking pots, simply *Akik*—The Pot. The metaphor extended further as shamans recognized pot holes as another opening into the supernatural underworld. Since many pot holes held status as sacred or special locales, I was not too surprised when John Fisher, last of the Nipissing tribal Elders, identified several of these natural stone basins as shrines where he and his ancestors left offerings of tobacco. The Little Wild Men collected these offerings and smoked the tobacco in their tiny pipes as they relayed to the spirits the prayers left with the gift.

On Little Missinaibi Lake, where waters flow north to the Arctic Ocean, a large glacial pot hole measuring 18 feet in diameter was transformed into a rock art site. Some time in the past, the lakeside wall of this kettle rock broke away, leaving a curved rock chamber recessed into the cliff. Although these features are often mentioned in native folklore as entrances to the spirit world, the Little Missinaibi pictograph site is the only known pot hole containing Algonkian rock art. In the volcanic terrain of northern California, the same aboriginal logic appears in a series of lava tube chambers such as Fern Cave in Lava Beds National Monument, where spectacular paintings line the hidden chambers.

When we consider how meaningful natural depressions, caves, and pot holes were in aboriginal cultures, the creation of smaller-scale, carved depressions is not difficult to understand.

LITTLE CUPS AND RAIN ROCKS

In order to better comprehend how some outcrops and boulders were chosen to bear rock art, we need to visit a series of cousins to painted rocks. Throughout the length of California, at widely scattered locations, masses of small, cup-like depressions mark the surfaces of bedrock and boulders. These carved pits are called "cupules" by archaeologists. The small, pecked pits range in size from a thumb print to a Chinese teacup. In addition to cupules, quite a few sites have also had grooves or lines scratched across their surfaces. Native people, recalling distant memories of their use, greet these sites as "rain rocks" or baby rocks.

The stones appear to be covered with dot-like indentations. On boulders, the cupules often lay in random disarray. At more formal settings, such as rock art sites associated with vision questing, the cupules are sometimes found in systematic patterns.

Like other types of rock art, the mysterious, dimpled boulders of the western United States may have had several unrelated origins. One of the problems in understanding the role of cupules may lie in referring to them as rock art. They may relate more to individual records, or statements of an activity completed—like lighting a candle in a modern church after prayer—than to a direct expression of an important religious concept.

Are rain rocks and baby rocks truly rock art? Here definition depends upon interpretation. These select rocks are part of the sacred landscape, offering focal points for communication with the forces that guide nature. While they may be records of events rather than art—even though a few sites do contain grizzly bear tracks carved amid the cupules—the rain rocks and baby rocks remain important elements in the rock art

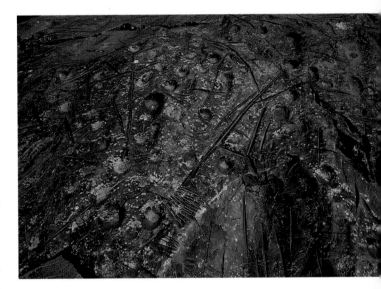

narratives. Fortunately, native men and women continued the traditions that produced these carved pits and grooves into the historic era.

California tribes that lived within view of sacred, snow-covered Mount Shasta spoke of rituals devoted to weather control. In ceremonies last performed a century ago, the Karok and Shasta aboriginal groups honored a special boulder thought to have power over rains and snow. According to their needs—whether ending a drought or beseeching nature for snow—an Indian would make a series of pits or grooves in a special rock. Long, parallel lines requested snow; a slash across these

▲ *The intensive mixture of cupules and incised lines on the Cloverdale boulder suggest long use on the Russian River, northern California.*

97

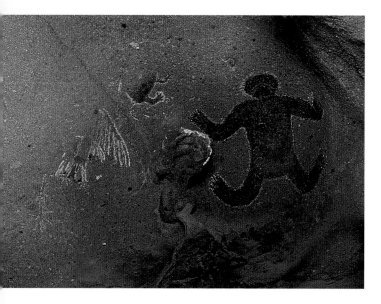

San Luis Obispo, the small, carved depressions appear on boulders far from any recorded rock art, yet within view of a traditional site.

Among the Chumash tribes, the use of cupules crosses over into the realm of art. Far above the coastal and inland valley villages, amidst the wind-scoured, ridgetop sacred caves where the Chumash *antap* cult members gathered in seclusion to pursue their narcotic dreams, the use of cupules became more sophisticated, or at least more purposefully displayed. In contrast to the village cupule stones, several prominent Chumash religious sites containing special pictographs—Condor Cave, Pool Rock, and Painted Rock—display elaborate rows of shallow rounded pits alongside striking paintings. Yet, for reasons unknown, other Chumash sites lack any sign of the tiny, cup-shaped depressions.

WHY A PAINTING HERE AND A CARVING THERE?

Across the United States and Canada, ancient shaman artists chose their stone canvases for special, often subtle, reasons. *Manidoog*—spirit voices—could sometimes be heard at these rocks. Other Native American medicine people recognized the Dreaming Rocks as energy openings in the earth. The Ojibwa speak of "cut rock," where physical and spiritual forces emerge. Often, mythic events led to the creation of rock art sites.

Anyone with a strong affinity for wilderness may at one time or another have wished for an Indian guide who could share a mix of natural history, spirituality, and personal experience. In 1982, my wife and I decided to follow the intuitive forces that often linger on the edge of conscious choice.

We were studying a painted cliff in the north channel of Lake Huron, known locally as Rooster Rock. Recording the site was a pleasant experience. Paddling beneath the overhanging cliff as rivulets of water streamed down the rock, we found 11 inconspicuous pictographs at Rooster Rock, including a pair of moose or caribou, a thunderbird, an inverted thunderbird image beside an odd branched figure, an abstract ladder-like design, a rake-like linear painting, a dot, two tally marks, and a vague pictograph too faded to identify. The artwork lies less than six feet above the lake waters on a limited span of the half-mile-wide rock exposure, as the cliff soars skyward, ending at a plateau and an operating uranium mine. At one time, I would have dismissed this modest pictograph site as a minor collection of paintings

sought an end to winter weather. Placing more pits into the rock brought rain, while incessant rainfall could be terminated with a simple act—covering the rock.

The Pomo tribe, which inhabited the area just north of San Francisco, left us an account that not only sheds light on the use of "baby rocks," but also shows the futility of trying to interpret rock art without referring to Native American cultural traditions. After a four-day fast, a Pomo woman who hoped to conceive a child would approach a "baby rock" and perform a ritualized series of actions repeated four times. After circling the rock and making contact with it, the woman seeking pregnancy cut four lines into the surface. The dust created by these fresh grooves was gathered like a blessed pollen and sprinkled in a careful pattern on her body. Prayers were then offered, and she rejoined her husband.

Evidence of possible variations of this personal fertility ceremony is found across a wide area. In the Sierra Nevada Mountains—the pine-covered spine that separates California and Nevada—similar rocks bearing clusters of pits and long grooves have been discovered alongside carved representations of feminine sexuality.

Rugged boulders and dome-shaped outcrops are also commonly found in Chumash territory. When archaeologists mapped the distribution of cupule stones, they discovered that the stones were usually associated with Chumash habitation sites. Classic cupule stones commonly occur at villages and smaller campsites, either singly or grouped on adjacent outcrops. Above the beach known today as Pirate's Cove, and at Diablo Canyon within sight of the nuclear power plant near

▲ *Some pictographs are reminiscent of sand paintings. Mutau Flat, Los Padres National Forest, California.*

left by Ojibwa shamans long ago. But that would have been a greatly mistaken viewpoint.

After leaving Rooster Rock, my wife and I drove on a whim to the Serpent River Indian Reserve, in an attempt to collect any surviving oral traditions about these pictographs. We were directed to two Elders of this Lake Huron tribe: Louis Meawasige, born in 1905, and his older brother, the now-deceased William Meawasige, who first entered this world in 1895. Upon arriving at the other end of the reservation, a nephew greeted us and directed us into his uncle's cedar-lined driveway.

After quick introductions, we sat on Louis Meawasige's front porch, among drying braids of the purification plant *Wingiss*, or sweetgrass, whose gentle aroma created a setting for speaking of the sacred. This meeting was remarkable. For two decades, I have collected folklore and aboriginal narratives about rock art. Louie's account stood out as a rich, unexpected living link to the aboriginal world. On that late-summer afternoon, Louie Meawasige and his brother Bill shared their common memories about the mythic events that created painted dreams at Rooster Rock:

Our people used to camp on the islands in that lake. Fishing for lake trout and pickerel. They would hear sounds coming out of that cliff. Sounds like a rooster or a chicken crowing. And clicking sounds. We call that place Ba-Kah-Ha-Kwen-Ganda, the Place of the Chicken.

In the first place, a little child would be put there to dream. When you're dreaming, you stay there for 10 days. No food. No water. Stay at the rock where the markings [pictographs] are, just around the corner there. It's a flat spot where they left that boy.

That's the place the Anishinabeg [Indians] used for dreams. Visions. When the Indians camped there one time, they left a boy on a rock ledge by those paintings. It was a place where he couldn't go anywhere. Cliffs above him. Water in front. He sat on that ledge to dream better.

The Elder went and asked the boy after one day, "What did you dream?" The boy told him. "No. No luck," the old man said.

So the boy was left there another day. Next day, the old man went back to the cliff. The boy jumped in the water. And the water splashed on the rock. The markings came

▲ *Hurricane Deck in the rugged San Rafael Wilderness Area—home to Chumash painted dreams at Bear Paw, Condor Cave, Pool Rock, and Wizard Cave.*

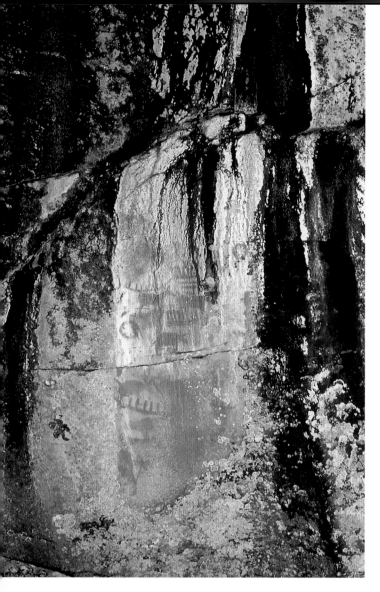

room. And then another room. And a rock just like a couch covered in moss. They saw chicken and cow manure on the cave's floor. But there's no chickens or cows there. It looked like somebody lived there with their animals. The cave was seen long ago, but now it's all covered up by fallen rocks.

This remarkable tale, examined in the light of other stories and living traditions from distant sites, revealed some wonderful insights into the nature of rock art. I returned several times to check the accuracy of my transcriptions with Louie Meawasige. I knew that within my lifetime these remaining Elders, whose lives spanned a long tradition of aboriginal life in the bush followed by a short era of reservation life, would soon depart to another world. Just a few years after our first meeting, Bill Meawasige joined his ancestors. His last gift to us was a retelling of the Rooster Rock story. I asked him about the unseen people who lived within the rock art site.

"They are a different nature of people, the Maymaygwashiuk," he explained. "Maymaygwashiuk used to come out of their cave at Rooster Rock in little canoes to go fishing. Those little people were covered in hair," he continued, "and they spoke the Indian language."

Similar races of rock elves have been reported to inhabit sacred sites across North America. The Ojibwa believe that Maymaygwashiuk act as intermediaries between Indian people and the spirit world. As Chief Norma Fox, a noted Lake Huron native leader, explained, "If you want to make contact with the supernatural, you'd better prepare."

The Meawasige brothers' stories reminded me of the mythic origins of a group of carvings on a island in Nett Lake, in northern Minnesota. In the early years of this century, informed Chippewa traditionalists told a story implying that the rock art appeared when supernatural beings splashed the rocks:

On approaching Picture Island, it was found to be inhabited by innumerable beings that were half fish and half sea lion. Upon the approach of the Chippewa, these became panic-stricken, and, diving into the water, they swam with all speed across the lake southwestward; the Chippewa followed them by the muddied water they stirred up in their mad flight. On reaching the southwestern shore of the lake, they fled up a little creek, and, coming to its source and having been caught as in a net, they dove down into the earth and are there yet.

You can see the water bubbling up [in a huge spring] today where the earth swallowed them up. We know this region as

from that water splashing.

That boy, he dreamt all right. They never got him. The boy swam down to somewhere inside the rock. He's still there. That's why I put tobacco in the water. Because that's where the boy went.

Some people leave things [gifts] on the rocks. They still do that today. That's where people put tobacco in. They wish. They wish like they're going to get something.

I never looked for markings on the rock. I never saw them. But I heard of them. I always left tobacco there when I went through on the way to my trapping ground. If you leave tobacco, expect good luck for trapping.

I crossed that big lake in a canoe. Left tobacco. I was safe. Many times, as soon as I reached the bay at the other end of the lake, those whitecaps would be blowing. But it was calm when I went across. That's what people did.

There's a cave in that rock. A different kind of people live in there. Indians found that cave and went in. There's a

▲ *Ojibwa visions recorded at Cuttle Lake, Ontario.*

holy ground. Because of these beings being caught in a net, we call our lake "Netor As-sab-aco-no" [Nett Lake]. When the pursuers returned from chasing the half fish, half sea lion beings, they found these rock pictures on the rocks of this island. They are the pictures of these beings our people found here.

This tale shares elements with the Rooster Rock story—supernatural beings who live underwater, rock art that magically appears when the rock is splashed with water, and creation of sacred ground by the supernaturals. Dan Pine gave an interpretation of the role of the Little Wild Men similar to those who reside at Rooster Rock. We had been talking about several important vision sites, from the Dreamer's Rock on Lake Huron where young native adults go to meet their spirit guides to Shingwaukonce's fasting and dream retreat at Agawa Rock on Lake Superior. Dan knew the procedures well:

You got to make fire at the base of Dreamer's Rock before going up to fast. The Little Wild Men live there. Make your fire across the lake at the base of the trail before it goes up the hill. Pick up pine cones and dry bark for the fire. Why pine? That's the tree Thunder blesses [strikes with lightning]. The fire with its smoke carries your intentions to the Little Wild Men. They are the go-between—between you and the Great Spirit.

The Little Wild Men want something. They are the people who are going to lead you somewhere. Tell them you are coming up. It's like rapping at the door. Take black gunpowder and tobacco, or a piece of lead shot. Put the gift where you see the little people. They might be hiding behind a tree. As soon as you see them, they disappear. It's the same idea with the paintings on the rocks. If you ask too many questions, the paintings disappear. You won't understand their gift for you. If you don't try to question, the paintings will lead you to your vision.

Fasting is a very advanced education. Scientists try to study the world. The Indian studied more when he fasted. And the spirits taught him. My people studied fruits, trees, animals, and insects. They could interpret signs—clouds, the shape of waves, the color of leaves—every natural sign.

Whoever can go the longest fasting can receive more power.

Ojibwa medicine men and women have offered insights into the selection of sacred places as locations for pictographs or petroglyphs. In tribal territories where detailed documentation of holy ground has been completed, rock art sites fall into the broader context of sacred earth. Many more sacred rocks, home to spiritual forces, exist among the Algonkian homelands than rock art sites. I was always greatly puzzled by the absence of ancient images at seemingly perfect, sheer cliffs on lakes just a few portages removed from existing pictograph sites. My confusion abated as medicine people revealed the prerequisite for both rock art and other sacred spots—a recognition of resident spirits.

Gradually, a pattern emerged. For each rock wall marked by a pictograph, several more stood unmarked but honored. On Lake Temagami and adjacent waterways, where small groups of highly abstract art and bird track symbols are common, the entire landscape changed before our eyes as Kush Kush, "Man Who Sleeps A Lot," and former Chief William Twain, identified several cave entrances to the underworld near Seal's Rock. They also pointed out Mindemoya, the ancestral grandmother stone; Manidoo Island, which capped an evil spirit; the spirit's mountain slide; standing stones known widely as Grandfather and Grandmother rocks; Thunder's Nesting Spot; Spirit Voice Cliff; White Beaver Mountain; and in the distance, the Mountain of Souls. None of these sacred sites contain rock art. Yet they complete the portrait of a sacred landscape that gives life, power, and identity to the Temagami area native people. Each sacred setting offered a gateway to the supernatural world. Most continue to function as shrines where coins, tobacco, and other personal gifts are offered. A few of the more remote sacred sites where vision questing still takes place continue to resonate with the sound of the shaman's drum. There are ancient legends and history associated with each of the Temagami area sacred sites. The natural world of the Temagami Anishinabe springs to life as each story is revealed.

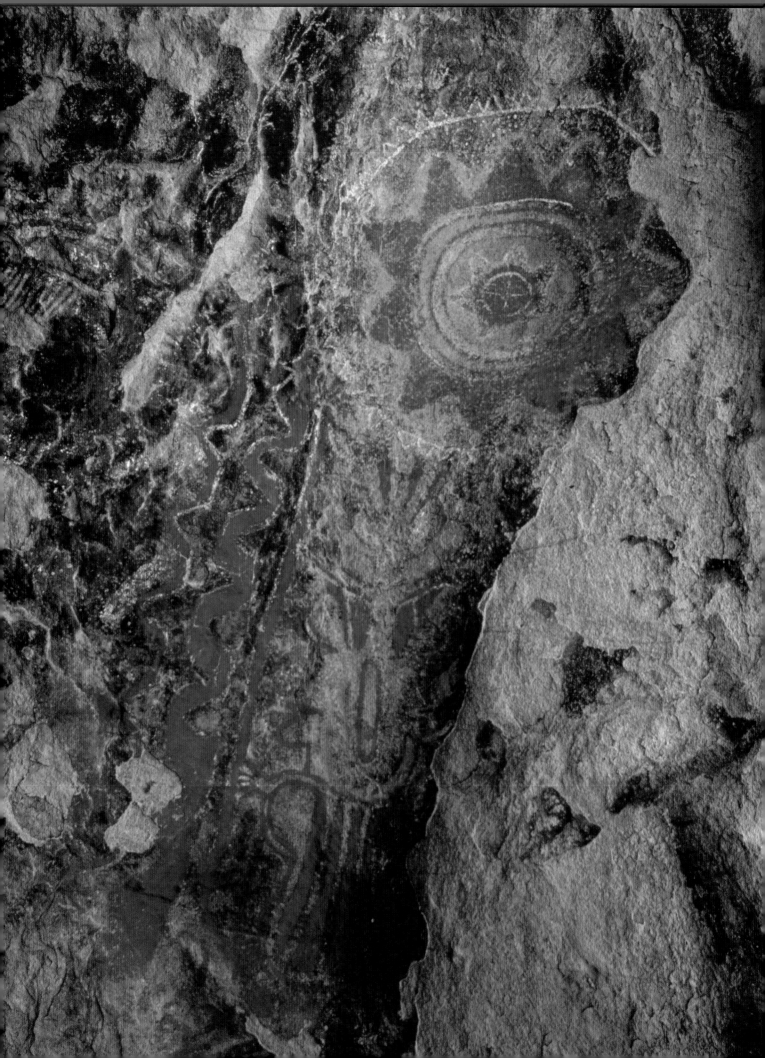

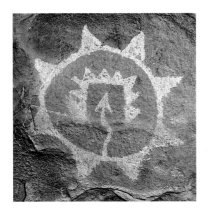

What Is the Meaning of Rock Art?

Why was rock art created? This difficult question, left almost unanswered, has puzzled travelers, casual observers, and researchers for hundreds of years. It can be difficult, if not impossible, to uncover the meanings behind these poetic images. Asking the wrong questions diverts our quest to interpret rock art. Anticipating a direct answer sometimes leaves the listener unable to understand explanations hidden in aboriginal mythology.

Many painted and carved dreams can be interpreted through the shamans—the special medicine men and women who influenced tribal North America for thousands of years. The shaman represents an ecstatic form of religion in which the practitioner journeys to subconscious, inner landscapes. Though it is important to make a distinction between the shaman and the vision quester, shamanism was very common in societies where a majority of adult individuals sought personal powers through vision quests.

Numerous native voices, recorded in the past, told of their vision quest experiences undertaken at sacred places and later marked on their rock walls. Spirit helpers and guardian animals portrayed

▲ *A design painted in white at Comanche Cave near El Paso, Texas.*

◀ *Few North American rock art compositions surpass the images at Pleito Creek, California, for color and intricacy.*

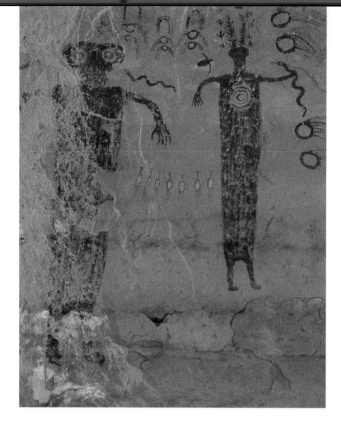

across the continent, and shield symbols in the Plains area, came from the visions induced by fasting or through ceremonial rites such as the sun dance. While those who had vision quested were able to participate in spiritual matters, the shaman continued in a life-long series of supernatural experiences. Some, such as the noted Ojibwa shaman, Shingwaukonce, suffered through as many as 10 formal vision quests during their lifetimes, in addition to entering countless trances.

Since shamanism deals with the same inner world charted by psychotherapists, much of the resulting imagery can be recognized by non-aboriginal people. First-hand accounts of shamans' experiences collected around the world—from Australian aborigines, Innuit hunters of the high Arctic, the bushmen of southern Africa, and diverse North American tribes—contain the same basic themes. Death and restoration is a common element in these experiences. In rock art, death metaphors appear as skeleton-like human figures portrayed as if caught in cosmic x-rays.

When I discovered a pictograph of a flying skeleton on the ceiling of a small rock shelter in northern Ontario, the sounds of clicking and clattering bones were almost audible. I recalled the story of Pagak, omen of death. Only a few days earlier, Deep Water tribal Elder Michael Paul had related the story of Pagak, a skeletal spirit who announces his arrival by the rattling of his bones and other eerie sounds. Pagak is first heard

▲ *Images such as this pair holding snakes in hand and mouth strongly suggest Native American ceremonial activities.*

in the distance, near the eastern horizon. Then the specter moves in to hover ominously over the smoke hole of the lodge where death will occur. Finally, he noisily flies off to the west.

SOURCES OF INTERPRETATION

Realistic interpretations of the Dreaming Rocks in North America come from two basic sources—the Indian shamans with their knowledge of mythology and direct links to particular sites; and through insights gained from the study of comparative religions and related psychological research.

We must let tribal voices speak for themselves. In North America, we have a rare cultural heritage—native people with living traditions regarding rock art, religion, vision questing, and other related knowledge. Only Australia and a few other isolated areas can claim a similar heritage. By comparison, the vivid Ice Age art masterpieces of western Europe remain muted by the long passage of time and tens of thousands of years of cultural change.

An appreciation of sacred space, shamanism, and the inner world of the mind help us understand and interpret rock art. In the long, complicated history of tribes on this planet, most religions have explored religious mysteries through the trance-induced inner world. Once the symbolism of trance is understood, including the unconscious images that we share as a species, we can see rock art with a fresh vision. First, we need to realize that, regardless of our global origins, all individuals share certain imagery based upon a species-wide response of our central nervous systems. Phosphorus, the highly reactive element that produces bright light, lends its name to the phenomena of inner lights, phosphenes. These are the patterns of bright light and color that appear when we close our eyes tightly. The same visual patterns appear in trance states.

Fred Pine described the onset of his recurring visions as "buzzing, bright lights flying around my head." Other Algonkian shamans, who entered a trance state inside the conjurer's lodge, reported that the spirits appeared before them as tiny sparks of light. These minute forces would rest upon the tent frame and speak to the shaman. We briefly share this experience when we rise too fast and patterns of swirling lights swim in front of our eyes. Migraine headache victims often involuntarily share trance imagery. During severe attacks, they report seeing haloes of light, checkerboard-like patterns, and swirling dots.

▶ *Canyonlands National Park, Utah.*

Armed with the knowledge that specific imagery recurs in trance states, a handful of rock art specialists began looking for these motifs in the regions where they worked. Everyone who was familiar with the vast literature on worldwide pictographs and petroglyphs realized that possible symbols of trance states—ladders, dot fields, and grid motifs—repeatedly appeared at diverse sites. Circular reasoning is often a danger when applying new insights, but fortunately, snippets of surviving ethnographic lore, coupled with abundant tribal mythologies as well as the testimony of living shamans, quickly demonstrated that many of the suspected trance motifs did indeed signify inner dream states later recorded on stone walls.

In a study of several possible trance motifs—including inverted or "diving" human forms, dots or spheres, and ladder-like designs—I learned that these images were not randomly distributed. While I suspected that the majority of Algonkian rock art sites served as vision quest locations, only a limited number have actually been documented as such. When I restricted my study to Algonkian rock art sites ethnographically identified as vision quest centers, I found a higher percentage of the suspected trance art than at the combined rock art sites from a variety of origins. The cultural prerequisites were well established—trance style dreaming was thoroughly a part of Ojibwa, Chippewa, Cree, and other Algonkian groups. Methods of achieving this level of learning varied from long fasts, meditative isolation, and prolonged drumming and singing of prayers to more institutionalized trance ceremonies performed by shamans in special structures called shaking tents.

The cultural context of vision quest sites containing rock art emphasizes the fact that these sacred sites were primarily used as visionary locations. The presence of rock art employed to record dreams is a secondary attribute. These sites are perceived as a variant of the many possible vision quest locations, most of which do not bear rock art.

SORCERERS' APPRENTICES

While just about any living thing, real or fabled, could become a shaman's spirit helper, different tribes recognized the special abilities of those creatures who transcended the various strata of the earth, underworld, or sky as part of their daily lives.

The Chumash and their neighbors believed that the centipede worked as a shaman's apprentice. This scurrying creature is an ideal metaphor—it easily travels back and forth from its underworld home up to the land of light. Centipedes have negative connotations of death, decaying vegetation, and the underground realm. They are easily regarded as vile creatures. Yet the concept that centipedes freely move between the world of light and the world of darkness was preserved on the ceiling of a painted cave in the Sierra foothills. At this site, a Yokuts Indian artist incorporated the blackened ceiling with the lighter outer wall to show a centipede emerging from the darkness.

"You must confront the serpent to enter the dream world," Dan Pine once whispered, as we burned tobacco and blossoming wild flowers at *Boukoudjininnik-Wabkung*, "The Cliff of the Little Wild Men." Earlier that day, sitting in his daughter's busy kitchen, I asked him about the mysteries surrounding the Midewewin, The Grand Medicine Society. He showed me copies of important birchbark scrolls carrying pictograph-like designs that acted both as prayers and as reminders of the complex rituals performed in the medicine lodge. An erect, horned serpent often stood at the doorway to the Midewewin lodge. Trying to follow Ojibwa protocol, I pointed this out in a passing remark and let my interest linger as an open question.

Now, in front of this shattered cliff, where Elders reported buzzing lights and nighttime flames indicating the movement of spiritual forces, Dan Pine answered the question I had suggested earlier. "Confronting the serpent" alluded to the seriousness of visioning—of entering the inner world where motivation and emotion dwell, and of facing truth.

SACRED SOUNDS—SACRED METAPHORS

The concept of hunting magic has provided a popular interpretation for rock art depictions of grouped animals along with individuals armed with bows and spears. Like many catch-all categories, the use of the hunting magic explanation tends to obscure, rather than illuminate, the ancient images. It fails on two accounts—by literally translating the activities shown on stone walls and by unduly emphasizing the hunting of large game. Despite the considerable abilities of aboriginal hunters—40 years ago, Cree children could shoot darting, wren-sized snowbirds out of the air using bows and arrows—native people in many parts of North America gathered immense amounts of food from rivers, streams, and lakes.

Another bias has crept into our perceptions of the

native hunter. Most early anthropologists were men who overlooked, through disinterest or lack of comfortable access, the plant gathering and fish harvesting contributions of native women. A handful of Algonkian rock art sites have benefited from several centuries of written observations and collected native oral history. These will help us to recognize the dangers of intriguing but seriously misleading hunting magic ideas. First, we need to consider the mysteries surrounding several Algonkian pictograph sites including Picture Rock.

Three pioneers of the mid-continent, Alexander MacKenzie, David Thompson, and Alexander Henry, passed a puzzling location, generally known then and now, as Picture Rock. On the shore of Crooked Lake, Minnesota, these 18th and 19th century travelers viewed a remarkable sight—a cleft in the granite cliff holding numerous arrows shot into the stone wall. The descriptions of the cliff on Crooked Lake are fairly consistent. After passing Picture Rock, alias Arrows In Rock, MacKenzie wrote in his diary that he saw "a remarkable rock, with a smooth face . . . and cracked in different parts, which hang over the water. Into one of its horizontal chasms a great number of arrows have been shot . . . " He attributed the arrows to the Lakota Sioux tribe, which was actively warring with the Ojibwa at the time.

A different interpretation of arrows fired at pictographs comes from the Canadian wilderness. The earliest recorded native activity at a sacred pictograph site in eastern Canada took place in 1623, and again in 1636, when the first French observers watched as native guides left tobacco offerings in the crevices of a prominent cliff on the Ottawa River known today as Roche a l'Oiseau, or Bird Rock. A series of subsequent travelers, missionaries, and military officers left additional remarks about the brooding cliff described by aboriginal passers as the "home of a spirit." Not surprisingly, Roche a l'Oiseau is covered with red ochre paintings. Unfortunately, these have been obscured by dense accumulations of modern graffiti.

The original Indian name for Roche a l'Oiseau refers to a mythological vulture, Michissay, described by tribal Elders as a monster resembling a pterodactyl with a turkey's neck and a vulture's wings. Legends tell us such a bird was found in its nest by a hunter who saw lightning flashing from the bird's beak. The same, almost incomprehensible power lay dormant at the cliff named after this mythological creature.

Chevalier de Troyes, a French officer who passed Roche a l'Oiseau in 1686, wrote in his journal that native people sent arrows tied with tobacco across the water to make offerings. His observation provided a missing piece of information that changed our interpretation of rock art site rituals. Fearing the power of the resident spirits, the native paddlers sent their offerings from a distance. Without this insight, we could easily interpret the arrows mentioned or found at various Algonkian rock art sites as part of hunting magic rituals.

The archers mimicked, in thought and action, the efforts of Nanabush, who sent magical arrows into impeding mountains. Dan Pine, the Garden River Ojibwa Elder, took me to a prominent ridge called Nanabush's Lookout near the St. Marys River so we could view the trickster's influence on the surrounding countryside between Lake Superior and Lake Huron. "Nanabush had such magical powers that he could split a mountain with his arrows," Dan Pine said. "When he traveled, he went on a straight trail. Even today, you can see the split rocks where he sent his arrows."

Today, bows and arrows have been replaced by rifles, but tobacco continues to retain its ceremonial role despite its common use. Tobacco originally grew as a sacred plant cultivated by farming tribes and widely traded across prehistoric America. According to Dan Pine, the smoke, aroma, and texture were the qualities that gave tobacco its status. When used in pipe ceremonies, tobacco symbolized the transformation from physical to ephemeral as the plant cuttings lost their material existence, but remained visible in the ascending smoke. Ojibwa fishermen regularly leave loose tobacco or a few cigarettes at Agawa Rock on Lake Superior, as their ancestors have done for several hundred years.

Perhaps the resident spirits have acquiesced, for today tobacco-wrapped arrows are not used to venerate the rock from a distance. A faint link to the older practice has continued in a few remote areas, as modern native hunters fire rifle shots at spirit cliffs. On the Nelson River of northern Manitoba, native hunters have fired a few shots for luck at a rock formation called the Moose's Flanks. Contemporary Ojibwa and Cree hunters explain that the noise of their rifles, echoing off the towering granite walls, imitates the voice of thunder. By "speaking" in this manner, the hunters acknowledge the presence, while invoking the protection, of the resident thunderbirds at these holy places.

Algonkian shamans tell stories of their ancestors treating the first rifles as weapons capable of carrying the voice of thunder or of slaying game. Today, a Cree hunter will explain that hunting is a serious pursuit with spiritual obligations—never done for sport, only for harvesting food and clothing.

MISCONCEPTIONS ABOUT PICTURE WRITING

When asking the question, "What does rock art mean?" we must be careful to avoid false interpretations. Inaccurate ideas about rock art are often the result of genuine attempts to understand its origins. Across the country, pictographs and petroglyphs have been called "picture writing," a natural reaction to what appear to be recognizable symbols. Unfortunately, this approach misses the truth—mistaking abstract metaphors for literal text. Along with the fact that many rock images are highly abstracted concepts contained in certain symbols, the diversity of Native American languages must also be considered. In California alone, over 60 distinct native languages existed prior to the 1700s. If this does not deter a persistent reader of rocks, there is an additional problem—even professional rock art researchers have difficulty assigning much of the rock art legacy of areas like the Great Plains to specific tribal groups. How are you going to "read" the painted walls if you don't even know which language to use?

AN ABORIGINAL CODE OF SILENCE

Attempts at finding meaning in rock art were largely abandoned until an obvious route to interpretation was recognized. The greatest successes in learning about the origins and purposes of pictographs and petroglyphs have been made with the cooperation of native people. Although common sense tells us that working with traditional shamans and the keepers of tribal culture would produce the most valid insights into rock art, surprisingly little work has been done with contemporary Indian groups in North America. The reasons are many: only a certain percentage of tribes retain connections to traditional religions; knowledgeable shamans are often reluctant to share their personal wisdom; and researchers are often discouraged by initial unresponsiveness. My experiences working with the Ojibwa, Algonkian, and Cree Elders and shamans have shown me that patience and persistence, along with sensitivity and reverence for the Dreaming Rocks, are necessary prerequisites when learning from the Elders. In some instances, I had to wait four or five years before the Elders would discuss any aspect of rock art or sacred sites.

VISION QUESTING

Sensory deprivation leads to visions through altered consciousness as surely as the express lane approach provided by hallucinogens. Fred Pine often stated, "I suffered for my education. Look at you. You are an educated man. You have many years of schooling. I never went to school for a day." He grinned. "Yet I have a better education than most people. Why is that? Because I fasted when I was a boy. The spirits taught me in six days what you couldn't learn in 20 years."

I agreed. In 12 years of close companionship, Fred had taken me across many thresholds of new understandings about aboriginal culture, native religion, and honoring the natural world. I truly appreciated his vast wisdom. He also experienced recurring visions through fasting, drumming, and prayer in the manner of his ancestors.

Across North America, the rock art that followed vision questing often shared similar imagery, regardless of the techniques used to cross over into the trance world. An Ojibwa tale about the loss of our original powers reminded me of similar informative stories out of the European tradition. During a long afternoon with Dan Pine, we enjoyed a storyteller's form of sport—narrating one legend, listening carefully to a slightly better crafted, yet entirely traditional and unembellished tale, and responding by building upon the theme.

I retold the Temagami legend of Nanabush slaying the lion queen of water monsters in her cave and the ensuing Great Flood that destroyed the earth. Without a blink, Dan Pine recited a segment that logically followed—Nanabush and the Thunder People:

Here the story goes. When the earth was reformed, Matchi-Manidoo [evil spirit] made serpents and other evil things. So these two powers, our Mother the Nature Spirit and the Thunderbird People, sat down to clean up everything [restore order].

In that time, Nanabush had equal powers like the Thunderbird People. With his bow and arrow, he could do magical things. You see places here and there where he didn't go over the hill in his travels. Nanabush just shot his arrow through the rock to cut an opening. He could do this feat through water, too. The narrow channels in Lake Huron show his ability.

The thunderbirds started cleaning up the snakes from the

rivers. Nanabush came along while a thunderer was lifting a serpent out of the water. "Shoot him for me," says the thunderbird. "No. No. Shoot the feathered one for me," hissed the giant snake.

Nanabush lifted his mighty bow to the sky, aimed at the snake's chest, and was ready to release a magical arrow to pierce the serpent's heart, when Nanabush's wife stopped him. "That's no good," she said. "We will never eat that foul animal of darkness. Shoot the bird," she yelled. "Quick. We can use it." She wanted Thunder's beautiful feathers. Whether by mistake or by following bad advice, Nanabush shot the thunderbird.

So after that, Mother Nature—the Earth Spirit—made life hard for the first people. At that time, only a few Indians were living on earth. Not as many as today. The first families almost starved to death. The animals, the fish, everything hated Nanabush and his people for what he had done. No more fruits from the plants. Nothing, until Mother Nature had a meeting with the Thunderers. "Let's forgive the poor, suffering people," she suggested.

They decided that an Indian boy will be born to become a great hunter through the help of the thunder people's daughter. So the child was born and he became a great hunter. He provided food and saved the Indians from perishing.

Finally the day came that the hunter wanted to marry. The boy had to ask his people. The girl had to ask hers. They got married in the Midewewin lodge longhouse. That's where people went to fast and have ceremonies. Because of this, years ago, power and blessings were very plentiful. But since Nanabush shot the thunderbird, the Indian people lost those great powers. "Now we have to struggle," they cried.

So the young hunter, son of thunder and the first Indians, and the girl got married. Thunderers came from the east. Thunderers came from the west. Thunderers came from the south. All of the Thunder people were there to perform the ceremony, since the girl was one of them.

Everything at the ceremony was all bound together by love—love for each other, love for the Creator and our Mother, The Earth. This took place in the central part of the longhouse [Midewewin Lodge]. The longhouse belongs to the thunder people. The medicine lodge is like the capitol for Mother Nature, a sea of power where Thunderers can appear among us.

This is the way the marriage went. The thunder people killed the young hunter by hitting him on the head. They killed the wrong that had cursed man since Nanabush shot a thunderbird. But the Thunderers brought the young husband alive again with spiritual power.

So the hard spell was broken. But man had to work for his powers, like fasting in the medicine lodge to ask for help. From that time on, my people fasted to gain knowledge.

The legendary origin of vision questing—referring to the marriage between daughter of thunder and son of man—symbolizes a union between earth and sky, mortals and immortals, just as the painted rocks wed us to the spiritual realm. Today, vision questers reenact the marriage and symbolic death through their fasting, which is done in the springtime when the voice of thunder returns to the earth.

VISUAL PUNNING

High above Mission San Antonio, midway between Santa Barbara and San Francisco, a dark-walled cave holds clues to past shamanic practices. Red and black paintings surround two small holes bored into the side walls by natural forces. As you stare at these entrance ways to another realm, suddenly—and without voluntary control—the pictographs break the artificial visual reality that we assume.

At this great Salinian Cave, I explained to my friends that we unconsciously agree upon common visual realities. My hiking companions gathered at the mouth of the cave, 20 feet away and 10 feet below. "When I look at you standing there 20 feet away, I know that you are five to six feet tall," I explained. "But by shifting my visual standards for a moment, I see you to be the height of a small child—two feet tall." To gain access to the

▲ *An abstract yet seemingly animate design from Payne Lake, Quetico Provincial Park, Ontario.*

subconscious, a path to religious understanding, ancient shaman artists sometimes left visual cues in an attempt to alter our perceptions.

A shift of focus occurred when anyone focused on the natural openings in the wall surrounded by the painted circles. Suddenly, the paintings encompassing the recessed pockets began to pulse, beckoning us inward. The added effects—a nighttime setting, firelight, shadows dancing on the walls, and the resonation of aboriginal chanting—could induce even more profound experiences.

The same visual tricks have been incorporated at other Dreaming Rocks. The rock-walled French River, once a major route for prehistoric Indians, early French explorers, and fur trade voyageurs in bark canoes, is marked with several small, inconspicuous rock art sites. One sunny afternoon, while paddling toward Recollet Falls to look for a single red ochre painting reported near the brink of the falls, Julie and I leisurely examined the length of the granite walls along the canyon-like river.

Rounding the corner of a small bay, we noticed an alcove protected by a slight overhang. Pushed by the strengthening current, we drifted closer and found a faint but familiar trio of pictographs beneath the protective cliff. Edging our boat closer, we could see a simple, stick-like human figure accompanied by a wolf. Both stood beside a painted curved line.

This might be tossed aside as an unimportant site, but it actually refers to a tale extending back to the beginning of time when the first people inhabited the northern Great Lakes forests. Ojibwa storytellers continue to speak about the adventures of the first Indian called Nanabush. A larger than life figure, he explored the vast country that became home to his people, the Anishinabe. The cycle of Nanabush stories serve as an Iliad and Odyssey for the Great Lakes tribes.

Gently bobbing in our boat, as tiny suns reflected off the river and danced across the pictographs, I thought of the tribal elders who have shared these Nanabush tales with my family. I remembered one episode out of Dan Pine's legendary recitation that took seven evenings to complete. This one particular tale enables us to connect some deceptively simple paintings to native mythology:

In Nanabush's time, people were immortal though their lives were troubled by dark forces such as underwater serpents and the giant, lynx-like Mishi-Peshu. Nanabush had a wolf brother named Myeengun who traveled everywhere with him. One sunny day, Myeengun walked alone along a long sand beach that extended as far as he could see beside Lake Superior. In the shimmering heat haze, Myeengun saw a few "logs" washed ashore by past storms. Continuing his wolf trot, he passed several logs when suddenly he was seized within the coils of Chignebik, the giant underwater serpent. As the wolf struggled, another snake ended its deception as a log and wrapped its scale-covered body around Myeengun. A third Chignebik joined the fight and Myeengun was slowly pulled under the darkened depths of Lake Superior.

Still alive, Nanabush's closest brother descended to the chilled bottom of the largest freshwater lake in the world. There, the massive serpents delivered Myeengun to the very spirit of Lake Superior, the underwater panther known to this day as Mishi-Peshu. Seated in a dark cavern far below the lake's surface, Mishi-Peshu swung its spike-covered tail and mortally wounded Myeengun.

Several days later, Nanabush roamed the shoreline in search of his missing brother. Finding faint tracks in the sand, he quickly arrived at the battle site. There he encountered broad grooves left in the sand by the giant serpents where Myeengun's trail ended. This frightened Nanabush. Racing with dread, he reached the water's edge and found his grey-coated brother dead upon the shore. Instinctively, Nanabush held his grief and began the first burial ceremony that continues today among traditional Ojibwa families. He sat four long nights with Myeengun, waiting until the soul left. On the final night, Nanabush saw a glowing shape rise out of Myeengun and fly upward into the star-filled sky.

As this soul continued to ascend toward the millions of stars we call the Milky Way, Nanabush heard a voice. "My brother, do not mourn too long. I will always be with you," the voice told Nanabush. "From this day, each of us will follow the Chibay Meekaun, or "Spirit's Trail," westward along the line of stars. But we will return again if we leave with love and respect."

Nanabush, who originally came to earth from the Morning Star to teach native people, heard further instructions. "Tell our people to honor the souls of all animals and plants taken for food. Their tribes will remain strong. And teach our people to learn from the signs of nature," the voice continued. "Even the endless arch of stars above you has lessons for us. As the Chibay Meekaun has numerous short branches off the main path, we must choose our trails carefully."

As motes of light danced across the French River pictographs of Nanabush, Myeengun, and the Milky Way, I thought more about Dan Pine's ability to narrate

the Nanabush stories, Fred Pine's explanations of these carefully crafted lessons, and how their ancestors summarized a chapter of the epic Nanabush tales using only three symbols on rock. We lingered long at this site, lost in thought.

In addition to the legend marked on this cliff, I realized that thousands, if not hundreds of thousands, of tribal tales once appeared on rock outcrops across North America. From the recorded observances of Henry Schoolcraft, the Indian Agent who lived at Sault Ste. Marie in the mid-19th century, another rock art depiction showing Myeengun's passing has survived even though the site appears to have vanished. Shingwaukonce, respectively grandfather and great-grandfather of Dan and Fred Pine, shared some of his knowledge about rock art with Henry Schoolcraft in 1837. During their conversation, Shingwaukonce drew images from two rock art sites onto a piece of birch bark. One site was the famed Agawa Rock. The motifs that

the aging warrior inscribed—canoes, crane, turtle, and horse—still mark Agawa's cliffs. But the second site, a sister to Agawa Rock located somewhere on the south shore of Lake Superior, has never been found, despite several attempts. Unlike the rock-of-ages qualities of granite, the softer sedimentary sandstones that rise out of Lake Superior's south shore quickly weather away.

Judging from the birchbark record, a familiar trio plus an added guest formed one panel at the lost site. A wolf stands beside a man who holds an arc in one hand. The added figure is a beaver, readily identified from Ojibwa origin tales as Puckewis, one of Nanabush's brothers. Originally a man, Puckewis turned into the first beaver so that native people would have a reliable food supply. It is said that Puckewis dove off a cliff, transforming into a beaver before he reached Lake Superior. This metaphor identifies a cliff as the appropriate place for transformation and a supernatural event.

Tribal elders have also recounted the legend of

▲ *The underwater panther, Mishi-Peshu, stands in profile. A source of legends, Mishi-Peshu represents the power and volatile nature of Lake Superior. Agawa Rock, Ontario.*

111

Nanabush's brother Myeengun, who became the wolf. Their adventures during the days of creation have been told over evening fires in the Canadian backwoods for hundreds of years. According to the last Ojibwa star-master, Fred Pine, these two mythical individuals continued their eternal travels overhead as constellations incorporating the stars that are also recognized as Orion and Canis Major. Ever since Myeengun's death, caused by the night panther and giant snake creatures of the underwater world, the departed souls of northern Indians have followed the westward path of the Milky Way trail, taken by Myeengun to the land of eternity. The trail, appearing on the cliff as a curved line, is found repeatedly with the other Nanabush and wolf motifs in northern Algonkian art—perhaps reminding us of our mortality and the discovery of life beyond the skies.

Returning to this world, we copied and photographed the small panel of paintings. Julie and I had learned to take time to sense the emotional and spiritual settings of these painted rocks. We absorbed the entire presence—cliffs, ochre images, sky, and flowing river—as reflected light danced across the site.

ILLUMINATION AND ILLUSION

Interpretation of rock art is filled with difficulties. In addition to the task of finding legitimate sources to understand the paintings or carvings being studied, it is sometimes difficult to properly recognize what lies before you on the rocks. One image from the Peterborough Petroglyph site has been extensively reproduced. The "sun god" has appeared in several publications and reviews of North American rock art. When follow-up research focused on this solar deity, its authenticity was questioned. Because the petroglyph was altered with black wax crayon, it is difficult to see the original carving—we do not know what is authentic. The image may be an amalgam of several separate carvings, or the original image may have been incompletely colored.

Regardless of the solar figure at the Peterborough Petroglyph site, genuine haloes and sun rays do appear around the painted heads of shamans at several other Algonkian sites. Solar imagery is a genuine part of Algonkian rock art—several first-hand accounts collected from shamans include visions filled with light. An Innuit shaman also described his vision as an "inward light, hovering over me as long as I was singing."

Dan Pine also shared an account of solar images. I placed a copy of a rock painting on the table between us. It showed a human figure with a long "life line" or "heart line" inside the chest and a rayed halo encircling the head. The image was from a remote site on Scotia Lake in northern Ontario. Dan Pine studied the reproduction for a moment, then related this experience he had while fasting for power:

They got these special places where they go to fast. It's just like university. That's where you learn the real world. See here, you start there [at the vision quest site], getting acquainted. Maybe somebody will want you there. [A spirit will contact you.]

Your gift is to go and spend a few days every year and fast to get your education right. Animals come and talk to you. Not only the animals. Trees are spiritual. It's very spiritual. Shingwaukonce, my grandfather, fasted many times. Ten times. They go in there to the fasting place. They go up there.

You're just chilly, you know, when you fast. Did you ever get scared? Did you ever get funny feelings when you just kind of felt tingly? Well, that's where you get that [while vision questing].

There's thunder people up there. Spiritual thunder people. Somebody wants to touch you or something. You just feel it around your head. Goes around your head. And your hair's standing up. People can't stay there very long when they go up there.

Dan Pine continued to explain that the sun symbolism was a double metaphor—standing for the visual and intuitive experience achieved while in a trance, and for an incomprehensible, endless source of power that comes from the Great Spirit. He also insisted that the rock art representations were personal illuminations, painted after the vision quest had ended. I asked if these might not be attempts at showing the Creator. Dan Pine dismissed my suggestion:

That's why the Little Wild Men appear at Dreamer's Rock. No man or woman could face the Great Spirit—the power would overcome them. And no one could show an image of the greatest mystery of all religions. Kitchi-Manitou [The Great Spirit] has the shape of the wind.

Dan Pine's words added a new dimension to interpreting some rock art figures. Even the English language has preserved some words from a time when shamanism was practiced in tribal Europe. The word "enlightenment," which literally means filled with light, conveys the visual experience of crossing into a state of profound spiritual understanding.

SHAMANIC TRANSFORMATION

Among the hundreds of southern California rock art sites left by the Chumash tribes, three stand out for the accessibility of their messages—Pool Rock, Condor Cave, and The House of the Sun. High in the mountains of the San Rafael Wilderness Area beyond Santa Barbara, wind, heat, and seasonal rains have sculpted immense sandstone rock formations into smooth, rounded, molar-like monuments sporadically darkened by erosional cavities. Pool Rock is the most exotic of Chumash cultural treasures. The crown of this towering shrine holds a vast reservoir of precious rain water in the otherwise dry hills. Around the base of Pool Rock, Chumash dreamers carefully rent the wall with a necklace of the small depressions called cupules, or "tiny cups." Ancient handholds, left from long ago, are cut into the steeper ascent to the top of the rock, leading to a natural reservoir of rain water. Below, at the base of Pool Rock in a room-sized cave, remains a well preserved shaman's sanctuary.

Some rock art sites display a single, central figure that carries the essence of the sacred rock. On a darkened wall at Pool Rock, a dramatic shamanic figure dances eternally to the rhythm of a trance. The Chumash shaman's arms are stretched out as if to embrace the unknown. On his head is a broad pair of red horns. Painted in black and outlined with red ochre, this is surely a shaman from Central Casting, with a stylized dance skirt across his waist. Examples of actual ceremonial skirts and headbands, made from colorful bird feathers, have been found preserved in the original dry storage caves near rock art sites. These costumes help us interpret numerous shamanic paintings.

A net-like device on one side and a lizard with bent legs on the other flank the Pool Rock medicine seeker. The net-like image—woven red lines on a white background—seems to hold small red ochre figures, possibly dolphins, that are now barely perceptible. The metaphor is apparent—capture the soul and you will surely entrap the body.

Depending upon the amount of moisture in the air, a magical transformation takes place inside the ancient shaman. When the humidity reaches a certain level, or when water is splashed onto the shaman's chest, a bird with spread wings emerges. Painted in white pigment, the bird-soul-shaman's trance personification magically appears and disappears. A little imagination recreates a primal scene. With the sounds of flute and rattle reverberating inside the small cave and firelight pulsing from outside the entrance, an initiate—perhaps released from reality by the narcotic plants favored by the Chumash—is led by experienced trance travelers before the Pool Rock painted shaman. A fine spray of water is blown onto the pictograph, white eagle suddenly swoops out, and the candidate is carried away to another dimension.

Less than a mile away, the shallow rock shelter known as Condor Cave embraces similar illusionary magic. Long ago, a Chumash dreamer painted a condor in white and red above the entrance to Condor Cave. Under most conditions, sunlight brightens the front wall of the sandstone outcrop, thereby obscuring the

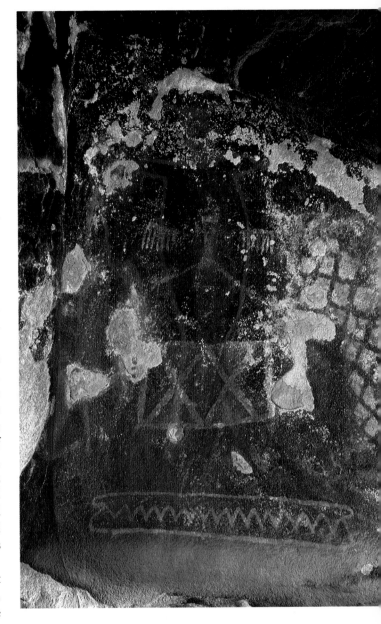

▲ *A Chumash shaman wearing a horned headdress. The white bird emerges from the shaman's chest when the air is moist. Pool Rock, San Rafael Wilderness Area, California.*

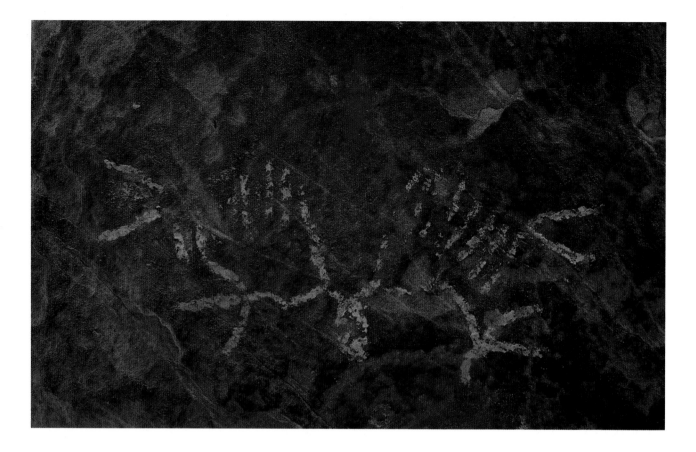

condor, but the artist who created the condor image must have intentionally used the natural lighting conditions at the site. By casting a shadow on the condor painting, a soaring bird suddenly appears out of the rock.

If Pool Rock is a direct link to the Chumash past, its magic also connects us to the Chumash present. Today, under the guidance of the Forest Service, Pool Rock and nearby Condor Cave have been reclaimed by the present generation of Chumash. Both locations have been withdrawn from public viewing while site stabilization is being completed.

During fasting and the vision quest, shamans acquire spirit guides—sometimes alter egos, other times angel-like visitors—capable of assisting them in their work. Spirit helpers can materialize in limitless forms at Dreamers' Rocks—as thunderbird, the controller of the elements at Great Lakes sites; as the threatening panthers painted in Texan caves; and in the shape of the grizzly, marked by paw prints, at isolated Chumash holy grounds.

Ojibwa master shaman Shingwaukonce lived from 1773 to 1854. His 10 vision quests allowed him to gain a pantheon of spirit guides and supernatural allies including Thunder, horse, and plover—a shore bird. But his preferred body state is both surprising and revealing.

Shingwaukonce, direct ancestor to Fred Pine and Dan Pine, confided to his family that one of his favorite spirit vehicles was the lowly, often maligned louse. This ultimate shaman kept a locked room in the loft of his square timber home for his empty body to remain undisturbed while he flew to the nether world. In an altered state of consciousness, Shingwaukonce transformed into a louse whenever he wanted to fly easily to distant villages. As his grandsons explained, "The body was there, in the loft, like an empty shell."

At Agawa Rock on Lake Superior, the famed "horse and rider" panel—horse depictions are rare in the northern woodlands—has intrigued observers for several decades. The group of paintings, enclosed by two concentric circles, shows a small person riding on—or emerging from—the back of a large horse; four red spheres; a cross; and a curious, insect-like pictograph. The insect has been painted with six legs attached to a round body and a central heart line down its middle. To our great amazement, Fred Pine identified the "horse and rider" group as the work of his great-grandfather

▲ *A thoughtfully painted condor image at Condor Cave, San Rafael Wilderness Area, California.*

114

Shingwaukonce. It is very rare when an individual has been credited as the actual artist of a pictograph. Fred provided a long explanation about each of the elements on the panel, ending with the origin of the strange and unique insect. It is a story of transformation and shamanic flight.

Shingwaukonce fought a shamanic duel with a conjurer, who used spells and dark magic to cause sickness and suffering. The conjurer—or bear walker, as corrupted shamans are called among the Ojibwa—steals part of your soul to accomplish his spell. Fred Pine tells the story:

Old Shingwaukonce. He could transform himself into any animal. One way he traveled and hid from his enemies was by becoming a louse. When he changed into a louse, nobody could recognize him.

In Shingwauk's time, women hung blankets along tree limbs to air out. Shingwauk would turn into a louse and sit on a blanket. When a raven landed on a tree, Shingwauk would hire him to fly where he needed to travel to do his business. The louse would just crawl onto the raven's feathers and direct the raven.

My great-grandfather was a powerful man to be able to change into animals. He was a soul. One time, Shingwaukonce had a duel with two other medicine men who wanted to kill him. These were Bear Walkers. And they had a grudge against Shingwauk's tribe.

The first one had a large knife and he walked up to old Shingwauk. They were standing in a village near wigwams and outdoor camp fires. Shingwauk warned the other medicine man to quit. But no, he wouldn't. He lunged toward Shingwauk with the knife. When his hand struck my great-grandfather, it was empty. Shingwauk told the man to look in a kettle of cooking food. The knife was there. Yet nobody saw this happen. That is how Shingwauk defeated the first man.

The second medicine man was more powerful. He tried to conjure spirits to kill Shingwauk right there in the open. Neither of them touched each other. They hurled dark power against each other. This went on for a long time. Both of them were injured; but their powers were evenly matched. Finally Shingwauk became very angry. In front of everyone, he changed into a soul—like a flame—and he flew through the other man and came out his back. That man dropped over dead. That's the power of Shingwauk.

Upon looking at the painted image of a loon,

▲ *A few Chumash rock art caves are adorned with carved bear paws. Shamans who took their power from the grizzly may have been responsible for these southern California petroglyphs.*

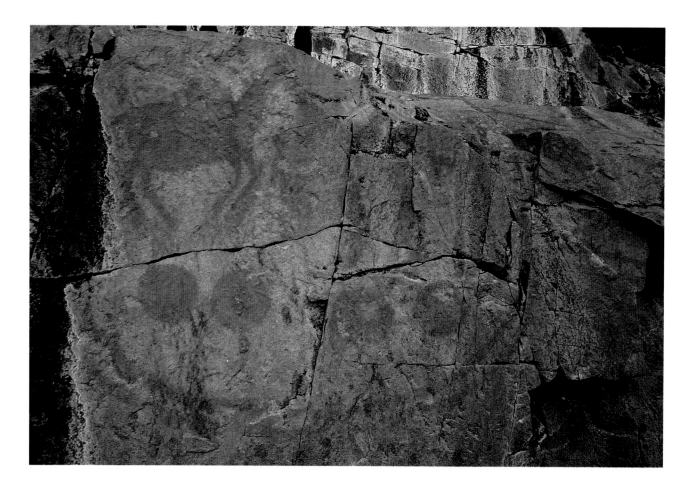

Shingwaukonce's grandson, Dan Pine Sr., remembered that in the time of the Indian wars on Lake Superior, a local shaman was fond of changing into a loon. This water bird, which cannot walk on land, gained from evolution extra powers to dive deep into lakes in pursuit of fish. During the years of warfare in the late 1600s, the Ojibwa moved to inland lake refuges protected by difficult access. While camped at Manitouwadge one summer, the tribe's shaman, who was a transformer that the Ojibwa call *Djiski-Innini,* or "Soul Man," sensed the presence of enemy warriors on Lake Superior. In order to spy upon the Iroquois raiding party, Loon Diver entered a trance, summoned his powers, changed into loon, and flew to the distant north shore of Lake Superior. There he landed in the waves near the enemy camp and listened as the Iroquois planned their attacks.

When loon flies, he makes a noisy, rattling call. Loon Diver, who did not want to alert the enemy, returned by swimming down to the bottom of Lake Superior and traveling back to Manitouwadge though the underwater caves. He reappeared among his people as loon, spoke

his findings, and changed back into a man. "That is another reason the Indian respects all life," Dan Pine concluded. "Because an appearance is like a mask. We never know who is underneath." His words apply aptly to rock art as well.

Common sense, along with a few firsthand accounts, informs us that most rock art was created upon completion of vision quests or shamanic trances. If they were apprentice shamans, vision seekers would carefully recite their vivid dreams to a master shaman. Other vision seekers would tell their dreams to their grandmothers or grandfathers. After their visions were recited, the full symbolic meaning of the dreams could be discussed, understood, and encapsulated into a pictograph or a panel of paintings.

Several pictographs across the continent preserve the experience of the transformation between person and spirit. Some show the navel as the exit point for the spirit—a connection rooted in birth as well as a recognition of the center of power. Even today, Chinese healers speak of the *tan tien,* near the navel, as the seat

▲ *Shingwaukonce's transformation into a louse appears in front of the horse's legs. Agawa Rock, Lake Superior Provincial Park, Ontario.*

of a person's energy, or *chi*. On Long Point Lake in northern Canada, a shaman's human form stands immobile as a thunderbird emerges from his navel.

VISIBLE MYTHOLOGIES

Mythologies can hold knowledge one step away from literal interpretations. Certain rock art panels were meant to be visual summaries of tribal myths. Kokopelli, the bringer of corn, is readily recognizable from New Mexico to the Great Lakes. Other images draw their inspiration from a cast of heroes, spirits, and animals, and use their myths to define the world and convey sophisticated messages under innocent mantles. Who else would play a prominent role in some rock art depictions than the male and female tricksters of legend? The leading characters of tribal myths—Glooscap in the Atlantic northeast, Nanabush in the Great Lakes, the Pueblo Warrior Twins in the southwest, and Coyote in the west—have alternately played the fool, shared their wisdom, and created order in the aboriginal world.

Mythology, recorded permanently in stone, reminds us of our basic connections to the land, animals, rocks, and water. Some rock art images remind us of the folklore behind the painting or carving. In Maine and nearby Nova Scotia, the mythological hero Glooscap has been identified at petroglyph sites that also preserve forms of historic-era Algonkian writing. Other rock art was surely meant to convey the same underlying lesson embodied in the original tale.

Images of lizards, painted by the Chumash of central and southern California, are commonly found at their sacred sites. Today, while visiting sites in the summer heat, we find that real lizards continue to sit, fixed on the warmed stones, beside their portraits, which have basked in the sun across the centuries. Lizards, such as the examples at the Painted Rock of the Carizzo Plains, take us back to the time of creation, when the immortals debated about the final shape of humans. Coyote boasted that his paws were spectacular and people would be fortunate to have such appendages. As the discussion continued beside a white rock, lizard quietly listened. He heard the sky beings say that when the shape of human hands or paws was agreed upon, the animal who was chosen as a model would touch the magical stone and the work would be done. Lizard scurried up to the glistening surface and gently placed his five-fingered hand onto the rock. Coyote was outraged, and we gained the shape of our hands. Even today, when we visit rock

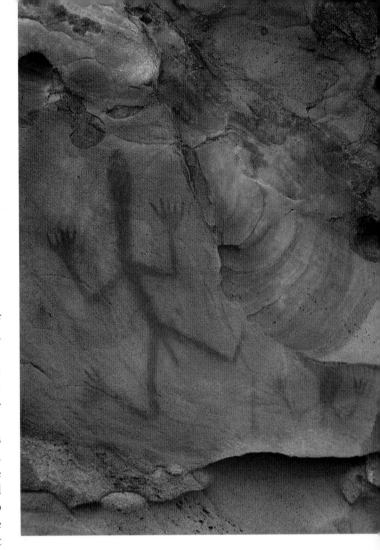

art sites in the western states, lizard still waits on the painted rocks, listening to our words.

Of course, the lesson implies a direct recognition of the role of sacred rocks. By touching the rock—interacting with nature's ability to lead us to another realm—we become human. What is our sense of humanity? In a holistic view, very little separates us from the plant and animal tribes. Our ability to project our dreams onto the walls of the land may be our greatest distinction.

Being human requires contemplation of the mysteries. This connection to the mystical world can be found at the galleries of previous seekers, who left painted reminders of their journeys—sometimes as images reflecting tribal folklore, other times as designs hinting at the depth of a religious experience. Currently, some researchers are exploring the possibility that whenever visions or trance states are induced—regardless of our cultural origins—we experience similar, basic imagery, subsequently colored by our particular

▲ *Insect imagery thought to be the creation of a solitary vision quester, Santa Barbara, California.*

117

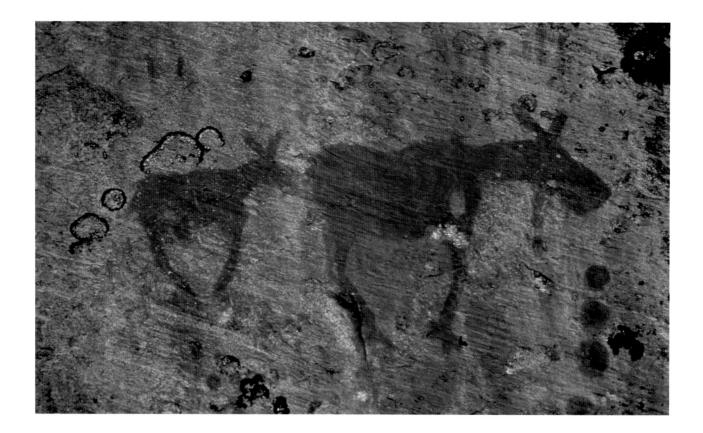

mythology and symbolism. This is the same dreamscape visited by Jung and other psychologists, an area where archetypal symbolism emerges regardless of race, language, or cultural origins.

REPEATED PATTERNS

Large surface exposures of granite form the vast Canadian shield—the setting for the lakes and forests found across half of Canada, from Quebec, across northern Ontario, and to the peripheries of Manitoba and Saskatchewan. Measured against the United States, this vast Algonkian homeland would stretch from Maine to Montana. Despite its imposing size, shamans across the shield maintained common archetypal mythologies that produced a widespread pictograph tradition, simultaneously simple and stunning.

Art historians seize images that appear with regularity and attempt to unravel their meaning by comparing similar recorded examples, by relating motifs to the underlying mythology, and through identifying the hallmarks of a particular motif or scene. At rock art sites, certain individual motifs and groups of images often turn up either regionally or within a single cultural area. Mishi-Peshu, the underwater panther,

represents Algonkian country in the same way that dolphins and sun disks define Chumash territory. Symbols such as horses, thunderbirds, and serpents transcend aboriginal boundaries and are found throughout the world.

In my own research, I repeatedly found two small scenes painted across the walls of Ojibwa lakeside sites. The first depicts a pair of deer, or moose, facing each other; the other illustrates an anthropomorphic figure standing with a pole or stick in one hand. After a decade of field work, I have accumulated a large data base of intentionally grouped images. The paired cervids, a general-use term that includes somewhat indistinctly rendered moose, deer, or woodland caribou, stand frozen in time on sites including Fairy Point, Alligator Rock, Scotia Lake, and Agawa Rock, all found in Ontario. Whenever repeated groupings appear across a tribal area, there is the possibility of common lore.

Why would past Algonkian shaman artists use this imagery? Certainly, natural features were incorporated into rock art presentations. Although the positioning of the cervids was not fortuitous—canines, turtles, lizards, birds, and fish were not shown paired together at cracks—I considered the possibility that the paintings

▲ *The moose painted at Darky Lake are well-known Ojibwa images in Quetico Provincial Park, Ontario.*

depicted the ritualized stances moose and their relatives use during courtship. The idea of mating-related posture seemed to carry some weight. In addition to the deliberate, nose to nose posture, a small fissure in the rock wall always divided the mammals. The meaning behind these patterns remained a puzzle.

Then my wife and I began to visit the Teaching Rock, also known as the Peterborough Petroglyphs, which is an outstanding display of Algonkian religious imagery. Under the guidance of Fred Pine, some of the Teaching Rock's mysteries were opened up. With dramatic artistry, this sea of carvings contains one major theme—fertility and the renewal of life. A pair of the most elaborate petroglyph moose ever recorded stood on either side of a deep fissure just below the Mother Earth carving—a large female image placed so that the metaphor of birth and life is reinforced by the natural features.

Beneath the rock surface, trickling water flowed under the carvings. Natural openings in the marble outcrop carried the sound to the images. Fred Pine cryptically told us that even moose have medicine skills and shaman's powers. Only moose, the largest land-dwelling animals in eastern Canada, can walk into a lake and disappear beneath the surface. Only moose, their broad antlers notwithstanding, can run with ease through the thickest bush in places where a hunter might struggle to take a single step. Moose, the vegetarian who eats "medicated food" such as willow sticks and lily roots, is a walking example of the power the Creator gives to animals.

The explanation of the double moose, deer, and caribou finally arrived 64 years late. In 1929, an anthropologist from the National Museum of Canada spent a summer with the Parry Island Ojibwa, who have always resided on the eastern shore of Lake Huron. They live at a place known to all Ojibwa as *Wasaksing* or Beaver Stick Waters—a reference to the freshly peeled beaver sticks found floating on the lake. There, an Elder named Jonas King—described as "a frank pagan, very keen and active"—spoke about the world beneath the earth, where the departed souls of all animals travel and dwell until reincarnation:

One winter a moose, in the form of a big old man, carried two boys away to a land where there was no snow. It was bitokomegog, *the underground world in which moose have their village. Some time afterward he brought the boys back to earth and restored them to their people.*

With this brief observation, artistic patterns and cultural beliefs were reunited. The concept is widespread. In a tale collected from a northern California tribe, two deer escaped from Mother Grizzly by lifting a pestle out of a bedrock mortar and descending to the underworld through the cylindrical hole. The deer emerged miles away on the side of a mountain. The underground passages featured in Native American literature and rock art teach us about the inward journey of the shaman and the tunnel of the near-death experience. This is a lesson of renewed life, whether through a soul's reincarnation after the death of the body, or through a symbolic death and restoration of life.

WHERE LAND AND SEA MARRIED

Whales frolic with fertile women on boulders circling a detached headland near the tip of Washington state. Their eyes weep salt tears of joy and sorrow as the rocks are swept twice daily with ocean water. In order to understand the site, we need to look up the shore to Ozette, an ancestral settlement of the Makah tribe.

A crushing mud slide paradoxically destroyed and preserved Ozette. Perhaps the Makah villagers felt an earth tremor or noticed unusually hard rains on the flat roofs of their cedar plank houses. Suddenly, 300 years ago, a terrible, abrupt break occurred in the cyclical life of fishing, seal hunting, and highly ritualized whaling at Ozette. A natural catastrophe struck several houses in a village of sea hunters. Seismic activity loosened tons of clay from the hillside and liquified the heavy soil, which in the energy of the moment ran down the steep ridge behind Ozette. Although built with sturdy posts, the long, cedar plank houses snapped like brittle twigs and collapsed into jumbled piles. It was a catastrophe which, with the passing of several hundred seasons, became a precious snapshot of life before European changes. The ancient mud slide contains a unique instant of time, preserved so well that we can almost travel back in time to stand amid the activity of a busy northwest coast house.

Ozette was the largest of the Makah winter villages—a settlement extending back 2,000 years and abandoned only because of the forceful actions of Indian agents around 1910. In the stratified societies of northwest coast tribes, where the spectrum of society included nobles, artisans, warriors, commoners, and slaves captured from enemies, village size carried extra significance. The Makah, who continue to live on their lands at Neah Bay, are closely related to the seaward tribes of Vancouver Island across the Strait of Juan de Fuca. Language, custom, and one special characteristic—a tradition of elaborate spiritual preparation for

whaling, the most sacred hunt in aboriginal North America—connect the Makah and Nootka.

Masked shamans once beat wooden box drums to rhythms that must have echoed off the steep island cliffs, looming hillsides, and shoreline rocks at Ozette. Life in the winter village was filled with ceremony. By late winter, the whaling leaders began their long, deliberate preparations for the spring migrations. At that time, the pulse of all Nootkan groups kept tempo with the rhythms of whale songs. Bold whale hunters not only pursued California grey whales and humpbacks returning in coastal lanes from the warm waters of Baja, but also tested their purity by venturing into deeper waters to kill sulphur bottom whales and right whales.

Long-buried remains emerged from the layers of shell and ash when Ozette was excavated—the massive ribs and vertebrae of whales. In the small parcel of the Makah village unearthed by archaeologists, the remains of over 67 whales were discovered. Analysis of all food remains—from clam shells to fish vertebrae to the long bones of whales, seal, and otters—revealed that whales furnished over three-quarters of the prehistoric diet.

Ozette has been characterized as the richest accumulation of large sea life remains south of the Aleutian Islands. In the lush, fertile months of spring and early summer, California grey whales migrate north. The coastal waters of British Columbia, Washington, and Oregon are spared from the potential bleakness of their northern setting by the Japanese current that warms the ocean and supports abundant sea life. Before the Boston whalers and Russian sea otter hunters decimated the natural sea mammal populations, the edge of the continent was famed for the richness of its sea life. Countless seals, sea otters, and sea lions could be found basking on offshore rocks and floating in the camouflage of kelp bed forests. Ozette has been described as the preeminent whale and seal habitat outside of the Arctic. This natural legacy was acknowledged with a unique whaling shrine inscribed with petroglyphs.

Ozette rock art is part of a fairly well documented cultural landscape. From tribal traditions, we can learn much about the connection between whaling and the very soul of the Nootkan nations. The shared lore includes prose, legends, and carved art of the tribes who once inhabited the seaside between Oregon and the Alaskan panhandle. Combined, these arts enable us to appreciate rock art as a unique link in the world of the northwest coast.

One summer, I lived in the Nootkan whaling village of Hesquiat, on the west shore of Vancouver Island. There, I listened to the few remaining Elders talk of the days of their grandfathers—always within sight of the passing whales. The tribes of this coast placed their Dreaming Rocks along the shore.

Several of the whales and human faces at the Ozette whaling shrine are marked with a weeping eye motif, a convention found again at rock art sites on Vancouver Island. In one instance, a woman stands or lies with a whale held in her arms in front of her shoulders. The whale is centered over her mouth—a reminder that women influence these creatures. Other whales, possible spirit state hybrids, combine the plump body of the grey whale with the broad tail and erect dorsal fin of the killer whale. These whales swim beside carved, round human faces.

The presence of an uncommon rock art site at Wedding Rock, devoted to the powers of life and fertility, makes sense when the cultural and biological settings are considered. According to the Elders of these seafaring tribes, whalers prepared for the hunt with lengthy periods of careful rituals. Cleansing and swimming in secluded pools were part of the slow, deliberate activities done to favorably influence the whales. On Wedding Rock, one of the whalers has been portrayed wearing branches on his head—a sign of purification. Whalers' wives would lie still in the plank houses, for women strongly influenced the sea creatures.

Elsewhere on the Wedding Rock boulders, basic representations of female genitalia lie carved beside sea creatures. The fertility symbolism culminates with two petroglyph women whose jewelry, hands, and headdress mimic their prominent sexuality.

The 17 marks of women's fertility, depicted as birth openings, record life springing forth from the earth and washed by the sea. The salt sea and tides within us connect all animals. There is an almost indefinable transition of land and sea where the waves break, akin to the daily wedding of night and day. Shamans call the vague instant, when night has almost faded and sun casts a pre-dawn glow in the east, the break in the universe. It is a time of healing—of power acquisition. Ojibwa Elders advise their followers that, lacking proper herbal medicines in an emergency, anyone could hold a container of water to the merging of night's darkness and day's light. With prayer and the opening of the soul, the water would be blessed and turned into a healing liquid capable of any cure.

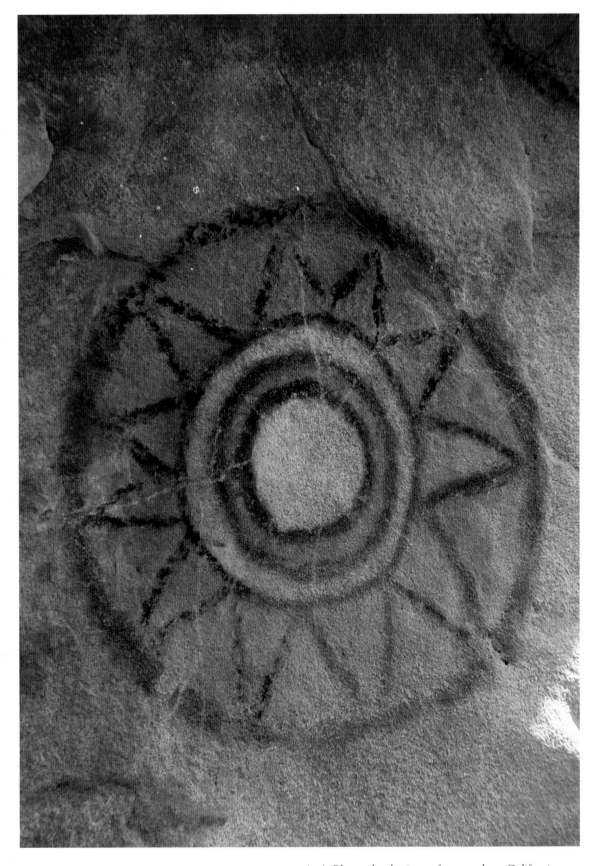

▲ *A Chumash solar image from southern California.*

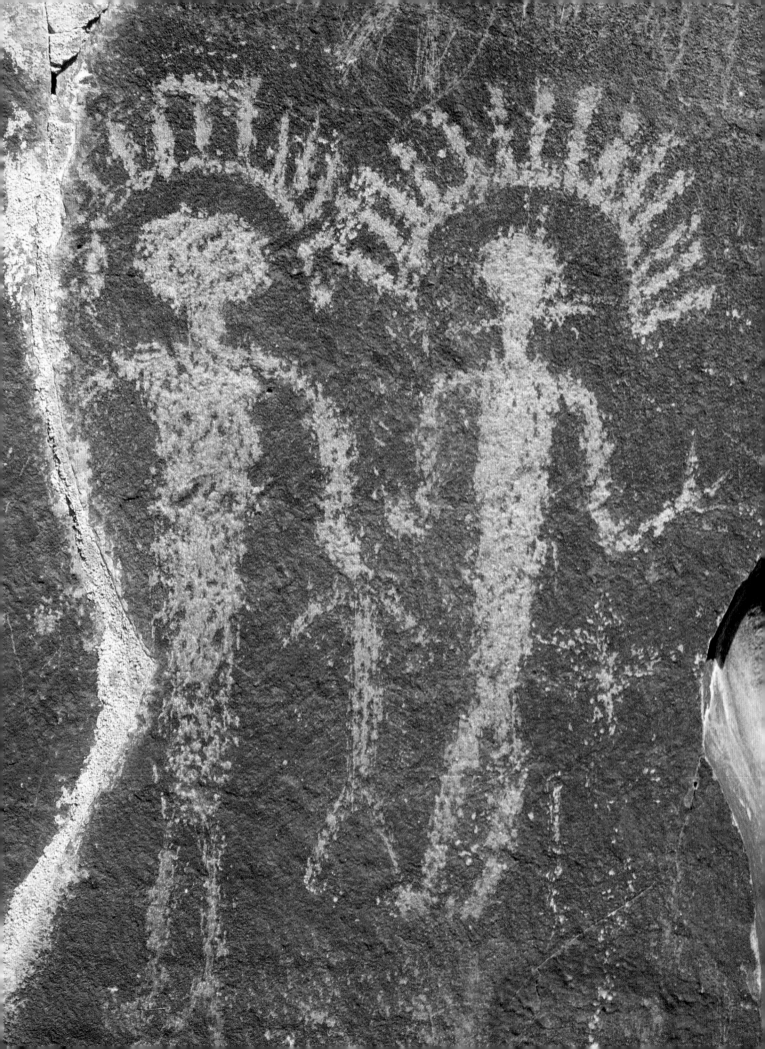

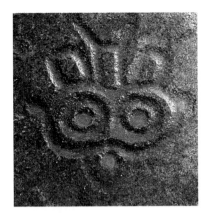

Warriors, Mummies, and Mona Lisa

Rock art can be puzzling, challenging, and contradictory. An imaginary catalogue that presented several hundred thousand rock art images could be divided into many broad categories, yet the idiosyncratic and often highly individualized subjects would remain distinct, uncomfortable with their neighbors. Any formal inventory of rock art faces this problem: How can it be divided into meaningful groupings? I don't think it can.

Most schemes reduce these inspired creations into mundane classifications beyond recognition or meaning. It is easy to assign many of the apparently recognizable depictions to common categories—real and imaginary animals; assembled human figures; artifacts such as bows and arrows, spears, pipes, and rifles; celestial objects frequently rendered as cross-like stars; hand prints and lines of animal tracks; and the catch-all, enigmatic group of abstract or geometric art. Yet ambiguity will always remain, for science is not prepared, by its nature or vocabulary, to master the dreams, visions, and insights gained from aboriginal culture.

▲ *What is probably a mask, carved into sandstone exposed during low tide at Port Neville, British Columbia.*

◀ *Twins from the Vantage site in the central Columbia River plateau area. Now on display at Ginko Petrified Forest State Park, Washington.*

We have already met some special Dreaming Rocks: the clever moon spider in Michigan; the extensive California Dream panel at La Piedra Pintada; an enlightened solar deity and alluring Earth Goddess at Ontario's fabled Teaching Rock; and the trance doorways and rainbow bridge motifs at Arrowhead Springs. The following introductions lend insights into the Dreaming Rocks that mere categorizations could never achieve. By meeting a few more memorable rock art personalities, we can gain further insights into Native American mythology and the realm of the sacred.

THE WARRIOR TWINS

Forgetting for a moment the characteristic images of particular Native American groups, such as thunderbirds and horned serpents, several other distinct, widespread images crossed rivers, prairies, and mountains, carefully nurtured in dreams, rituals, and legends. On the western side of the continent, a pair of brothers known from Navaho and Zuni rock art sites and tales as Ahaiyute, the Warrior Twins, appear again at rock art sites in eastern Washington and the southern interior of British Columbia. Whether carved or painted, these northwest twins stand side by side, often with joined hands.

The Warrior Twins' roots extend deep into the mythology and elaborate rituals preserved among the Navaho and Pueblo groups of the southwest. They also appear, holding various ceremonial items, at several painting sites. Sunburst half-haloes or horns, common devices used to indicate supernatural status, often appear above their heads. Rowdy, instructive, and intimately connected with Zuni and Navaho religious observances, the Warrior Twins' adventures often form the basis for martial ceremonies like the Scalp Ceremony. These are gods with feet of clay whose rude deeds and scandalous conduct counterbalance their helpful instruction.

These same deities were a central part of the Twin War God rock art site, a sacred setting on the San Juan River in northern New Mexico. Although background environmental studies—completed prior to the construction of the Navaho Dam on this river—preserved in print the memory of this important rock, sadness lingers over the now submerged holy ground where the Navaho once prayed to the Warrior Twins for rain and other favors. Native traditionalists continued to use the Twin War God site right up to its last days,

until it became inaccessible in 1963.

Throughout the Columbia Plateau, from the Snake River to The Dalles just above the Columbia Gorge, pairs of hand-holding human figures also appear on pictograph sites. The presence of the rainbow-like, arched haloes with radiating light above their heads indicates their special status and powers. Painted horns sometimes replace the haloes. In this land, well-preserved mythology and tribal customs offer some insights into the role of the twins as emissaries of the animal kingdom.

Most northwest tribes believed that salmon lived like people under the sea, only donning fish costumes during their long migrations up the rivers. Stories recall a male salmon coming ashore under the shade of night, hanging up his fish skin clothing, and entering a coastal encampment as a man to court and wed a noble's daughter.

Among these river tribes, twins have wielded legendary influence over salmon. In fact, the Chinook Wind Brothers—suggestive of but not identified as twins—wrestled with the Cold Wind Brothers over possession of this vital food fish. Chinook Wind Brothers, a warming influence on earthly affairs, won the match and forever held the Cold Wind Brothers in abeyance. Now the salmon run freely during the periods of better weather.

For the Columbia River tribes, the arrival of twins at birth signalled a need for caution. Perhaps the presence of one life visibly transformed into two led to the belief that twins possessed magnified, potentially dangerous shamanic powers. James Teit learned from the Thompson Indians of the British Columbia interior that twins announced their presence to their pregnant mother by sending images of the grizzly bear into her dreams. After delivery, the twins gained bear status and were given nicknames such as "grizzly bear children" and the indirect "hairy feet."

Elaborate ceremonies nervously welcomed the twins, who carried special access to their benefactor, grizzly the salmon eater. From these powers, twins could control the weather—a determinant of food resources including fish. Twins were so infused with power that, after their birth, their parents would move the family lodge some distance outside of the main camp. Aromatic and purifying fir boughs were used to disperse the babies' powers. Their father would walk circles around them, creating sacred space by dragging fir boughs on the ground. These same plants appear on the painted

boulders of the Thompson Indians, as another indication of sacred space. Similar abbreviated insights into the connection between painted twins and mythology are repeated at dozens of rock art sites.

A FAMILIAR TRAVELER AT DREAMER'S ROCK

Another unmistakable depiction, a traveler who carried along a flute, staff, and the seeds of revolution, journeyed from the valley of Mexico across the parched southwest lands of the Pueblo tribes to the northern reaches of the continent. His final stopping place is marked on a marble slab hidden in the forests of Canada. Neither fatigue nor difficult paths halted his progress. Only the hoary breath of the north wind and early frost could stop this seasoned traveler. The most familiar name for him is Kokopelli—seducer, sordid hunchback, and famous nurturer of corn.

Where did the association between fertility and this misshapen figure arise? The idea belongs to several North American Indian groups. By looking at other humpbacked images and the ideas preserved in folk tales, we can gain a better understanding of this unusual concept.

According to the tribes of the American southwest, the humpbacked man was a fertility spirit. Inside his enlarged back, he carried seeds and the moist clouds necessary to foster plant life. Some First Nations called him Kokopelli. Often shown with his seductive flute, which swayed maidens with its sweet music, Kokopelli appears on sacred, painted cliffs, and is also found on ancient clay bowls. The Ojibwa knew him as Bebukowe, a bent man who sometimes wore a grasshopper's face.

Some say Kokopelli looks like a rabbit; others see a grasshopper's face. With his sexuality often depicted, Kokopelli enjoys life as he spreads his seed. To the Navaho, who mix corn growing with sheep herding, he is Ganaskidi, who plants seed corn, waters it with the mist carried in his hunched back, and guards sheep with his staff. At the Peterborough Petroglyph site, he watches over a graphically displayed male figure renowned as a fertility image.

Kokopelli's appearance so far from his homeland in the southwest is a clue to the "meaning" behind the image—reminding us not only of fertility and corn's sustenance, but also of the rituals that would ensure successful crops. Ritual objects, or their depictions, physically confirm an entire set of practices, beliefs, and lore. Nurtured by customs and ceremonies, corn

migrated to the Great Lakes area.

Legends differ in their details about the supernatural hunchback. Some storytellers said he originally sprang from his knapsack. Over the centuries, he evolved into a figure whose burden was an integral part of his body. Sometimes he exchanged his flute for a staff. He travels ceaselessly, nurturing crops and other beginnings of life. His staff also serves as a digging stick for planting seeds.

In the Great Lakes area, Kokopelli moved under an alias. "Do you know about a hunched-over man who is carved at the Teaching Rock?" I asked Fred Pine.

He replied without hesitation. "Oh, we haven't seen him for years and years. We call him Moh-Kwah-Oh-Gun in Indian; but people started to call him Old Jacob when I was a boy." Fred Pine then told the following story:

Wabmaymay, whose name means "The Dawn's Pileated

▲ *Kokopelli, the seducer, with flute. Sand Island, Utah.*

Woodpecker," told me this story when I was a boy. It must be an old, old story. One time, the Indians were having trouble with the Windigo—a terrible giant made of ice. Windigo came near our camps in the middle of winter. Many times Windigo killed and ate Indian people. The elders always spoke of Windigo as a terrible thing.

"We have to kill it," the elders decided in a council. "We must do something to the Windigo." Eventually the Indians got rid of the Windigo and those other strange men, too. They were desperate men. So they hired a strange man to help them. He was a man who later became known as Moh-Kwah-Oh-Gun, "The Broken Back."

That strange man did something wrong to that Windigo. So the Windigo said, "You will never be able to look like a man again. You made a fool out of me." He is Chi-Mackinah-Goh. That means "You Made Me A Fool."

Anyway, the Windigo got this strange man home and broke his back. And broke his nose. So that Moh-Kwah-Oh-Gun was always walking around with a broken back and snot running out of his nose. A dirty looking person after that. Well, the Windigo fixed him for making fun of him. Indians still see the Broken Back Man once in awhile, but nobody can get near him.

This story reveals how the hunchbacked person became bent over. He challenged and outwitted the

Windigo, who later took revenge by breaking the man's back. There are other elements hidden beneath the surface of this tale. The "Broken Back Man" is a carrier of life's elements just as the spring rains nurture new plants. Humble and non-threatening, for he is a broken man, he is the opposite of the powerful Windigo. The ice giant represents the neighborhood of death—frozen flesh, murder, and other vicious crimes against life.

"He's a dirty old fellow, but he has a way with the ladies," Fred continued, laughing. "There's something serious about him, too. He had a job to do just like all of the spiritual people the Creator put on this earth."

PIPES AND DREAMS

During the late 19th century, years of intense tragedy for the Sioux, a miracle took place among the Sioux tribes. The White Buffalo Spirit, capable of transforming into a wise woman, walked into the dreams of the Lakota Sioux. *Wakan Tanka*, the White Buffalo Spirit, introduced ceremonies capable of restoring their relationship to the Creator. The sacred pipe achieved prominence in these dreams. The vision spread quickly, reaching neighboring tribes.

At Basswood River, shaman artists left a dream portrait of a moose bearing the sacred pipe in its mouth. Is this the boreal forest equivalent of *Wakan Tanka*—the ultimate spirit—with moose replacing buffalo as resident lord of the land? Although the Sioux and Ojibwa fought each other across the borders of woodlands and prairie in what became northern Wisconsin, Minnesota, and Ontario, few people recall that some Sioux groups originally dwelled in the forest prior to the arrival of the horse. Through wartime raids and subsequent capture of enemies, and during peaceful interludes of trade and intermarriage, the neighboring Sioux and Chippewa-Ojibwa nations exchanged many ideas.

Not far away on Lac La Croix, an ultimate dream animal—once seen, never forgotten—endures the passing seasons. This elegant male moose holds aloft the most elaborate antlers ever painted in the Boundary Waters region of northern Minnesota and northwestern Ontario. A consummate portrayal, the moose brings to mind legends of the "boss animal"—the ogima, leader of the moose tribe. The Lac La Croix moose stands as guardian of his tribe, intervening into the lives of native people, demanding respect, entering dreams to give advice.

Several core Algonkian images appear in the beaded,

▲ *Dream moose carrying a ceremonial pipe in its mouth. Basswood River, Boundary Waters Canoe Area Wilderness, northern Minnesota.*

▶ *The Lac La Croix moose remains one of the outstanding pictographs from the boundary waters of Ontario and Minnesota.*

drawn, and carved art of the Sioux. Photographs of late 19th-century Sioux delegations to Washington, D.C., show leaders wearing decorated vests and carrying ceremonial objects bearing motifs directly related to those of their northern rivals. Similarly, when the Ghost Dance spread hope as rapidly as a prairie grass fire among the Sioux horse tribes, the Ojibwa subsequently adopted a Ghost Lodge into their indigenous Grand Medicine Society.

The smoking moose of Basswood River, a spirit carrying ritual and wisdom in a shaman's dream, probably embodies a relationship to Wakan Tanka, the ultimate spirit. The same message and sacred pipe rituals were widely shared. A spirit buffalo appeared to the Sioux in dreams, offering them the sacred pipe. Not far away, the Ojibwa painted an image of moose holding a sacred pipe in her mouth. It makes us wonder: "Is there a connection?" Amazingly, Algonkian groups—living as far removed from the prairies as western Quebec—have a word for buffalo that they later adopted to describe the cattle brought by Europeans. Did the buffalo travel by pipe, dream, and ritual across dense forests? A few buffalo appear painted at rock art sites situated well within the boreal forest of northwestern Ontario. Although moose is not called anything but *mooz* by Algonkian tribes, the supreme animal could be thought of as the "forest buffalo."

Lakota Sioux medicine traditions lend their interpretations to moose, the pipe carrier. The pipe-smoking moose of northwestern Ontario may be related to the White Buffalo Spirit of the Lakota Sioux. However, two distinctive moose, cow and calf, stand frozen in time at Darky Lake in Quetico Provincial Park's famed canoe country. The lead animal has been called the "heartless moose." An unpainted area marks her chest. Was it deliberate? Or has the pigment flecked away? What do the red spheres dropping below her muzzle mean? This is an intriguing moose family, and there are many questions to be asked.

The interplay between animal spirits and Native Americans continued well into this century. In the remote Temagami wilderness near the Ontario-Quebec border, a famed conjurer nicknamed Temagami Ned demonstrated his connection to the animal spirit world. Seventy years later, Chief Bill Twain recalled how desperate his parents were to slay a moose for food that winter. Traveling across their family grounds in the company of Ned the conjurer, they stopped, exhausted by hunger. Ned asked to borrow a small mirror used by one of the men for shaving. He squatted down beneath a blanket and gazed deep into the reflection. Forcing his spirit out through an opening in the universe created by the mirror's surface, Ned flew across the densely wooded hills and contacted the soul of a moose. Ned rose up, gave directions, and within the hour the Twain family had killed a moose after days without a sign of the reclusive animal. This is the communication between tribes, native and animal, that helps us understand the ochre images of moose and buffalo.

PRAIRIE VISIONS

The great touchstone for Sioux nations lies amid the holy Black Hills, where legends, spirits, and ancestors merge in the hazy distance. One sacred place, left preserved in southwestern Minnesota and now known as the Jeffers Petroglyph site, appears to have been a place of Sioux dreams for several thousand years. There, amid the tall grasses, butterflies occasionally flitter above the distinctive Sioux butterfly carvings. Rendered like stick-figure biplanes, the insects lie preserved in rose-colored quartzite. Although Black Elk probably did not have a direct connection to the Jeffers site, the symbolism found in his visions identifies this sacred rock as a Sioux vision quest site.

A famed Oglala Sioux medicine man, Black Elk had a profound vision. As eagle and hawk soared in to meet him at the holy circle, Black Elk lamented his nation's suffering. Facing south, a cloud of multi-colored butterflies drew near and swarmed around him, so that Black Elk became lost in a sea of their beating wings. Eagle, perched on a nearby pine, told him that the butterflies were the Sioux people. Black Elk listened closely and heard their voices crying over the destruction of their land and the sorrows that came upon them. The small, winged creatures left and thunder arrived, intensifying Black Elk's vision. In this complicated spectacle, which took place between dusk and dawn, the butterflies returned as thick as a dust cloud before transforming into diving swallows—a Sioux metaphor for thunderbirds—that symbolically destroyed the Sioux nation's enemies.

Black Elk's visions inform us twice. His words carry the breath of life for petroglyphs such as those at the Jeffers site. And through the good fortune of being a Plains Indian of the late 19th century, Black Elk drew several of his visions onto paper just as his ancestors reformed the surfaces of stone. Black Elk's sketches show butterflies and swallows drawn in the same styles as the

Jeffers carvings, thus providing cultural links between silent stone and the living Sioux. Characteristically, in nature, the swallows precede ominous clouds—a metaphor based on observations of the frantic feeding that sometimes occurs before a storm.

Other petroglyph elements at this outstanding site—over 1,885 images have endured at Jeffers—call attention to Sioux ritual life. Simple human figures, wearing horned bison headdresses, abound, as do hunting implements and bison. The interchangeable thunderbirds and swallows outnumber the bison—sky elements to remind us that the supernatural resides here.

While rock art preserves Sioux dreams at the Jeffers outcrops, a unique sacred pipestone quarry found about 60 miles to west also contains carvings in stone. The well-traveled artist George Catlin lent his name to the blood-red stone catlinite, a stone sought for ceremonial pipes. Although Pipestone National Monument

preserved the catlinite source, an artifact collector—lacking any reverence for a shrine marked by rock art—removed the carvings designating this sacred space over 100 years ago. It is not too surprising that the guardians were images of thunder, whose bolts fertilize the earth and destroy evil personified by the serpent. These images originally covered a boulder shrine created by glacial ice.

In the 1880s, the Sioux recalled the origins of the petroglyphs at the shrine. According to legend, a storm appeared to be forming over the area. The Sioux took precautions:

Each one hurried to his lodge, expecting a storm, when a vivid flash of lightning, followed immediately by a crashing peal of thunder, broke over them, and, looking towards the huge bowlder [sic] beyond their camp, they saw a pillar or column of smoke standing upon it, which moved to and fro, and gradually settled down into the outline of a huge giant, seated upon the bowlder, with one long arm extended to

▲ *The Jeffers petroglyph site is a quartzite outcrop amid a sea of grass. Southwestern Minnesota.*

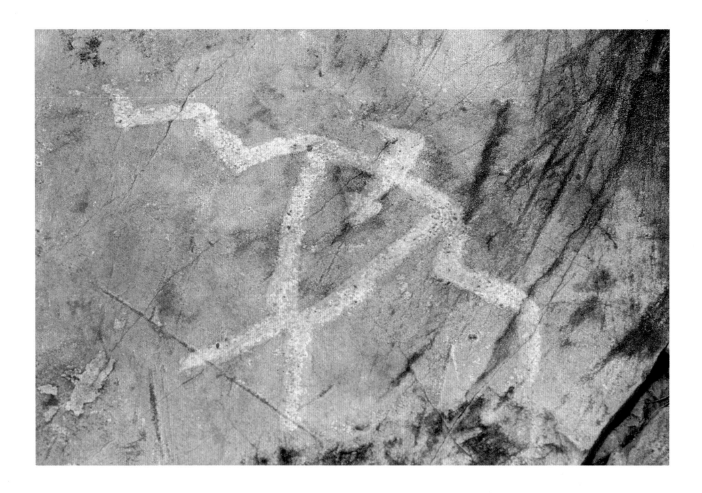

heaven and the other pointing down to his feet. Peal after peal of thunder, and flashes of lightning in quick succession followed, and this figure then suddenly disappeared. The next morning the Sioux went to this bowlder and found these figures and images upon it, where before there had been nothing, and ever since that the place has been regarded as wakan, or sacred.

A few of the indigenous petroglyphs—born in the thunderstorm—have been recovered. Today, the pecked thunderbirds watch over the pipestone, perched uncomfortably and cemented into man-made walls. The prominence of carved Thunderers at the catlinite quarry brings to mind a statement by the Ojibwa pipe carrier, Dan Pine. He said the reason vision questing was done in the springtime was the need to hear "Thunder's cry." The break-of-season storms crossed his homeland, resonating with thunder's voice and infusing new plants and baby animals with lightning's energy. For this reason, he would re-light his pipe in a special springtime ceremony—after the first storm—to

acknowledge thunder's life-giving forces.

Pipe ceremonies spread far and wide across tribal country. In 1844, a Jesuit living among the Ottawa on Lake Huron's Manitoulin Island described one vital role of the pipe, which is also called a calumet:

When the [Indians] of a tribe are divided by some sport of reciprocal animosity, the chiefs assemble the tribe. The orator speaks, and after speaking lights the calumet, smokes four mouthfuls, then presents the calumet to each person present. Those who wish to be reconciled smoke four bowls; those who wish to refuse, also refuse the calumet. For everyone to smoke the same pipe is a sign of unity.

From the Black Hills to the prairie to the edge of the forest, the Sioux marked their land with carved and painted images and brought life to natural landscape features with creation stories. Like all tribal nations, the Sioux also personalized their world with mythology. Their sacred geography has been compared to a reflection of stars, for each of the topographic features shares a comparable image in the stars. At places like

▲ *A thunderbird with heart at the Jeffers site, Minnesota.*

the Devil's Tower, where legend tells us that ancestors escaped grizzly by jumping on a stump and commanding it to rise to dizzying heights, fluted walls preserve bear's clawing at the stump as it ascended. Each night, a certain constellation rises overhead as a reminder of this cultural reference point.

SHIELD-BEARING WARRIORS

Petroglyphs from the prehistoric and historic periods of the Great Plains tribes appear in great abundance at *Aysin'eep*, "It Has Been Written," as the Blackfoot tribes call Writing-On-Stone Provincial Park in southern Alberta's shortgrass prairie. Along this section of the Milk River, which flows south into Montana, forces of erosion have opened the prairie earth, exposing soft sandstone bedrock. For thousands of years, flowing water and scouring winds reshaped Writing-On-Stone into a mysteriously dramatic setting, filled with hoodoos—sculpted towers of rock, sometimes capped with oddly shaped stone slabs. To native groups concerned with the spirit world, this valley was home. Today, hundreds of carvings and a few paintings lie hidden amid the maze of hoodoos that line the river terraces.

One group of painted and carved elements emblazoned on these rocks has gained a distinctive name—shield-bearing warriors. These unforgettable images reappear at numerous sites across the vast prairies and eastern Rocky Mountains. The large, round, body-sized shields display pure personal power. The highly individual designs adorning each shield testify to the owner's dream—his source of identity and power. These shields tend to eclipse the warriors, who barely emerge from behind the protective discs.

Action scenes, depicting the shield-bearing warriors in combat, on foot, and riding their war horses, are common. This artistic tradition is characterized by frequent depiction of horses, guns, lances, coup sticks, historic battles, and even distinctive tribal clothing. Horse images changed from the earlier, blocky renditions to meticulous images, recognizable by breed and brand. The level of detail expanded as battle scenes included bullets flying from rifle barrels and tracks linking the sequence of events across the panel. It is even possible to identify warriors counting coup—touching their enemies while weaponless. Another example of attention to detail is found in the carvings of Crow Indians, who favored a coiffure, where the hair was piled high in a pompadour above the forehead and

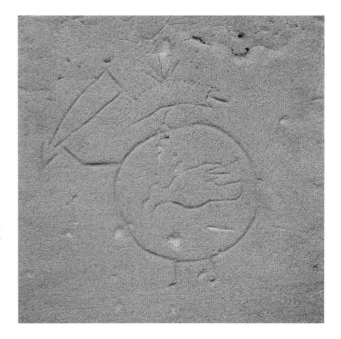

long braids trailed over the warrior's shoulders. This tribal style appears in early photographs of Crow men, in ledger book drawings, and carved in rock at Writing-On-Stone and other Great Plains sites.

The Shoshoni inhabited Writing-On-Stone prior to the arrival of the horse. While scholarly disagreements continue, it appears that the Shoshoni participated in creating the shield-bearing warrior images. On the continuously weathering sandstone walls of Writing-On-Stone, the visible rock art probably extends back no more than a thousand years. Earlier petroglyphs have been erased by the wind and returned to the earth. In addition to the ubiquitous buffalo hide shields, Shoshoni rock art includes numerous human figures with distinctive V-shaped necks and pointed shoulders, and animals with boat-shaped bodies. Unlike the later, shallow carvings made by Blackfoot warriors, Shoshoni art is deeply incised into the vertical panels. Unlike the dynamic, action-filled battle scenes created by the Blackfoot, these images are generally static, depicting shield-bearing warriors displaying traditional weaponry—lances, clubs, and bows.

The presence of two related yet differing uses of rock art at Writing-On-Stone records the rapid changes in tribal life across the Great Plains. Rock art content was shifting dramatically from the ceremonial to the biographic. In the 1770s, biographical rock art, containing true narrative scenes, spread rapidly across the Great Plains. The confederated Blackfoot tribes

▲ *Shield-bearing warrior with club from Writing-On-Stone, Alberta.*

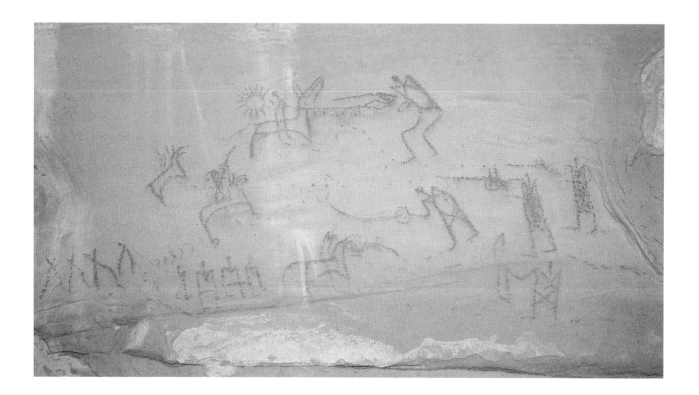

swept south to Writing-On-Stone, displacing the Shoshoni and adopting the same sacred earth canvases for a prairie art movement that evolved in the 1800s. For the first time, true narrative art, showing historical events, appeared on stone beside older images devoted to vision questing and appeasing spirits.

These recordings of historical events, including skirmishes, prepare us for the premiere piece at Writing-On-Stone—the Battle Scene. This detailed composition records a major battle fought by over 100 warriors armed with rifles. Along with the warriors, nearly a dozen horses, dozens of teepees, and possible defensive embankments were etched into the rock. This is probably the memory of an inter-tribal battle, such as the bitter fight in 1866 between the Piegan Indians and the Gros Ventre or a similar action.

Although the history of the mounted tribes is confined to a period of 150 years—about 1730 to 1880—whirlwind changes took place, enabling them to widely roam the prairies and wage warfare with surrounding groups. These tribes, which include the Cheyenne, Blackfoot, Sioux, and others, left their mark through distinctive rock art traditions that spread across the northwest plains and southward to Texas and New Mexico.

SHROUDED MUMMIES IN A UTAH CANYON

Perhaps the most famous concentration of aboriginal pictographs and petroglyphs occurs on the Colorado Plateau—an area also known as the Four Corners that includes Utah, Colorado, Arizona, and New Mexico. Here, among the canyons and mesas, a vast rock art legacy has accumulated over thousands of years.

In a series of canyons across southeastern Utah, majestic and truly haunting apparitions rise up like banshees. A great number of these ghosts, with their tapered torsos lacking legs and arms, were discovered in Barrier Canyon, Utah, which then lent its name to this unique style of shaman or spirit paintings.

Barrier Canyon lies near Canyonlands National Park, a magical landscape that straddles the Colorado River. Throughout this area, eerie spirit figures rise above the ledges, out of sight of casual viewers. In the still, lingering heat of the afternoon, these images work upon our imaginations. The life-sized, dramatic ochre bodies lend a sense of calm to the gallery. Some are seven feet high.

This sophisticated rock art, product of an artistic tradition that suddenly appeared in the Great Gallery of the Barrier Canyon and then vanished abruptly a thousand years later, is simply unequalled. The Barrier

▲ *A horse raid between two Indian groups recorded at Writing-On-Stone, Alberta. The raiders (left) armed with bows, rifles, and a sword, arrive on foot. Mounted warriors leave their camp, indicated by four teepees at lower right.*

▶ *Ghost-like, Barrier Canyon-style pictographs and their grand setting in Canyonlands, Utah.*

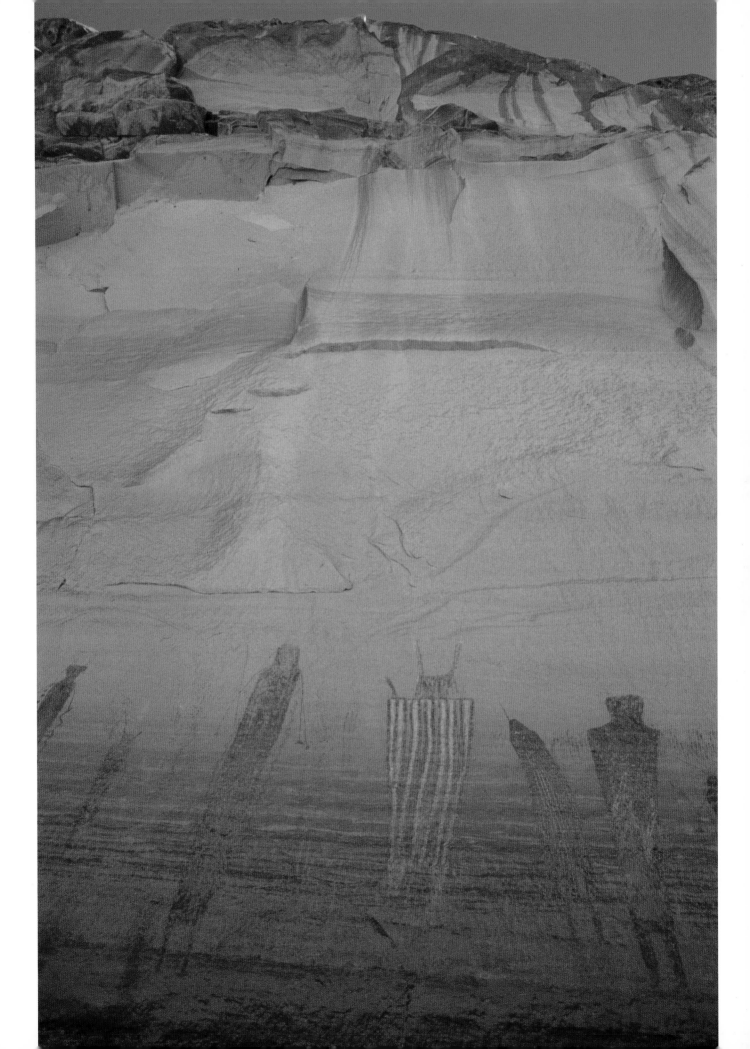

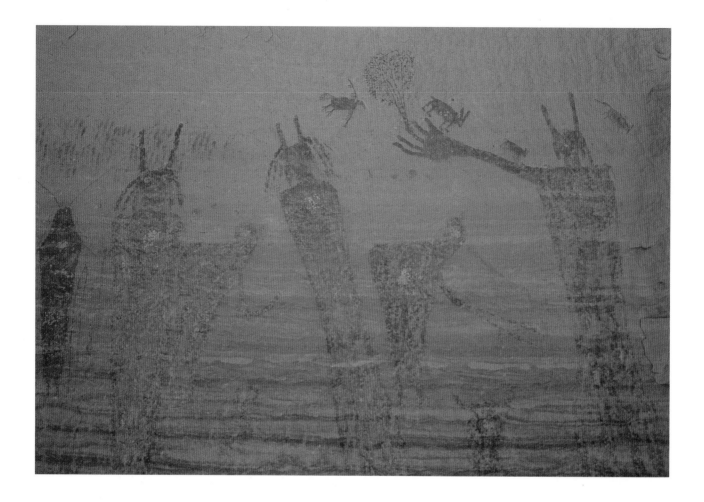

Canyon images often occur as a series of figures lined up across magnificent canyon walls. The Great Gallery is 140 feet wide. In addition to their overpowering size, these ghosts gain stature from their careful positioning on the canyon walls. A special gathering of these spectres—often called the Holy Ghost and Attendants—uses taller and shorter human forms to create depth and perspective—a situation not often encountered in rock art. Because of the clever interplay of sizes, these panels were undoubtedly meant to be viewed from afar. The juxtaposed figures are very effective.

The spirit forms are mysterious and foreboding. Hooded, bucket-shaped heads contain round, extra-large spaces in place of eyes, never letting us forget that we are confronting the supernatural. At times, the paintings almost reverse the viewing experience. Their careful positioning gives the feeling that ancient tribes have gathered to watch over *us*.

What purpose did this eerie rock serve so long ago?

We may never know. But the Barrier Canyon spectres may be connected to two other artistic traditions also found in the canyons of the southwest. Similar ghost-like paintings have been found along the Texas-Mexico border, and others are newly discovered in Arizona's Grand Canyon. Each offers clues to an untold story. The relationships intertwine universal shamanic themes and suggest past interaction between the regions.

WILLOW SPRINGS

Not too far from Tuba City, Arizona, a famed collection of rock art appears at Willow Springs. These images, consisting of carefully repeated rows of clan symbol carvings, have been interpreted by Hopi Elders. Within memory, the Hopi made long, difficult pilgrimages of over 70 miles from their mesa-top villages to the confluence of the Colorado and Little Colorado Rivers, in search of salt. The Willow Springs shrine, known as Tutevini or "Writing," provided a trailside stopover for the travelers. It was a dangerous journey. In

▲ *Plant harvest rock art from Horse Canyon in The Maze, Utah. A plant springs forth from the exaggerated hand of one shaman or spirit as animals run and fly across the panel. The bent individuals hold a seed beater and a harvesting sickle.*

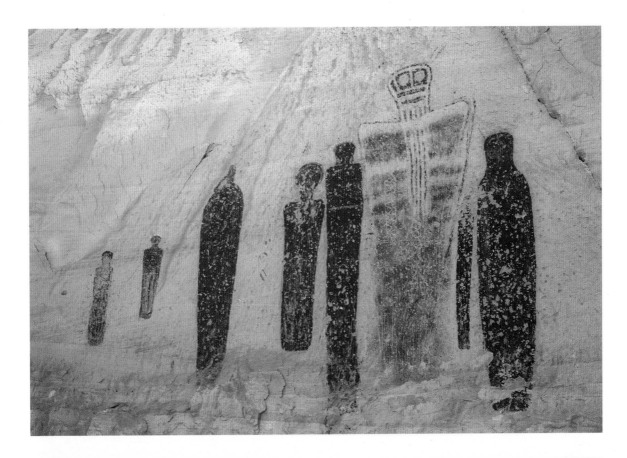

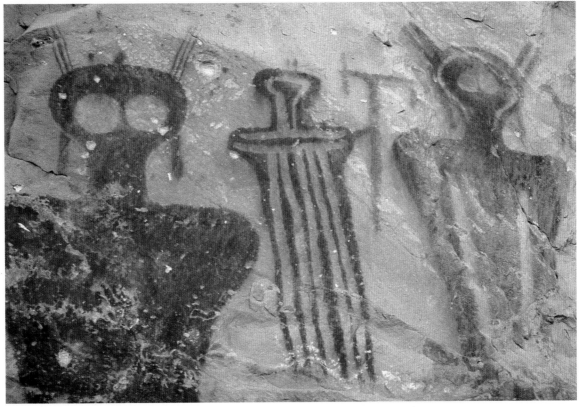

▲ Upper: A group of large specters, often called "The Holy Ghost and Attendants," hovering on the Great Gallery of Barrier Canyon, Utah. The tallest is seven feet high.

▲ Lower: Various shamans or spirits, probably wearing ritual hoods and other ceremonial items. Sego Canyon, Utah.

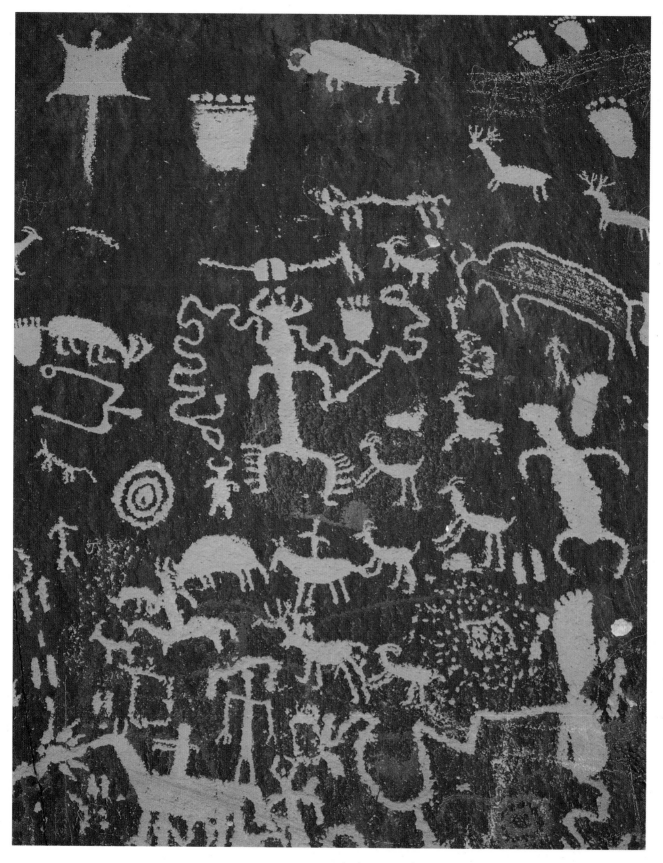

▲ *A portion of Newspaper Rock showing bison, horned shamans, riders on horses, bear tracks, bighorn sheep, a field of dots, and meandering lines. Indian Creek State Park, near Monticello, Utah.*

order to reach the salt deposits at the bottom of the Grand Canyon, the Hopi lowered themselves down by rope into the river valley, where the salt could be gathered.

Like many aboriginal groups, the Hopi take their identity from ancestral clans. At Willow Springs, the symbols of over two dozen clans line the surrounding rocks. The cloud clan's easily identified storm clouds with falling rain are placed in a row near the marks of the corn clan, the rope clan, and the coyote clan. Crow clan stands close to corn, perhaps watching over the clan's favorite food.

Each distinct clan mark occurs several times. Hopi Elders reported that they pecked a single clan symbol during each visit. When returning on later expeditions, the Elder would duplicate his clan sign to the left of the previous carving. The practice extended so far back in time that some of the clan figures could not be identified by knowledgeable Elders even in the 1930s.

NEWSPAPER ROCK

Across the country, small communities have long supported local newspapers that record events of interest and importance. When travelers ponder the busy, intense petroglyph panels at various rock art settings in the southwest, the scene often reminds them of pages from a newspaper. Today, rock art sites in Petrified National Park in Arizona and at Newspaper Rock State Historical Monument in Utah intrigue visitors. Many attempt to read these stone pages for insights into past lives.

Utah's Newspaper Rock is 20 feet wide, an expanse of dark stone bearing carved footprints, mountain sheep, shamans with horned headdresses, spirals, and meandering lines. Some of the carvings can be dated to the 10th century A.D. Others, such as the individuals on horseback, could be no older than the 1600s. The site is indeed a "newspaper" that conveys—or at least implies—much cultural history.

MASKED GODS

Native groups around the world have used masks to indicate transformations achieved during ceremonies. Among the Pueblo tribes of New Mexico, the well-established use of kachina masks in dances extends into rock art imagery. The Zuni have stated that it is the paint on the dance mask that holds the power. Thus, a pictograph of a mask is far more than a representation. The rich cultures that evolved over thousands of years

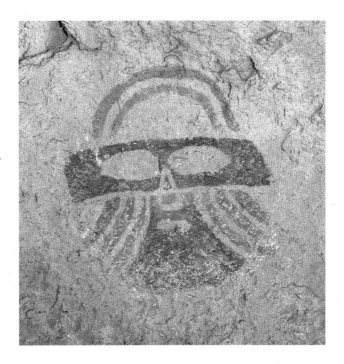

in the southwest developed sacred imagery that was repeated on wooden masks, on secret rock art sites, and as murals within subterranean kivas—ceremonial rooms hidden underground. Petroglyphs carved as recognizable kachina masks have been found along the Colorado River. Masks emblazoned on canyon walls are found throughout New Mexico. Some, such as the multi-colored Zuni kachina masks at the Village of the Great Kivas, vibrate with life and spirit.

NORTH AMERICA'S MONA LISA

I recently met an old Indian woman crying on the bank of a river. Her despair began long ago, in a time of dreams, when the world was being formed. Her tale gives meaning to the greatest river in North America—the once terrifyingly wild Columbia.

Unlike the coastal rain forests and the mist-nurtured Cascades, the interior of Oregon and Washington changes to high desert along a six-mile-long narrowing of the Columbia River known today as the Columbia Gorge. The Columbia gained its name from Captain Grey's ship, the *Columbia Redivia*, which sailed the river in 1792. That same year, Captain Vancouver unknowingly passed by the broad sand bar at the river mouth. Twelve years earlier, Captain Cook, who sailed amid gales from Hawaii, also missed the great river, hidden from the Royal Navy Explorers by rain and fog.

When Lewis and Clark reached the Columbia in the

▲ *A mask painted at Hueco Tanks near El Paso, Texas.*

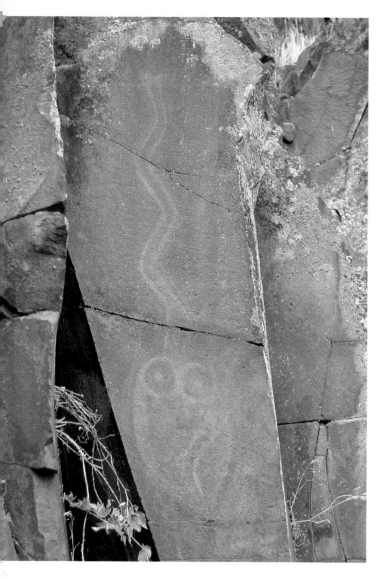

coast of North America in the later 1700s, at a time when the Russian fur trade in Alaska spilled down the same coast in search of sea otters. An unprecedented swirl of native cultures—Aleut hunters and native Hawaiians had settled and married into Chumash island villages off the Santa Barbara coast by the time of the Spanish missions—had taken place in the three decades prior to Lewis and Clark's westward journey.

This era, around the time of the American Revolutionary War, also saw the arrival of Boston traders along the west coast. Shipwrecked and captive sailors, taken as slaves by the Nootka, left us important descriptions about native life and customs in the face of change. In the rock art record, ship petroglyphs appear on traditional spiritual sites from southern California to the shores of Vancouver Island—for what reasons, we do not know. The portraits are accurate enough that we can firmly date these masted vessels to this time. The rigging style, as well as the configuration of their decks and forecastles, confirm this.

The recent history of the Columbia River has been a story of environmental destruction, a paring away of its beauty, history, and indigenous populations with their 8,000 years of river wisdom. Today, the Big River is flanked by overgrazed hills above The Dalles; salmon are denied access to over a thousand miles of their original spawning grounds; and one of the most significant concentrations of Native American heritage has nearly been washed away by dams built for hydroelectric power.

Within less than a century, the national treasure we call the Columbia was no longer wild. By contrast, local Indians continued to honor the first salmon in a yearly ceremony meant to instill, in each generation, a primal relationship with all living creatures.

Amazingly, in a world so filled with salmon, few fish representations appear in the local rock art. Native fishermen did identify some of the bizarre creatures carved along the falls and whirlpools, oddly resembling Halloween masks or Mardi Gras headdresses, as resident river spirits called "water devils." The tribes wisely decreed certain periods of the year open to salmon harvesting, while at other times fishing was prohibited. This system allowed the fish that offered themselves as food to reach the instinct-driven goal of their last journey—the gravel-covered spawning grounds. Today, we tend to disregard this respect for nature's rhythms.

The upriver entrance to the Columbia Gorge not only channelled waters draining tribal lands in parts of

spring of 1805, they continued a tradition first started by local Indians who called it *Nch'i-Wana,* "The Great River." Lewis and Clark's journals refer to "great quantities of salmon" and "a large number of Indians" even though more than half of the villages they passed lay silenced by epidemics that preceded them. Although previous explorers likely worked their way along Indian trails through the mountains to the Columbia, none left descriptions of the area. Diseases were carried by less-documented Europeans who arrived well ahead of this famous expedition.

As they reached the mouth of the Columbia River, Lewis and Clark met an Indian with red hair and freckles who stated that his father was a Spaniard. In fact, the Spanish renewed their interest along the west

▲ *A salmon spirit near the Columbia River at Horsethief Lake State Park, Washington.*

Oregon, Idaho, Washington, and British Columbia, but also served as a gathering place for the rich diversity of aboriginal cultures. All congregated there to feast upon the abundant salmon, to trade, and to reestablish ties to the ritual landscape. Coastal visitors, Salish, Chinook, native traders from northern California, and interior tribes from the Columbia's tributaries (later known as Nez Perce, Yakima, Wishram, and Wasco), created the original North American cultural melting pot. The neighboring First Nations shared in the Columbia's rich food resources. Their prophets and seers left the distinctive marks of their rituals co-mingled on rock walls and outcrops along the length of the Columbia Gorge from Celilo Falls to Portland.

Ideas, dreams, and rituals flowed for thousands of years through the only breach in the Cascade Range. Much of the river's rich history lies drowned by a recent quest for water power. But traces of the northwest's colorful aboriginal legacy have been relayed across the centuries by farsighted keepers of tribal wisdom. Images recalling the past remain tucked under the higher ledges and quietly planted among boulders that barely escaped the silencing effects of power dam flood waters.

Many thousands more carved and painted spirits were condemned to darkness and deluge when the original shoreline was submerged. Entire rock art galleries, such as Petroglyph Canyon, lie under the backed up waters of sequential dams from the Bonneville to the Dalles and Celilo dams. Vintage photographs hint at this lost connection to one of the richest concentrations of riverside aboriginal art on the continent. Despite the losses, so much carved and painted art was created on the river banks that we can still feel enriched by the remaining connections to the spirit of the Columbia.

The surviving rock art galleries of the Columbia River originated out of the diverse artistic traditions of many tribes. An inventory of motifs includes numerous human-like representations, fantastic creatures sometimes called "water devils" by the turn-of-the-century Indians, flocks of mountain sheep, graceful elk, and enough rayed suns to illuminate the entire drainage basin. Another peculiar symbol, named after a place or family once living at today's community of Spearfish, stands guard along the Columbia—the Spedis Owl. These haunting owls were carved with large heads merging into rounded bodies. Their eyes stare across the centuries.

Spedis Owls suggest watchfulness and potentially dark spirits. Prior to the flooding of vast sections of the

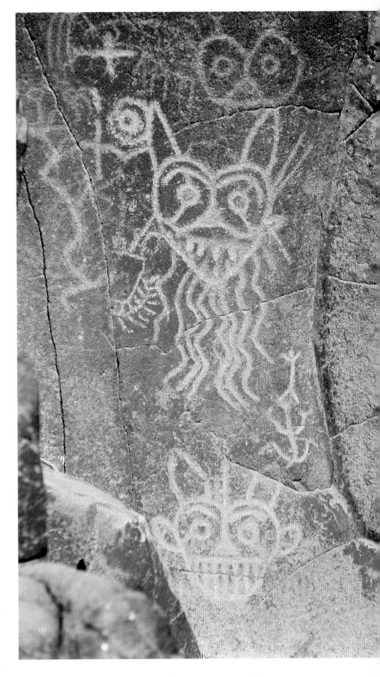

Columbia, a remarkable, natural stone owl was perched atop one of the numerous detached pinnacles lining the Big River's steep walled shores. Native Americans regarded these night birds as omens. Similarly, the spotted owl perches today in the face of destruction. Like its rock art ancestor, the spotted owl waits and whispers across the rain forest: "Destroy me, and the landscape will completely darken."

In order to fully understand the rock art of the

▲ *Resident spirits of the lower Columbia River, often called "water devils," carved into the walls of the now-flooded Petroglyph Canyon. A fragment of this mesmerizing panel has been moved and preserved at the Dalles, Oregon.*

139

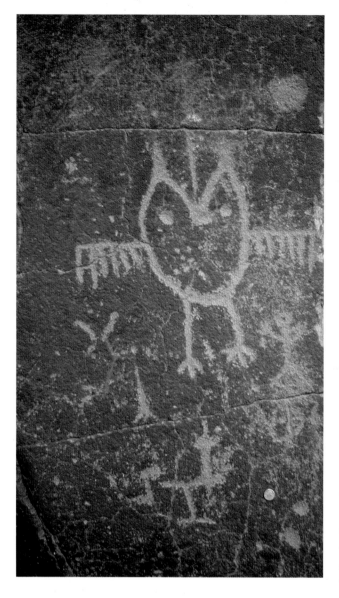

dugout canoe, they described the Columbia as "boiling and whorling in every direction."

The Columbia often presents a grandiose scale of events and natural wonders. No wonder Indian storytellers turned to Coyote's exaggerated deeds to explain the current shape of the land. Through tribal lore, the complicated natural landscape changes into a personalized setting. To understand rock art, we need to know the land. We can follow the trail of Coyote—trickster, hero, and master of contrary wisdom. It was Coyote who, when angered, changed a beautiful woman's flowing hair into Horsetail Falls. The rapids in the Columbia were formed by rubble from great waterfalls that Coyote destroyed so the salmon could swim inland. Later, this clever canine turned his family into stones—rocks known as Coyote's Children.

Driving from Portland east into the Columbia Gorge, few will escape the legendary winds that howl through this break in the rugged Cascade mountain range. Continental winds continue to defend nature's primacy despite dams, roads, and other modern changes. The scores of wind surfers who welcome the gale-like gusts probably do not realize that Native Americans had discovered the secret to controlling the wind. It began with Coyote, who dug an opening into the hard rock wall of the Columbia River long ago.

Coyote's Hole, a small, den-like opening in a cliff at the upriver entrance to the Columbia Gorge, is located between Celilo and The Dalles. Until recently, local Indians kept a timeless tradition alive by filling the Coyote's Hole with wads of fresh grass secured by small rocks when they wanted fairer weather. Uncovered, the opening unleashed relentless winds that produced fierce waves on a river already noted for its wrath. In the shimmering heat of summer, the plug would be removed to provide a breeze—relief for the tribes along the river. According to tradition, in rarer times of drought, water placed in the recess would inevitably bring rain.

The climate control activities practiced by local Indians at Coyote's Hole are characteristic Native American ways of influencing the environment—find a landscape feature linked to the past by legend, acknowledge its natural forces, and use subtle actions to create the desired effect. The three interacting elements at Coyote's Hole—rocks, water, and plants—are acknowledged for their natural symbiotic relationship. Add or remove part of the triad, and conditions change.

In a peculiar way, Coyote's Hole is also a rain rock, possibly related to the thousands of boulders covered

Columbia River, we need to reshape our vision of the landscape in order to recognize a world shaped by dream-time individuals—a world where the actions of Coyote and other early agents of change remain visible today as waterfalls, rock formations, and rock art. When French Canadian trappers first encountered the precipitous stone walls and surging rapids at the upper end of the Columbia Gorge, they immediately named the area, "Les Dalles." The Dalles, named after stone troughs or cobble-lined gutters common in France, formed a narrow, bottleneck canyon for a river carrying thousands of cubic feet of fresh water per second from the interior of the continent toward the Pacific. Lewis and Clark were not exaggerating when, descending by

▲ *An owl petroglyph, called the Spedis Owl, characteristic of the lower Columbia River. A fragment of this panel is preserved in the Dalles, Oregon.*

with smaller, pecked, cup-like holes found along the Pacific coast from southern California to parts of Oregon. Several west coast tribal nations beyond the Columbia also believed that respectful acts performed at certain boulders would change the weather.

The lessons of western science instill skepticism regarding folk wisdom, and this will cause doubt about native use of Coyote's Hole to control the winds. Yet aboriginal wisdom often wears a colorful and easily underestimated mask. Consider *Adoomoog*, the "Weather Stars" of the northern Ojibwa in Minnesota and Ontario. These three stars of Orion's belt were viewed as travelers in a canoe, paddling across the night sky. According to the native trappers and hunters who relied upon weather prediction for safe travel, when colder weather was imminent, the *Adoomoog* would huddle closer together for warmth. This observation, in fact, works in the northern latitudes, where weather fronts alter the atmosphere's clarity. It is a natural observation similar to the changes in precipitation heralded by rocks that "sweat" the day before an approaching storm.

The same wandering Coyote dug the river channels north of The Dalles in order to free the salmon from some selfish sisters. In the early days, five sisters built a vast dam across the Columbia River, thus preventing the salmon from following their migrations to the interior. Coyote, who often made changes in the land, decided to free the salmon. Transforming himself into a baby, he drifted down the Columbia River in a cradle board toward Celilo Falls, where the sisters found Coyote and took care of him. In the following days, as the women trekked into the surrounding hills to collect edible plants, Coyote changed into his customary canine form and began to dig into the dam. The sisters sensed a problem just as Coyote was finishing his task. They struggled briefly with Coyote, but the dam finally burst. Coyote triumphed and the sisters became swallows. Today, Indians believe these birds are connected to the arrival of the springtime Chinook salmon migrations. Ironically, a vast dam has now been built at Celilo, forever destroying Coyote's work and again restricting the salmon.

Today, visitors at Horsethief Lake State Park can discover hints of an older world in the exposed, barren rocks of Atlatl Valley. Despite the intrusion of roads, parking lots, and railroad tracks, medicine people still confer, huddled at the base of a cliff, wearing ritual red ochre colors. Even a quick glance at dozens of Washington and Oregon rock art sites leaves a lasting impression of ceremonial life. Pictographs and carvings repeatedly show individuals and their spirit aides dressed in elaborate costumes, faces painted, wearing unmistakable horned headdresses.

The well-documented gatherings of distinct tribes is mimicked in the rock art. Some groups of paintings show small, stick-figure individuals, mountain sheep, and lizards that are more characteristic of interior tribes. Other paintings and carvings are rendered with broader, hatched bodies, a concern for symmetry, and the one unmistakable trait that hints at coastal origins—haunting eyes. Pairs of concentric circles were the focal points of these ancient faces. The lower Columbia River served as home to tribes that shared cultural ties with the more famous northwest coast groups—Nootka, Kwakiutal, Salish, Tsimpshian, and others.

Many who visit rock art yearn for a voice from the past—words capable of explaining the mysteries left by generations of native people whose spiritual life went far beyond the salmon fishing and plant gathering of daily life. Overcoming incredible odds, the native voice has survived. Another Coyote story, retold thousands of times by the tribal Elders, is best heard against the background of the Columbia's low rush and murmur. Like all indelible mythology, this tale begins in the present:

"Daddy, I found her," my daughter yelled, as she trotted down a narrow path hugging the outcrops above The Dalles. "I found the Bear Lady." Our journey to the rock art of the Columbia had a single goal, mimicking a pilgrim's trek to a shrine. Here we shared in the mystery of this river that flowed under the eternal gaze of the woman with a tongue twister name—*Tsagiglalal*, "She Who Watches."

As Amber lead me to this outstanding example of North American aboriginal art, I thought about the origins of "She Who Watches." According to legend, Coyote visited here long ago. He climbed up from the riverside village to meet Tsagiglalal, who "lived up in the rocks, where she could look down on the village and know all that was going on."

Another account adds a less mythic dimension to this extraordinary rock art creation:

On the north bank of the Big River, near the village of Wishram, stands a rock shaped like a monument or marker. On it has been painted an eye, large and all-seeing. No matter from what part of the village a person looks at the eye, it appears to watch every movement.

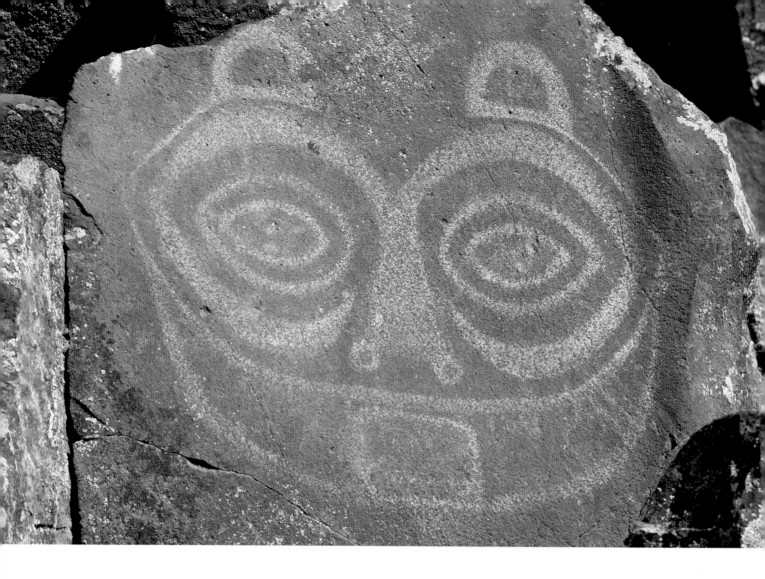

The eye was painted long ago in the days of our grandfathers. One night a medicine man of the Wishram mixed some paint made from roots. Then an unseen power guided his hand and his brush across the stone. The night was dark, without moon and without stars. The man could not see what he was painting.

He worked hard, so that his work would be done before morning came. He was alone, and there was no sound except the splashing of the water on the rocks below. When dawn came, the medicine man had finished. Later he was found, in a trance, at the foot of the rock. A ghostly eye was looking down on him and on the people who came to him. All he knew was that the Tahmahnawis [fairies] had painted it.

Ever since then, the eye has watched the village. It protects the people from evil spirits. It sees everything that everyone does.

For generations, people asked it for help. Bringing it gifts of baskets, mats, weapons, beads, and eagle feathers, men prayed to it for wealth, or women asked that the young men of their choice might love them. The all-seeing and ever-watchful eye seemed always to hear their prayers.

Today, few visitors fail to sense the Native American presence so dramatically expressed in the large, combined pictograph-petroglyph of Tsagiglalal. The eyes—they never let go. Her stone gaze reminds me of the words of my Ojibwa teacher, Sun Rising Over The Mountain, when I asked him about the effect of rock art on ordinary people. He entranced me with his powerful gaze as he whispered, "The spirits of those paintings can take a bite out of your soul."

On examination of this stone age masterpiece, we found how carefully the Columbia River Indians had prepared the image of "She Who Watches." They chose the one vertical slab of rock, broken from the cliffs above, that would support her powerful presence. This naturally standing stone leans slightly toward us, adding

▲ *She-Who-Watches, the resident guardian of aboriginal spirit on the lower Columbia River. Horsethief Lake State Park, Washington.*

a threat. She looms large above the trail and is large enough so that all who journeyed along the original river course would see her. Her massive head, combining the features of bear and woman, is delicately pecked onto a slightly concave surface prepared as carefully as an astronomer polishes her mirrors. A wise and obviously skilled Native American artist laid down a stain of enduring red ochre across the upper surface of this powerful stone guardian, then fitted the image to fill the available space. Slow, deliberate pecking with a hammer stone removed the ochre stain and underlying rock patina to create her subdued features.

Tsagiglalal wears her short, black bear's ears above her bruin's face—an identity also suggested by the rounded frontal lobes of her forehead. Her bear's nose ends in two diminutive nostrils. If we did not have her story, we might mistake "She Who Watches" for a bear alone.

Three concentric rings producing hypnotic eyes are further emphasized by the curved rock surface. These are eyes that originate in coastal art. Her broad mouth, with tapered corners reaching far up the sides of her face, borrows a trait repeated in numerous northwest coast designs. The nearly square mouth opening is an additional, common feature of Tsagiglalal and bear faces. Perhaps the opening is her voice. Very close scrutiny of this Mona Lisa—after all, she too is enigmatic, with eyes following your movements—shows traces of recent history. A careless attempt to copy Tsagiglalal or make a rubbing left small ribbons of modern paint. Around the time of World War I, marks left from the impacts of two bullets scarred her eyes, according to early observers. But Tsagiglalal has endured the seasons fairly well. Like most rock art, "She Who Watches" was meant to survive.

No one really knows when the first Native American recorded a vision or tribal legend on this ledge above the Columbia River, but one of the very last carvings may have been this Bear Lady. Archaeologists who probed Dalles area village sites dating to the historic period uncovered portable images similar to Tsagiglalal carved in bone and antler. Their recurrence in cremations, done at a time when terrible illness darkened the Columbia valley, suggest a connection with death. For the native stewards of the Columbia valley, sadness and loss have continued since that time. And as the stirring morning breeze pushed low clouds of mist across the historic grounds, I suspected that "She Who Watches" had shed a tear for her people and the fate of her river.

The Greatest Discovery

▲ A massive bear or powerful bear shaman—the hand-like paws may hint at transformation from human to spirit animal—dwarfs mountain sheep and aboriginal hunters near Moab, Utah.

◄ Nearly eighty feet high, Pool Rock includes several caves containing Chumash carvings and paintings. A natural depression on top holds a large pool with several thousand gallons of rainwater in otherwise parched country. San Rafael Wilderness Area.

"What is your greatest archaeological discovery?" has been the most difficult question for me to answer. When asked, I immediately think of finding the lost village of the Ottawa Sand People on Lake Huron; the deeply stratified Ojibwa camp sites in Lake Superior Provincial Park; sea caves filled with Nootkan history on the remote coast of Vancouver Island; multi-colored paintings in the Chumash caves of southern California; or the Carib Indian shrine beneath a waterfall in the Virgin Islands. Although these are mysterious, exciting, and sometimes romantic discoveries, they are surpassed by the central event of my life— meeting my cultural grandfather, Fred Pine.

For 11 years, we met twice a week and, on the intervening days, held long telephone conversations. I never exhausted the depth and breadth of his wisdom. He spoke of herbs, folklore, tribal history, sacred sites, visionary experiences, personal struggles, life in the trenches of World War I, work as a logger, elusive star lore, Nanabush narratives, and wisdom gained from nature.

He often looked at our scientific publications, posters, and copies of the paintings his direct ancestors and other past shamans had produced.

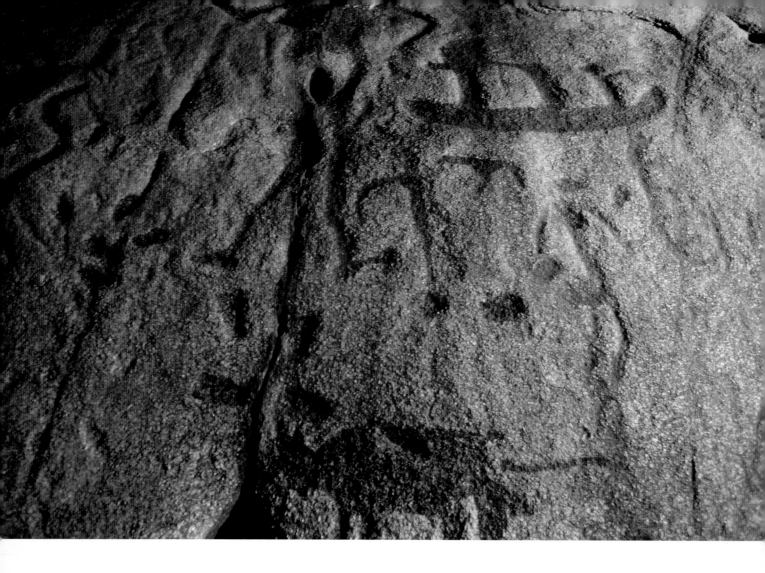

We talked incessantly about aboriginal life, values, and the supernatural.

I admit that I once dreamed about my single wish—to speak with a Native American medicine person who had made rock art and would share its secrets. Although I was born a hundred years too late to accomplish this goal, Fred Pine became a precious link to that dream.

ELUSIVE ANSWERS

Most mythology is finely honed, with an edge sharp enough to carry its hidden meanings and lessons deep into our subconscious. This is why these clever tales have survived the erosion of time. Having been reintroduced by my children to fables from many cultures, I marveled again at the levels of meaning within native mythology. Recently, while working for tribal councils, documenting traditional land use and culture, I have become immersed in the realities of mythology. As an integral part of my consulting work, I regularly collect oral histories and time-honored dreamer's tales. For 20 years, the shamans I have known used the same clever stories to teach complex ideas.

A pair of diminutive painted bears at Agawa Rock reminded Fred Pine of several stories he learned in the early 1900s. They were originally told by a tribal story keeper of the Garden River Ojibwa—a man called Wab-May-May, The Dawn's Pileated Woodpecker.

"Listen now. I'm going to tell you some stories about the bear," Fred said as we walked. "I want you to learn these." He paused for a moment. "And I want you to think about what I say." I understood Fred Pine's advice and sensed his crafty but traditional teaching method. If any Ojibwa could curve a conversation around a topic, leading off to seemingly unrelated areas, Fred could do so with consummate mastery.

I enjoy tales about Bear as much as I appreciate the

▲ *Carvings arranged to incorporate natural rock features at the Teaching Rock, near Peterborough, Ontario. Springs trickle and murmur within the fissure, adding another dimension of life.*

ancient role that this near-human animal played, not only in aboriginal settings but also in western European cultures. Not too long ago, the ancestors of all residents of the United States and Canada were tribal people. Many of us who are not Native Americans are descended from the Germanic tribes—the Gauls, Picts, and Celts, who lived in a world filled with mythology, rock art, and rituals. Through a shaman's skills, bear unites our otherwise distant cultures—removing illusion and revealing deeper truths. Here is Fred Pine's story:

The bear is our closest relative. The old people always said that bear came from Indians who had been changed. There is a story.

One time a boy was sent out to fast for his dreams. He sat on a powerful rock waiting for thunder or the Little Wild Men to give him instruction. As the days passed, his body grew weaker and weaker, but the visions became filled with medicine powers. The boy's grandfather told him to seek a vision for four days, then return to his village.

Power is a dangerous thing. By itself, even great medicine power is useless if you don't have wisdom. The boy forgot this advice from his Elders. As the spirits returned in his dreams, he took more power than he needed. He became greedy. He stayed at the Dreaming Rock long past his time.

The grandfather returned to check up on the boy. He was a Djiski-Innini [shaman], so he sensed danger near the boy. But the grandfather was too late. When he arrived at the visioning place, he saw the boy stand up. He was covered in black hair. His hands and feet still looked like ours, but larger with long claws. He was a powerful creature, almost man but different. He was the first bear. And since that time, others have changed into bears. That's why bear understands the Indian language, eats berries and fish, and looks so much like us.

Fred Pine had told a powerful tale of transformation, but he was not finished. He turned to me with a familiar opening. "Say. Listen now, Thor," he began. "I'm going to tell you some more about bear."

Near the small town of Eckerman in the Upper Peninsula of Michigan, an Indian named Torn Clothes lived alone in the bush. His name means something like ragged clothes made out of bark or animal hides. In the old days, Indians made their pants and everything out of rawhide. Wind does not penetrate skin clothes. I wore skin clothes as a boy. I remember my grandmother made me a hat out of a groundhog skin. She just sewed up the arms and tied the legs up tight. The inside of the pelt fit over my head. When I wore those hide clothes and that groundhog fur hat, I kind of looked like an animal myself.

Torn Clothes was a good medicine man and he trained bears. Torn Clothes had six or seven bears around his house all the time. He gathered food for them. Sometimes Torn Clothes would kill a deer for his bears. The bears just came and went. He could communicate with the animals. That was his gift. He didn't need a fence or cage for the bears. He loved them and the bears loved him. And they licked him in the face. He fed them and raised them.

Torn Clothes' home was a three-log shack with a hip roof. Earth was banked up against the three logs. I slept there one night—the time I walked from the Soo to Sheldrake to load a boat with lumber. It was a long walk along the flat, sandy shore of Lake Superior. I was about fourteen at the time. I remember Torn Clothes' three-log cabin. It just had room for the stove and beds. And was it hot in there.

Old Torn Clothes was quite a man. He wore long hair and whiskers down to his chest. They used to say that made a man stronger—not to cut his beard or hair. All the time at his cabin, bears walked into the clearing. Stuck their noses into the building. And just lived there. Torn Clothes would say, "Nindahway Mahgahnug. There go my relations."

He came across those bears one day when walking in the bush. Torn Clothes smelled something rotten. So he followed the scent to a big pine stump. When he looked inside, Torn Clothes saw the mother bear dead there. Some hunter had shot her, and she was able to crawl back to her den inside that pine tree.

When Torn Clothes moved the mother bear, he found the cubs curled up there. They must not have eaten for a few days. So he took the cubs out of the den and carried them back to his home. A bear raises its young for two years. Torn Clothes brought the cubs up, and they felt related to him. He kept the cubs in his cabin all winter. They hibernated in a corner. He said the bears got up once in awhile to take a drink of water out of a pail and then went back to sleep.

When the cubs grew up, they would be away for three or four weeks and then come back to his house for food. Torn Clothes was an awfully strong man. One bear tackled him and they wrestled. But Torn Clothes beat that bear. They got along after that. The bear was testing him. It left him alone after that.

People say that Torn Clothes cut firewood, and the bears carried it out of the bush to his house. In later years when Torn Clothes was very old, White Loon lived with Torn Clothes and cooked for him. And the bears were always there. I think that old man must have been a bear himself one time to have that relationship.

Fred Pine sat for awhile, lost in thought. I understood that somehow he was guiding me through these stories

to provide an understanding about the painted bears. He continued his storytelling.

One time there was a woman who had two kids. She did not follow the rules of proper living—respect for all life, love for your family, and honesty. She was a bad person and a disgrace to her tribe. In those days, everyone fasted—men and women—to learn the spiritual path. She rejected her power.

Her campsite was dirty because she did not honor her Mother, the Earth. On a sunny afternoon, this woman heard loud noises in the distance. Clear day thunder. She knew that this meant the Holy Spirit was coming. Sometimes the Creator visits us to offer guidance. But she didn't want the Creator to see how she had neglected her children, who were hungry and crying.

Before the great powerful Creator reached her camp, she turned over a large copper kettle—people had big pots around in those days to boil maple syrup—and she hid her two children under it. The Holy Spirit arrived like a glowing sun-person. Above the Creator, thunderbirds hovered. The spirit spoke to the woman. He was testing her.

The Holy Spirit was asking questions to this woman. "I thought I heard children crying here," the spirit told the woman. "Is something wrong?" he asked.

"No." She was foolish. She told the first lie to the Holy Spirit. You can not trick the spirits.

"What's under the tub?" the Creator asked her.

"Oh, nothing," the woman replied. "No living thing is under there."

The spirit gave her another chance. "What's under that kettle? I think I hear something moving."

The woman lied again. "Nothing," she whispered, staring at the ground.

Again, the Holy Spirit asked her, "Tell me what's under there."

"There's nothing there."

The Creator told her, "Turn it over."

As she approached the kettle, this woman began to hear, "Maw, Maw, Maw," coming from beneath the overturned pot. The sound of young bears.

"You tell me there's nothing there?"

"Well, I have two bears under there." When she lifted up the basket, the mother saw two bear cubs huddled together. The Holy Spirit had turned the children into bears, and they ran into the bush.

To me, this story revealed the nature and folly of deceit. If we need a reminder of the consequences of deception, just think of the broken treaties that are part of our recent history. Today, tribal leaders continue to insist that treaties must be honored.

Again, Fred Pine followed his story with a long silence, finally broken with this unsettling observation: "The Ojibwa can be a jealous-minded people."

"Whoa. Wait," I thought. "What's going on?" Then the instantaneous insight, as abrupt as a Zen master's rap, flashed into my mind. "Do you mean the woman in the story stands for our duty to family and tribe? To teach values and respect?" I asked. He looked directly into my eyes, slightly narrowed his own eyes, and waited for more.

"And your visit to Torn Clothes showed that people and bears could live together when individuals understood their relationship to all life," I suggested.

"The story of Torn Clothes is not so much a tale of bears and humans getting along as it is a lesson about finding our connection to nature," I concluded.

Fred nodded and laughed. "There's one more thing that you better know," he told me. "Jealousy comes from the bear. We were a bear to start with. When we take the bear's nature, we become a jealous-minded people. The Indian is like the bear. He protects what is his. He protects his family just like a bear protects her cubs. The Ojibwa medicine men don't let much knowledge out to strangers. They have to take account of a person's background first. Then the leaders let him in."

This I did understand. Native Americans traditionally acted with dignity and careful manners. All the tales—about native women who married a bear and about the men who fasted too long, greedily seeking more power, only to turn into bears—suddenly made sense. Marrying a bear, or becoming a bear, were wonderful metaphors for succumbing to jealousy and rage—two behaviors disdained by the Elders.

Our dialogues continued for several years, until Fred Pine, master shaman, storyteller, and vision seeker, joined his ancestors in 1992. About two years before he returned to the spirit world, Fred telephoned me one morning. "Pick me up," he said, abruptly and purposefully. I sensed the reason for his immediacy—it was time to connect the pieces of traditional culture and rock art legacy that Fred Pine had been allowing me to assemble.

An hour later, Fred Pine and I walked hand in hand down the gravel road. At age 93, his determination supplemented the failings of his legs. We were headed to Kensington Point, a place where his tribe had summered at the turn of the century. We sat on a grey outcrop. I knew that despite cottages, a marina, and

access roads, this island-filled channel of the St. Marys River, darkened by pines and softened by moss, was part of the Ojibwa psychic identity.

That afternoon, Fred completed my carefully paced education about rock art. I never needed to articulate my questions. After our years of travel together to pictographs and other ancestral sacred sites across the upper Great Lakes, my deep interest was apparent.

Previously, Fred had offered isolated stories about the origins of a few particular paintings or identified his great-grandfather's involvement with Agawa Rock. Now he felt he had laid the cultural foundations securely enough to speak freely of the sources for this artistic tradition:

You know, Thor, when all of this culture [traditional wisdom] started at the creation of the world, the Holy Spirit placed several different kinds of spirits to assist the Indian.

There was Way-Wee-Bee-Kohnah-Say, a patroller of lakes. He could swim the waters of every river and lake. Or fly. Or travel in the winter.

Way-Wee-Bee-Kohnah-Say looked like a person, but he was a spirit. He looked after all fish. He made sure their populations were healthy. It was Way-Wee-Bee-Kohnah-Say who established the natural order of all life in the lakes and rivers. Eventually, the medicine people heard his voice and learned this knowledge.

Another thing—the Indians had their culture and learned from the four spirits, sort of like men, sitting up there in the sky. Above the Hole-In-The-Sky. So when an Indian medicine person lit up his pipe, he pointed the pipe and its smoke up to these fellows. And asked for help. Whatever he wanted. To guide his people, too.

We had our gods. We'd go by them [follow their instructions]. When we asked the spirits for help, they could even split the electrical storm. There is no greater natural power than lightning. There were groups of Ojibwa families camped, and they didn't want too much of a storm. Well, the medicine people split that electrical storm. They'd put it all in half.

Storms are controlled by the four spirits up there. That one is a wind-maker; one is storm-maker. You know, different jobs. Change the weather. And the old medicine men knew all about that.

Deh-Bahm-Deh-Koh-Inniniwug are men who study the weather [male weather prophets]. Deh-Bahm-Deh-Kway [female weather watcher]. They can see everything from where they sit. They overlook the whole world, because they sit way up on top of the sky. The same thing happens at the rocks. Contact the spirits and you can see the real world. It's

a saying. You will see your duties and obligations to nature, yourself, and your community.

Day-Deh-Bahm-Ndung the "Weather Watcher" was very old. He composed the first Indian songs. He was the weather man. But he watches more than the weather. He was appointed by the wise leaders to watch for danger.

Long ago, medicine men created island posts to watch for the Iroquois. This island out here—Beaver, He's Heading Out Island—was a lookout for the "Weather Watcher." When the Iroquois came to kill and steal from our people, the educated people [shamans] gathered everyone and placed them on that island. Then the "Weather Watcher" commanded the giant beaver to come alive again. Where the people stood in the trees on that island, it became the back of the beaver. He carried them to safety. Misamick [the Giant Beaver] swam out to the Lake Huron to protect our people, just like he paddled the waters long ago when the earth was created. When the fighting was over, beaver returned to the same place in the river and turned to stone again.

Oh, the medicine people who had fasted could pray anywhere. Anywhere, where they had a site [a pictograph rock] they used to go. Meet there. It wouldn't be like this group. It would be like educated men. They had a name for those fellows. Leaders, a different name they had. And they go out and chase them out in kind of a secret meeting, you know. [Turn into spirits themselves to contact the sky world spirits.] And the medicine men will come back. And tell the tribe what's going to take place.

What titles? What did they ask for? Well, the Djiski-Inninik [Soul Seekers] asked for something like living, to understand the duties of respecting plants, animals, and all

▲ *Petroglyphs at the Jeffers site in southwestern Minnesota.*

▲ The Chippewa-Ojibwa tribes regard cliffs marked with pictographs, such as this site on Hegman Lake in the Boundary Waters Canoe Area Wilderness of northern Minnesota, as sources of spiritual enlightenment from the resident spirits.

living things. *That's how we lived. We honored the Earth.*

The medicine man heard a voice. A voice coming out of the rock. Manidoo—the spirit's voice. The educated people [medicine men and women] were the ones who heard the rocks speak. Not only rocks, sacred springs too. Muh-Dway-Djiwun, "You Can Hear the Water Running," was the voice of the spring. He too could advise the educated people.

Look at that rock near Curve Lake [Peterborough Petroglyphs]. The water is always running under the pictures. There is a voice in that water. But you had to prepare yourself to listen. That's why those carvings were there. To help you prepare.

Muh-Dway-Djiwun, "I Can Hear Water Running," originally, that was a spirit like a person. Before Nanabush came to earth. Now, Muh-Dway-Djiwun is the name of a dead-end river near the St. Joseph Island bridge. There is an island there in the lake [Lake Huron] where the St. Marys River comes out. Indians could hear the water running in that rock as they paddled on the river. That's why the Indians did a little bit of writing on the rock near there. The island is on the left side at the mouth of the river when you come out.

You see, the Indians never stopped. You read about that. Maybe it's in a story. The Indians never stopped exploring. Because the country is so big, you see. And they knew it was theirs, because there was nobody else there.

When I was a child, I saw the markings on stone. Indians kept those writings clean all of the time. Since then, the moss has covered some of them up. On that cut rock [vertical outcrop], there are rocks like cups all through the channel there. Indians put tobacco and gunpowder in the hollows. You could see a little bit of water in those basins, too.

Over there. Writing there. High rocks. They marked that cliff because that's where Nanabush chased Puckewis off the cliff, and Puckewis became the first beaver.

Indians had ravens to guide them to special places. I talked to ravens too, and learned a lot. Raven builds her nest at those marked rocks [pictographs]. That's why raven is so smart. My grandfather traveled with raven.

Muh-Dway-Gihn-Ahdjigun is the "Sound Maker." He learned from the woodpecker, Pahpahsay. Listen to woodpecker working on a tree. You could not create the sound he creates. Then Muh-Dji-Kewiss came into the world to gather the news from the "Sound Maker." Muh-Dji-Kewiss acted like a teacher for the Indians.

This spirit, Muh-Dji-Kewiss, was like a senator. He gathered up gossip. He was a spirit who traveled all over, listening to the Elders speak. He could travel under the ground or through the clouds. That was the work of Muh-Dji-Kewiss. To spread wisdom from tribe to tribe. But he had to have a special place to talk to the medicine men. He chose that rock.

"The Spokesman" always stayed in a cave, inside the rock. He got the sounds out of the rock. Muzhiniway was a like a person and a spirit. He was the medicine man's right hand man. Muzhiniway was not only a spokesman, he left the paintings on some rocks to communicate. Spiritual communication. You could call him "The Marker." Muzhiniway. A storyteller also could be called Muzhiniway.

The old people always told us, "We know where we are going to go anyway. We are going someplace. We will meet somebody at those painted rocks, but you don't know that. You got to go someplace after death. This thing is going around [traditional beliefs are returning]. We might be lucky to get that."

All the Indian stories we tell—I tell—are just like fitting together a puzzle. They all make sense. We know that we have been misled all along by modern beliefs. But we can't help it. Now we got to get away from that thinking. We must go back to our education from the rocks and from our visions.

You can burn a holy book, but you can't burn this [pictograph] rock. It guides you. When I see one of those marks, I know what it is right away. But there is more meaning to it. You have to dream about it.

One word on the rocks is a lot of meaning. It's like shorthand. If one of those painted animals bites you, don't follow the road before you [in your vision]. "Biting" is a saying—the painted animal bites you. Rock art is an effort on your soul by the spirits. You will become uncontrolled.

Here at last, with this narrative, I felt the life spirit that animates rock art. Through Fred's words, I now had a guide to these painted dreams.

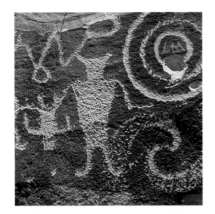

Voices from the Past, Wisdom for the Future

Wilderness has succumbed to a disastrous fate across North America. Along with the removal of the caretakers, we have lost the balance of nature. We need wilderness as a place in which we can get lost from the distractions and illusions of daily life. But successful journeys require guideposts. When rock art reflects the earth's spirit, it serves that purpose.

What we perceive as wilderness often overlaps with rock art settings. Some rock art sites served as the basis for setting aside park lands. Yet many of the Dreaming Rocks found in the state, provincial, and national parks of North America went mostly unnoticed, and gained protection through coincidence. But it was never really a chance occurrence. Societies, including the Nacirema—as anthropologists jokingly refer to our contemporary American tribe—tend to respond to the same, self-preserving values found in these areas of natural beauty.

In its true cultural setting, rock art becomes a touchstone where the vast mysteries of life and spirituality can be contemplated. The poetic images lead us to insights along curved paths rather than through direct answers. Dan Pine believed that

▲ *Concentric circles, horned shamans, Yin-Yang symbols, and inverted human forms are interconnected at Split Mountain Canyon, Dinosaur National Monument, Utah.*

◀ *Hoodoos, silent stone sentinels formed by wind erosion, guard Writing-On-Stone, Alberta, and create an eerie landscape suited to mystical art.*

the pictographs of his ancestors provided a connection not only between people, but also with our brothers and sisters of the animal tribes:

Another name for the paintings on rock is "blazing." The idea is the paintings mark a trail for you to follow, just like blazes on a winter trail. Even the animals go into that rock. It guides them, too. Today these painted rocks are coming back. More people recognize them—study their meaning. This was a prophesy. The paintings would come back.

Incessant questioning about age, meaning, or authorship of rock art will forever ring with the hollowness of a rock chamber. Rock art comes from vision and instinct more than intellect. By its very nature, rock art is paradox and ambiguity. Instead of settling for inaccurate and incomplete descriptions, we should learn to embrace these enigmatic images as personalizations of nature. In the Native American environmental perspective, self merges quickly into the surrounding world. Three environments are often depicted on the rock walls: the personal, often directed inward through vision questing or the shaman's journey; the community, where rock art is part of an established sacred site; and ultimately, the intertwined landscapes of the natural world. These sites provide settings where we can sense our intuitive relationship to nature. Today, as our awareness of the native landscape grows, the power of these spiritual places can have a positive impact on our lives.

Are all of us Native Americans when we accept our land's legacy and spirituality? Special physical settings, containing sacred properties, provide a place for contemplation. Distractions fall away. Here, an intimate relationship with nature can be achieved. As our awareness of the spirit within us develops, we can discover the web of connectedness. Then the soul of the place enters us. We in turn can yield and become part of the multi-dimensioned place. At that moment, we too become native.

In a sense, the holy land is also here in North America, where we are born, raised, and live. This approach, based so firmly on aboriginal wisdom, treats rock art images as gateways to Native American knowledge.

Because so many rock art sites are devoted to spirituality, the whole experience of place is important. If we linger too long on individual details, we lose the carefully crafted experience—moments formed by nature's grand work and guided by past visionaries. Dan Pine explained the recovery of the sacred:

You must pray when you travel to sacred sites. Pray that all these lost things will come back to you. And it does. The rocks will speak to you in a voice so clear. These are the preparations that you make when you are out. Say the words that are right. Make the proper interpretations.

As for the real understanding, sometimes you can almost hear the Elders talking from years ago. They want you to be blessed. This is spiritual communication. We live in a spiritual world. We must see that, honor it, and be true. Then the greatest powers will be with us.

If you deny the spiritual, it's like sitting in a house and saying there is no wind. The sacred mountains and cliffs are the important places in your life. If we don't feel them, if we only see them, then we are the ones who are dumb. All the knowledge you will ever need is out there in nature. The Great Spirit put Mother Nature here just like a government. Four winds. The sun and moon. Rivers. Water. Trees. And Thunder People. They are the spiritual government that takes care of the earth. You must claim that relationship. You must claim it where they are present, at the holy rocks.

If we honor the same things, we can communicate anywhere, with anyone. The understanding that comes from spiritual discovery is like the communication between a mother and child, only much stronger, because of the power of our grandmother, the Earth.

These words left by the great spiritual leader of the Ojibwa offer us a rare insight into the larger role of rock art sites. Dan Pine taught his vision to many people, always stressing that we develop our common heritage and relationship when we turn to nature. Dan Pine carried prophesies and wisdom across a time of incredible change for his tribe. His knowledge speaks to all of us who seek a connection to the land that he so lovingly called our grandmother.

A NIGHT INSIDE A DREAMING ROCK

The journey of the Dreaming Rocks began with an Ojibwa shaman's vision. It ends with another dream—possibly the ultimate insight into rock art. This last story, an ancient memory from long ago, came from an elderly Indian named Shannon Cryer. I found Shannon and his wife sitting in the kitchen of his small home in northern Ontario. He seemed to have been expecting us. We met only this one time, but I think of his gift almost daily. My wife Julie spread out the reproductions we had made a day earlier at Fairy Point on Missinaibi Lake. The couple quietly looked at the indelible dreams of their ancestors. Then Shannon narrated the following story that took place on *Matagaming Sagagen*,

now known as Horwood Lake. Like the dreams that surfaced in this tale, the pictograph site was extraordinary.

Indian people used to see those Maymaygwashiuk fishing with their little nets in front of that rock with the markings on Matagaming Sagagen. As soon as the elves saw you, they would paddle their tiny canoes as fast as they could and disappear into that cliff.

One windy day, an Indian fellow spotted the little people fishing. So he paddled up close to see them. They were hairy all over. But he could hear them speaking the Indian language. All of a sudden, the fairies turned in their canoes and saw the Indian man. The fairies raced toward the cliff with the paintings. But the Indian man paddled hard and kept close behind them.

Suddenly, the wall of paintings opened up in front of the fairies. The little men sped into a deep cave inside the cliff as they often had before. This time, the Indian dug his cedar paddle into the deep lake waters as furiously as he could. He reached the dark opening just as the rock began to close. In an instant, he was inside the fairies' cave.

"You caught us!" the Maymaygwashiuk yelled. They stood on a flat rock shelf that went further back into the cave. Their birchbark canoes were pulled onto the edge of the small bay of lake water that extended into the cave.

"You speak my language," the Indian man said excitedly. "I waited many years to catch you. I want to know how you live. And why do fairies avoid my people?" he asked.

The rock elves laughed. "You tricked us today," they told him. "You caught us and now you can have anything you want." The Indian was so surprised to be talking to this mysterious tribe that he had not taken time to look around their home. As he glanced beyond their miniature camp fires made of twigs, the Indian was startled to find their residence so attractive. Like most of the Matagaming tribe, he thought the little men lived in a dark, damp, hole in the cliff. Instead, the Indian saw a beautiful, perfect image of wilderness. The floor of the cave had the finest yellow sand floor even though

▲ *A typical dreaming rock and home to the fairies at Lac La Croix, Boundary Waters Canoe Area, Ontario.*

155

there was no sand in that part of the lake.

Old stories raced through the Indian's head. The fairies were respected and feared. They had the power to help Indian people, but fairies also caused trouble. One time some Matagaming Indians were camping near this lake. The parents hung the cradle board up in a tree to protect the baby while they collected limbs for their fire. While the parents spread out to gather more firewood, the Maymaygwashiuk took the baby. The little people ran off with the child still wrapped in blankets and moss safely in the cradle board.

When the baby's parents heard its cries, they chased after the sounds. The little wild men could not get to their canoe fast enough. And they did not want to get caught. After awhile, the Indians found their baby by its cries. The fairies had hung it up on a pine limb on their way to the water.

Everyone knew that the Maymaygwashiuk stole tools from the Indians. You could never actually see the little people do this. They always hid behind trees or rocks. Sometimes there would be a quick flash of lightning and your axe or knife would be gone. Even on a clear day without clouds, the lightning bolt would strike when they moved. These fairies are a very powerful tribe. They converse with the Thunder people. That is why the Maymaygwashiuk live in caves where there are markings on rock.

Inside, the cave was filled with fine bush food—smoked lake trout, strips of moose meat, woodland caribou stews, snowshoe hares fried with berries, ruffed grouse browning on roasting sticks, fat beaver roasts in bark dishes, everything an Indian could dream for. And one side of the cave was covered with painted skin drums, bone-handled flint knives, tightly woven black ash baskets, medicine bags filled with fresh herbs, and many more things. The Indian recognized a few of the things. Some had belonged to his grandparents when he was a boy, and had disappeared long ago. Others looked very old. He had never seen such treasures in his 40 years of life.

"So this is where everything that gets lost ends up," the visitor thought. "I knew that the fairies steal from us, but never dreamed that they lived so well," he said to himself.

"Of course, we do," one of the little wild men answered. "And we hear your thoughts just as we listen to your prayers at this spirit rock. Although we hunt and fish like you, we are influenced by the spirits. We take your messages to Thunder and the other forces that cannot be seen."

The Indian sensed that he was present in a living vision—a place and source of great spiritual power. He accepted the fairy's offer to stay as their guest for one night. It was an evening of good food. He felt as full as the times he sat at a feast to honor bear. The little wild men drummed until dawn and sang medicine songs so old that the Indian could barely understand the words. When he asked why the song-prayers used such ancient words, the fairy told the Indian that these were the songs he learned in his youth. Then the Indian noticed that all of the fairies looked youthful and very old at the same time. With the small fires casting dancing shadows on the smooth walls and ceiling of their home, heartbeat drumming pulsing through the night, and the high-pitched songs echoing across the lake, the Indian received many visions while sitting with the little wild men.

At dawn, the leader of the fairies told the Indian man that it was time for him to rejoin his own nation. As the sunlight spread across the eastern hills, the cave filled with a yellow glow. And the cliff, still transparent from inside, shimmered in the light. The Indian could not believe what he saw. The entire rock wall that he had viewed many times from the outside was clear. Each rock painting hung in the air, reddened to the deepest hue by the arrival of Manidoo Ghesis, the Spirit Of The Sun. Matagaming Lake sparkled with globes of fire as each small wave reflected the rising sun. And the ancient paintings of stars, suns, caribou, and animal spirits came to life. The broad mouth of the cave formed a clear tapestry of pictograph images.

Low sounds, like a crowd of voices, could be heard around the groups of paintings. As the Indian man walked closer to the magical wall, he understood the sounds. They were the voices of his people! He heard his grandmother praying 30 years ago as she left tobacco at the cliff. And he

▲ A disembodied woodland caribou head at the Quetico Lake site, Quetico Provincial Park, Ontario.

heard his father and uncles sing the songs of Djiski-Inninik while they painted images fresh from their vision quests. These hunters too had passed to the land beyond the stars long before.

The Indian man stepped into his bark canoe inside the cave near the wall of pictures and prayers. He thanked the little wild men for his visit. No one had ever lived such a full, single evening. The Maymaygwashiuk stood by their tiny canoes as he paddled into the clear wall of paintings. With a few deep strokes, the Indian glided out of the cave. As soon as he turned around to look again at his hosts, he saw only a wall of rock covered with the same paintings, now silent. He thought he heard the sound of one tiny drum inside the cliff, but the waves were lapping the sides of his canoe with such force that he could not be sure.

"How will I best use the power of my visit to the little wild men?" the Indian wondered. He decided to talk with the Elders. The Indian man returned to his camp at the pine-covered point on Matagaming Lake. But something was not right. He beached his canoe where several children were playing. "I have never seen these children," he said. And the summer camp seemed different. Stopping for a moment, he tried to understand what was changed. "The pines!" he yelled. "The pines are so tall now. What is happening?"

The Indian, who left this village the previous afternoon, was confused. He asked a man standing by a summer lodge, "Who are you?" The hunter told him his name. "I don't know you." Now the Indian walked over to a group of women who were preparing hides. No one knew him.

Fear rose within the Indian's heart. He asked about his wife and children. The other Indians said they once heard of that family, but that was a long time before. "I remember hearing that story. The husband of that family disappeared one clear day while fishing on the lake," a woman told him. "That was before my time."

Finally, the Indian man spoke to an old, old woman. "Grandmother," he said, "do you know of my family?" The old woman looked at him in amazement. "I am your youngest daughter!" she gasped. "You left when I was only a baby. Now I have lived for 80 winters." The Indian man understood. His single evening with the spirits' helpers had lasted a lifetime. He lived a few more years after his return. A night with the fairies had caused a strange event.

Shannon Cryer paused before sharing the final part of this remarkable story. I will never forget the moment. Our copies of the Fairy Point pictographs, red paint on clear acetate, were piled on his kitchen table. His wife sat beside him. Her slight nods affirmed his recollections. This was an old story, learned in his youth when northern lands still echoed to the pulse of tribal drums. He concluded the tale:

The Indian had entered straight into the cave. The entire time he stood talking to the fairies and looking around, he kept his back to the lake. Now he turned around. And the Indian could look out of the cave and see the lake as if the rock wall were a window. This was not possible. He knew that the opening to the cave had closed behind him.

Now he understood why the fairies could live on the same lake as the Matagaming tribe yet remain almost invisible. They watched the broad lake through their magical rock window, so two worlds could exist as one.

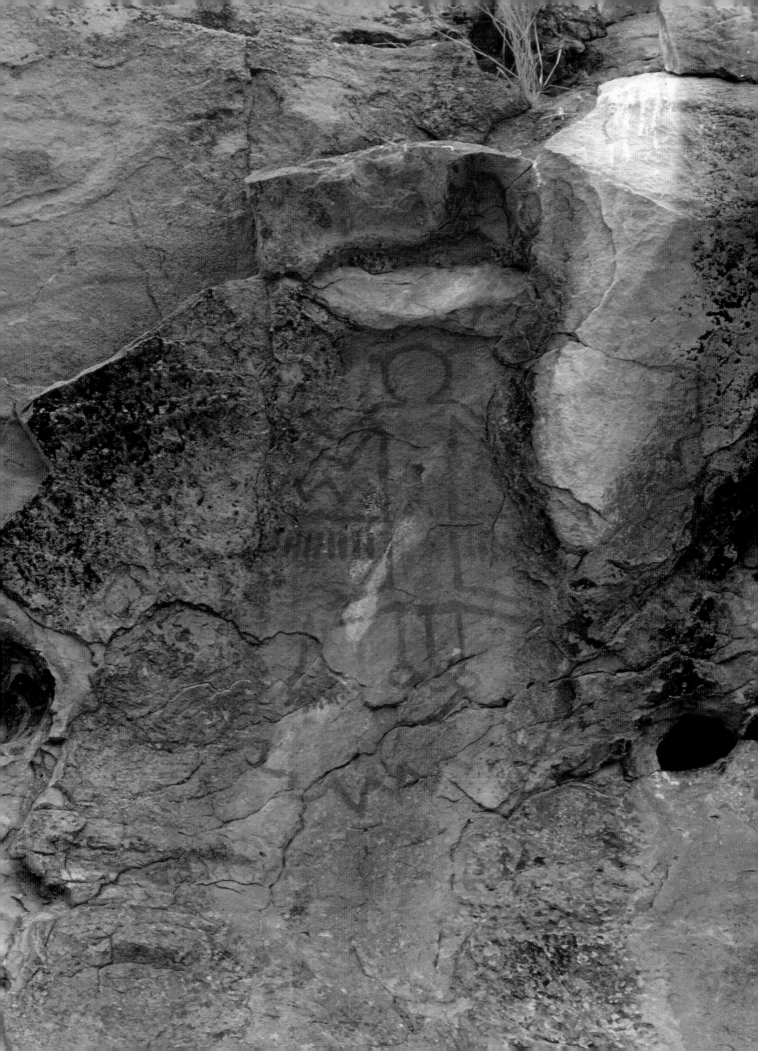

Epilogue

I have carried the precious, magical story told by Shannon Cryer with me for a dozen years, enjoying its imagery and its insight into the heart of rock art. After repeating the tale many times, one day I finally understood the subtler message carried in the ancient tribal narrative.

Some master storytellers advise against explaining a folk tale, and I often agree. But today we live in an age of distraction, where the subtle meanings of well-crafted tales can be easily overlooked.

Metaphor is a kind teacher. The parting of the painted, sacred cliff in "A Night Inside a Dreaming Rock" stands for the opening of knowledge. The inner world of the Little Wild Men, filled with "lost" riches, reveals to us that our greatest treasures—wisdom, health, and understanding—lie within, but are often out of reach.

The final metaphor hints at a common theme. When the Indian returned to his home village, no one recognized him. This single evening of enlightenment lapsed into a lifetime. Here the original storyteller expressed the universal concept that the price of greater wisdom is becoming a stranger in your community. The accelerated passage of time served to reaffirm a wisdom that views Elders as living links to a distant past.

In one of my final conversations with Fred Pine, we talked about this book, *Painted Dreams*, and how much he had contributed by sharing his tribal and personal wisdom. One of the last statements he made about the Dreaming Rocks was:

"Never let the spirit go out of the rock. These are the dreams of my ancestors. My dreams. Your future."

◄ *A shamanic figure, nestled into a natural alcove, appears to be wearing ceremonial clothing. Chumash dance skirts made from eagle and crow feathers, have been found cached near pictograph caves. Zigzag power lines, or a solar motif, suggest that this is the record of a trance experience.*

PHOTOGRAPHY